03

WORLD PRESS PHOTO

Thames & Hudson

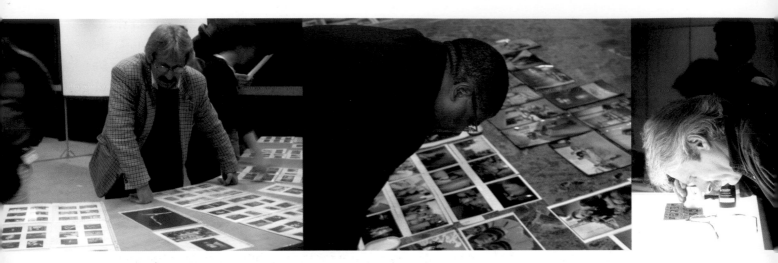

It took the jury of the 46th World Press Photo
Contest two weeks of intensive deliberation to
arrive at the results published in this book. They
had to judge 53,597 entries submitted by 3,913
photographers from 118 countries.

World Press Photo

World Press Photo is an independent non-profit organization, founded in the Netherlands in 1955. Its main aim is to support and promote internationally the work of professional press photographers. Over the years, World Press Photo has evolved into an independent platform for photojournalism and the free exchange of information. The organization operates under the patronage of H.R.H. Prince Bernhard of the Netherlands.

In order to realize its objectives, World Press Photo organizes the world's largest and most prestigious annual press photography contest. The prizewinning photographs are assembled into a traveling exhibition, which is visited by over a million people in 40 countries every year. This yearbook presenting all prizewinning entries is published annually in seven languages. Reflecting the best in the photojournalism of a particular year, the book is both a catalogue for the exhibition and an interesting document in its own right.

Besides managing the extensive exhibition program, the organization closely monitors developments in photojournalism. Educational projects play an increasing role in World Press Photo's annual calendar. Seven times a year seminars open to individual photographers, photo agencies and picture editors are organized in developing countries. The annual Joop Swart Masterclass, held in the Netherlands, is aimed at talented photographers at the start of their careers. They receive practical instruction and are shown how they can enhance their professionalism by some of the most accomplished people in photojournalism.

World Press Photo is sponsored worldwide by Canon, KLM Royal Dutch Airlines and TPG, global mail, express and logistics.

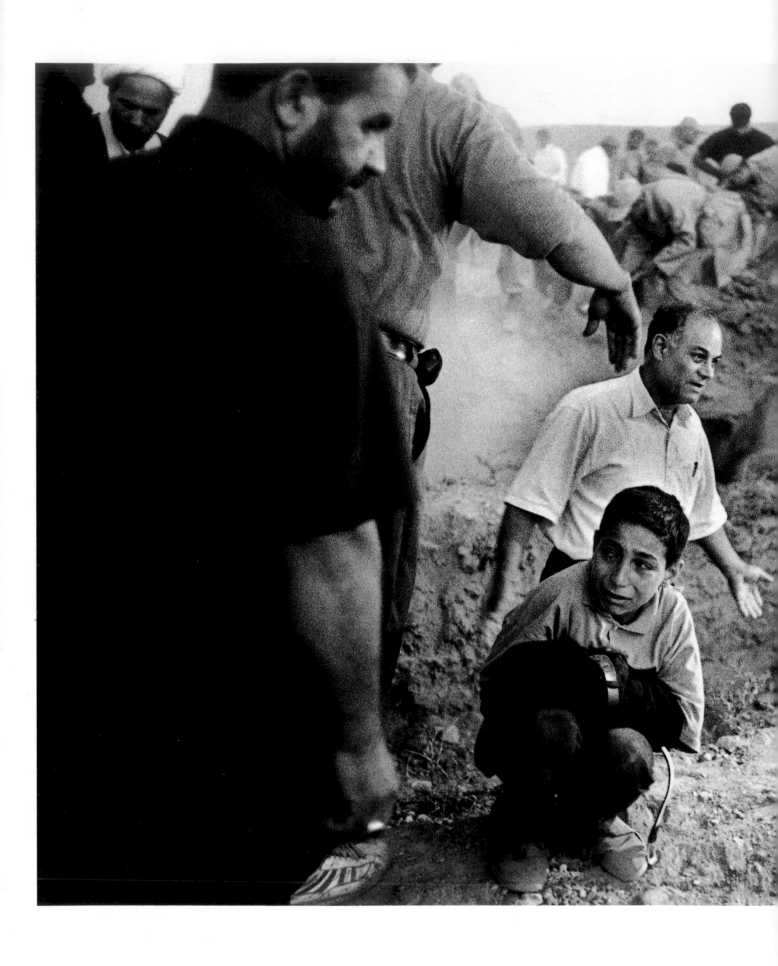

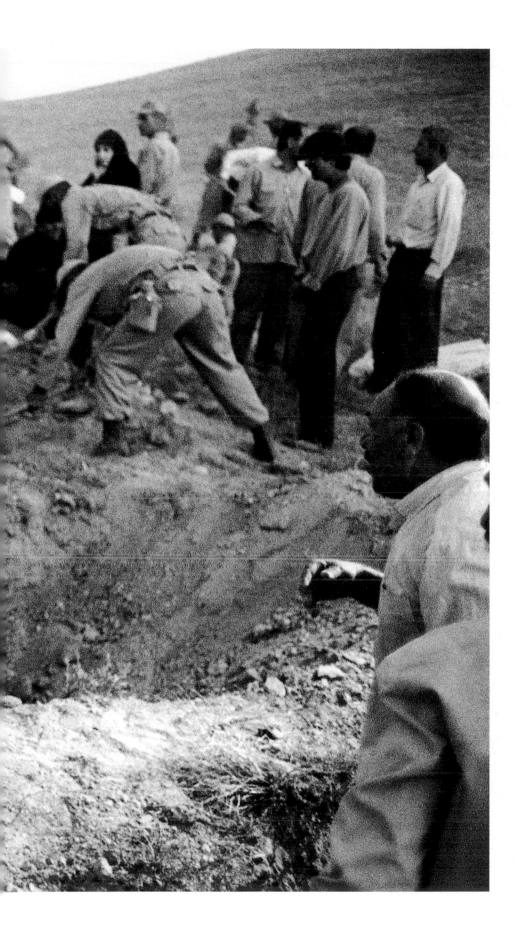

World Press Photo of the Year 2002

Eric Grigorian
Armenia/USA, Polaris Images

Honorable Mention
General News Singles

Surrounded by soldiers and villagers digging graves for victims of an earthquake in Qazvin Province, Iran, a boy holds his dead father's trousers as he squats beside the spot where his father is to be buried. The earthquake, measuring 6.0 on the Richter scale, struck on June 23. Dozens of villages were destroyed and hundreds of people killed across the province.

Eric Grigorian was born to Armenian parents in Iran in 1969. At the start of the Iranian revolution in 1979, he left with his family for the United States. While completing a degree in photojournalism at the San Jose State University, he spent a semester abroad studying under Ed Kashi in London. After graduating, he freelanced for the *Los Angeles Daily News*, later moving on to magazines before joining the new Polaris Images agency in 2002.

Eric Grigorian

Eric Grigorian, the author of the World Press Photo of the Year 2002, answered some questions about his work.

How did the winning photo come about?
I was in Tehran visiting my uncle. The earthquake happened while I was there. We felt it in the morning, but it seemed like quite a small one as it was 200 miles away. Around two o'clock we began to hear rumors that it had been pretty devastating. I called a taxi and together with another photographer we made the four or five hour's journey out there. It was almost dusk by the time we arrived, and we had about half an hour of light left. The picture was taken within the first 20 minutes of our arrival. As soon as we got there we walked into the village. People were in a state of shock, as if they didn't know what had happened – or were just beginning to realize it. Many were crying. The first thing we did was walk up to a hill where we'd been told people were being buried. There was a cemetery on top of the hill, but because of the number of people killed they had brought bulldozers, and there were soldiers digging. It was a really emotional place to be. You just could not believe that all of those people had died. I began to think that this could have happened to me or my family, and was picturing myself in their situation, thinking about my family members going through what they were going through. It was very emotional just being there.

You were born in Iran, and are described as both an Armenian and American photographer. What do these labels mean to you?
We left Iran and came to the United States when I was nine. I've lived in the US for over 20 years, but I consider myself Armenian because my heritage is Armenian. A lot of people find that hard to understand and say 'You were born in Iran, so you must be Iranian', or 'You live in the States, so you must be American', but the culture I grew up in is Armenian, I speak Armenian with my family. I identify with that. Labeling myself as an Armenian photographer now makes the Armenian community proud, and the country of Armenia proud.

When did your interest in photography begin?
It was in college in the States that I took my first photographs. I was looking for something interesting to do, besides the usual general courses. At the time I just wanted to do something that was fun. That led on to more serious photojournalism classes, and into photojournalism itself.

What was it that grabbed you about photojournalism?
The impact that photojournalism can have. Or at least that's what I thought back then. I thought photojournalism was something you could change the world with. But that's not strictly true. It helps, obviously, but it doesn't necessarily change the world. Even so, I still think photographs can have a strong impact on society. A lot of my incentive in taking photographs is to dispel the sort of myths that people have about places like Afghanistan or Iran – we tend to tie the people and the culture of a country to the government, and that's just not true. If I can change people's ideas, this is going to be one way – by taking photographs that bring humanity to a situation. But it's difficult as a freelancer to go and do the projects you think are important, and finance them yourself.

Do you find it difficult to get editors to care about the things you care about?
It seems like the media are interested in only whatever everyone else in the media is interested in. If it's not a trend or a hot topic, then it's not going to arouse much of an interest. To try and get your own project, something which is not already getting a lot of attention, into the media is difficult.

How do you feel about the fact that your winning photograph was not published until after the competition?
I was disappointed. Because I was shooting film, and because it was in a distant village, I didn't have a chance to send it anywhere until two or three days after the earthquake. I was told that as it was in black-and-white, and because it was two days old and no longer news, it couldn't be sold. Later, someone said another reason it wouldn't be published was that the death toll in the earthquake was not as large as they had originally thought, so it wasn't as newsworthy. That's ridiculous. Even though reports now put the death toll at between 250 and 500, if that many people had been killed in Los Angeles, it would be covered everywhere.

What does winning the prize mean for you?
People ask me whether I feel odd winning the competition so early in my career, as it is something that is on many photographers' wish-lists as an ultimate goal. But this is just one photograph. You can't judge someone's work from one photograph, but winning is going to give me the opportunity to make a real impact in the world of photojournalism. For me this is just the start.

THIS YEAR'S JURY.
In front, from left to right:
Herbert Mabuza, South Africa
Shahidul Alam, Bangladesh (chair)
The rest of the jury, from left to right:
Pablo Ortiz Monasterio, Mexico
Mitsuaki Iwago, Japan
Eva Fischer, Germany
Andrew Wong, People's Republic of China
Alexander Zemlianichenko, Russia
Brechtje Rood, The Netherlands
Adriaan Monshouwer (secretary)
Maggie Steber, USA
Sarah Harbutt, USA
Paolo Pellegrin, Italy
Margot Klingsporn, Germany
Pierre Fernandez, France

Foreword

Much is made of the figures, but this is not a numbers game. While the sheer volume of photographs is daunting, it is still in the end a qualitative choice. How does one weigh one photograph against another? What makes one compelling image more special than another? What criteria do juries use to determine which one is best?

The parameters for the World Press Photo of the year are known: a photograph showing outstanding visual qualities and representing a news situation of global importance. News photographs are often taken on the run, in situations of extreme stress, often in situations of danger. Only outstanding photographers are able to create powerful, moving, beautifully constructed images even under such conditions. But their qualities need to combine with outstanding news-value to create the most talked about press image of the year.

2002 was a year of waiting. Waiting for UN resolutions to be applied equally to all. Waiting for aggressors to be punished. Waiting for a war that the world abhorred but seemed unable to stop. Missing were the moments that news networks paid millions to cover. Disasters in western countries lacked significant death tolls. Nothing significant had happened in the countries that mattered.

That is not to say that nothing had happened, or that the world was at peace. In a world where all lives are not equal, some lives are easily forgotten. Their daily plight does not count. Their struggles are insignificant. No war machines come to their rescue. Unless material interests intervene.

But riots, earthquakes and indiscriminate bombings have taken place, and occupation continues. And there have been photographers who have been there. At a time when defence pools, restricted access, and editorial policy define the perimeters of journalism, some photographers have gone against the grain and covered stories which should have been news but weren't, about people who should have mattered but didn't.

Clinging to the trousers of his dead father, a young boy cries for a loss that is as universal as it is personal. The image talks of humankind's eternal struggle against nature, and a community's ability to stand by the afflicted. Yet, amidst all these people, the young man is alone in his misery. The death he mourns might not matter to a world that doesn't care, but to him, the world might well have stopped. And one photograph preserved that moment, a silent witness of an emptiness that speaks to us all. One photographer takes on the challenge of questioning our definitions of news.

As for the judging itself, it was a complex, passionate, fervent affair. Time and time again, we were humbled by someone's insight into a moment that had completely passed us by. Again and again, our zone of comfort was invaded. We were shaken into responding to an argument that questioned the values that we had always considered unshakeable. Our tools of measurement were cast aside. We stood naked, our prejudices exposed.

The photographers too stretched us. Images that explored the gaps in our visual spaces, played with our sense of balance. War was presented through lingering traces. Political systems presented through emptiness and solid structures. Consumerism and decadence exposed through garish images, unashamedly rejecting the classical norms of image construction. Tender moments rendered without sentimentality. And of course those stark images, where the photojournalist, at the right place at the right time, but hopefully for not too long, returned with the horrors of what man does to man.

When the credibility of our media, shrouded in propaganda, struggles for survival, a few brave women and men continue to report the news that is no longer newsworthy. This contest salutes their courage.

SHAHIDUL ALAM
Chairman of the 2003 jury

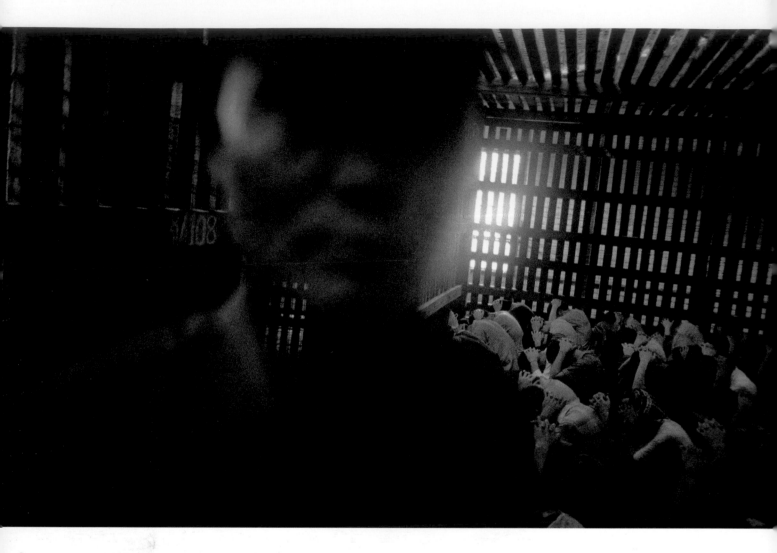

Antonin Kratochvil
Czech Republic, VII for The New York
Times Magazine

1st Prize Singles

In Burmese prisons like this one in
Muse, inmates sit in leg irons in a
labyrinth of wooden cages, forbidden
to move from the lotus position.
Myanmar, as Burma is now known,
briefly toppled Afghanistan as the
globally dominant producer of
opium when Afghan production
dropped as a result of US military
operations against the Taliban in
2001. The international community
blamed the Burmese military regime
and former rebels supported by the
government for the spiraling drug
traffic. But in January the authorities
announced a crack down, handing
out harsh penalties to drug runners.

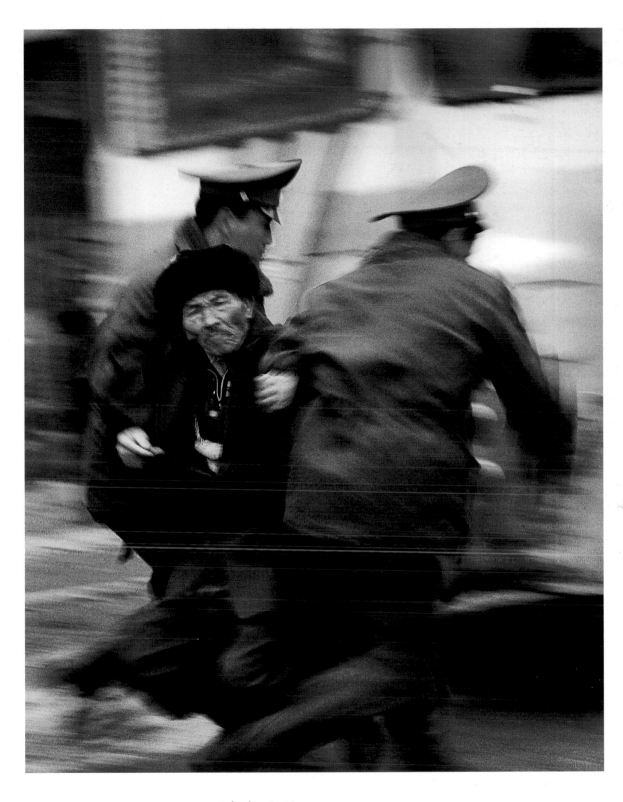

Vladimir Pirogov
Kyrgyzstan, Moya Stolitsa/Reuters

2nd Prize Singles

A protestor is carried away by police in Bishkek, Kyrgyzstan, in November. The demonstrators were calling for the impeachment of Kyrgyzstan president Askar Akaev. They blamed the government for taking no action against officials considered responsible for fatal shootings at an earlier demonstration. The march began at a town 20 kilometers from Bishkek, but was halted at the city limits. Police removed demonstrators to buses. They were taken to jail, and sent home a few days later..

Patrick Andrade
USA, Gamma for Newsweek

Children's Award
3rd Prize Singles

A boy crouches beneath a truck to gather stray lumps of charcoal dropped during distribution by Red Cross workers in Kabul. Twenty years of conflict had ravaged the country and made everyday life difficult, especially in Kabul and the densely populated south. Winter brought further difficulties to an already destitute population. Aid organizations implemented programs to help with reconstruction of the country, including rehabilitating the water supply and providing blankets, winter fuel and plastic sheeting.

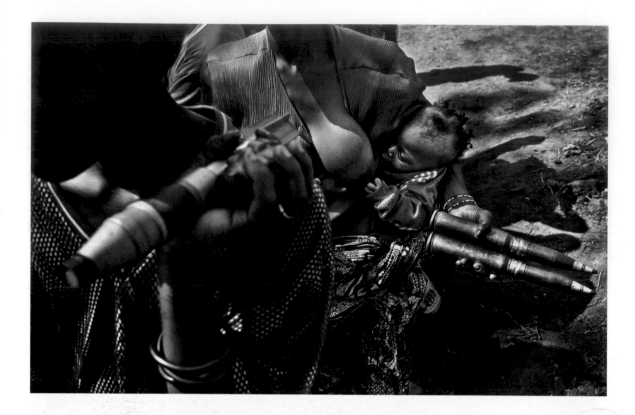

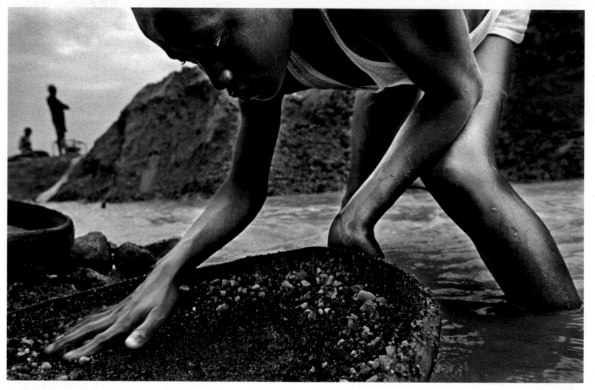

Jan Dago

Denmark, Magnum Photos/Alexia Foundation for World Peace

1st Prize Stories

A long-running war in Sierra Leone finally came to an end in the first months of 2002 as the UN, British armed forces, and government troops edged clashing factions towards a peace agreement. The UN supervised rebel disarmament, and democratic elections were held in May. Top: Rebels line up to surrender their weapons. Below: A boy sifts for diamonds. The struggle for control of diamond mining and other natural resources was a source of the conflict. Facing page, below: Refugees returning from Guinea come to the end of a 12-hour journey. Following pages: Members of former rival factions, now doing military service together, relax at the Bemguema training camp.

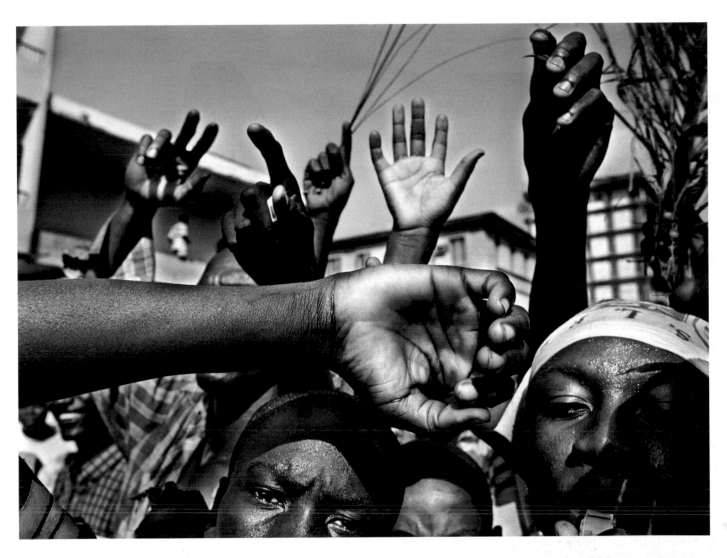

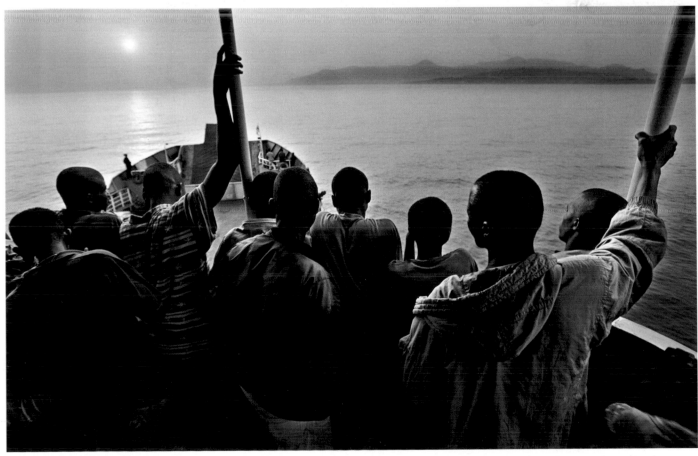

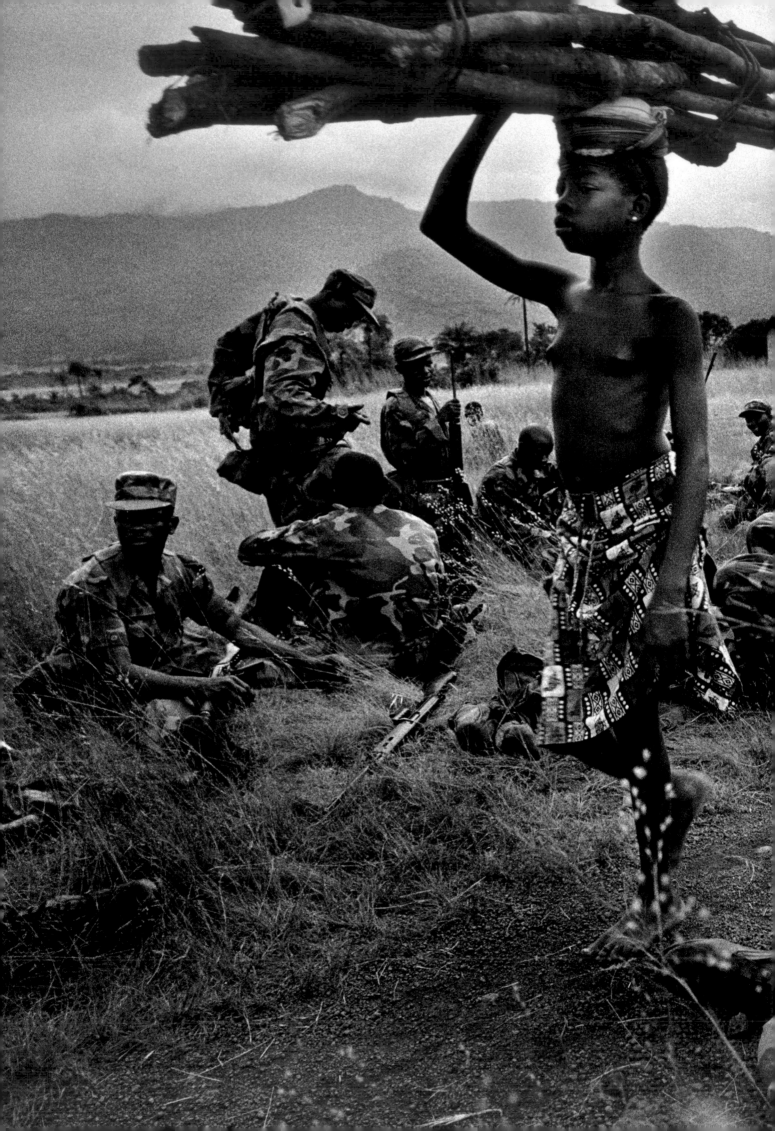

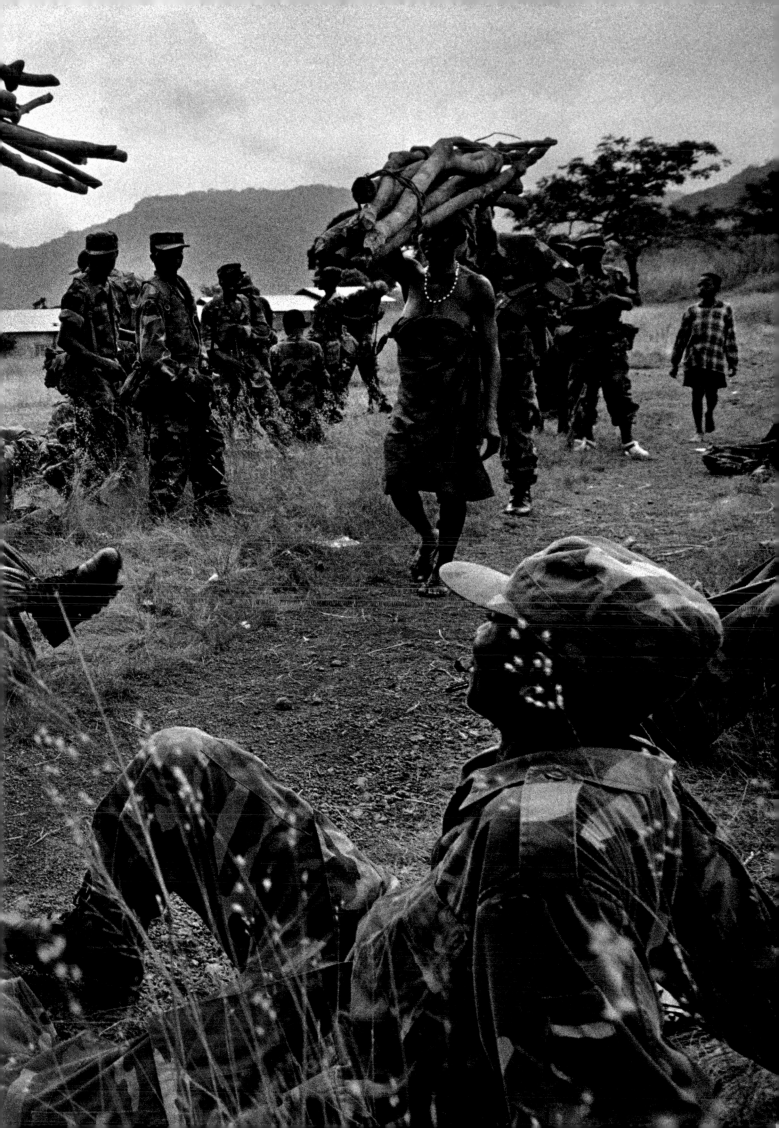

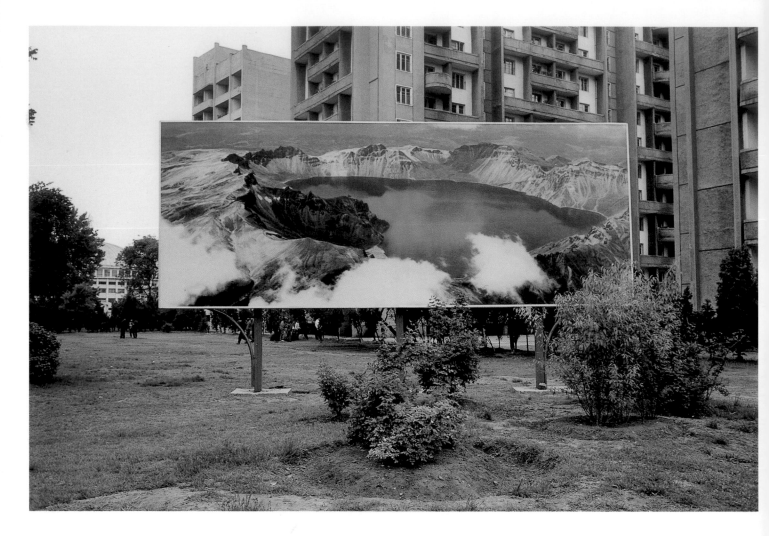

Olivier Mirguet

France, for Le Monde 2

2nd Prize Stories

After the Korean War, the then North Korean president Kim Il-sung introduced a socialist philosophy of *Juche*, or militant self-reliance. For decades North Korea was one of the world's most secretive societies, but in recent years relations with South Korea and some other states appeared to be undergoing a thaw. Above: There is no advertising in North Korea, but the government does use billboards in its own campaigns. This one depicts Mount Paektu, legendary ancestral home of the Korean people and the present North Korean leader's official birthplace. Facing page, top: The Children's Palace, a youth cultural center in Pyongyang, frequently receives foreign visitors. Below: Taiwanese tourists visit the monument to the foundation of the Korean Workers' Party in Pyongyang. (story continues)

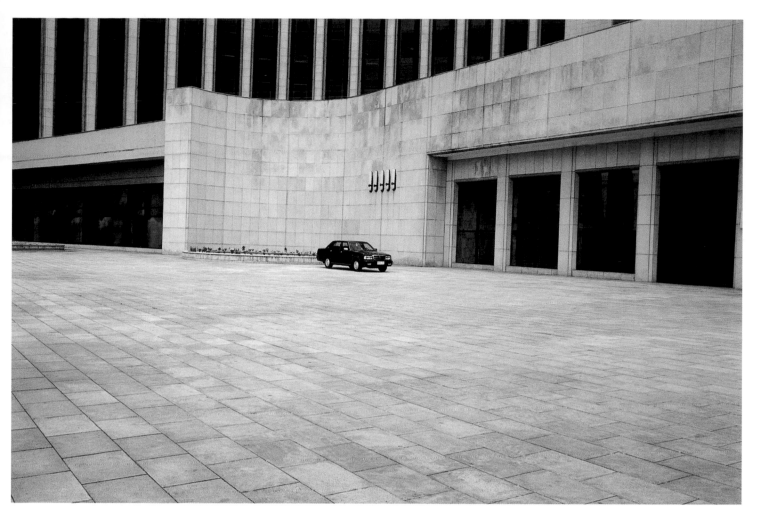

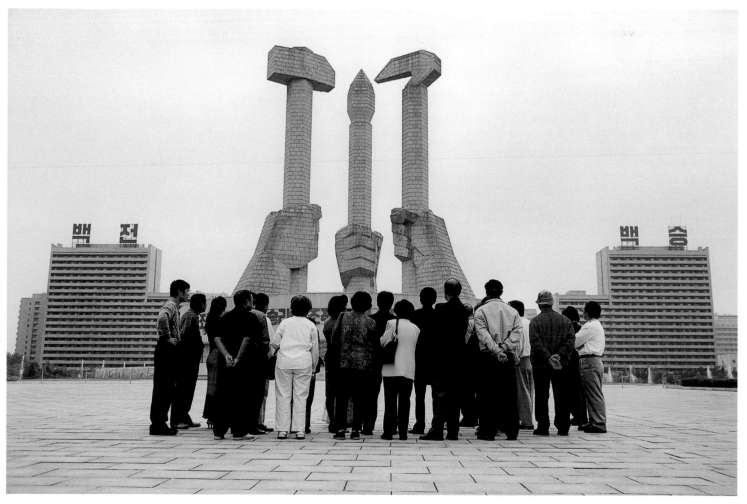

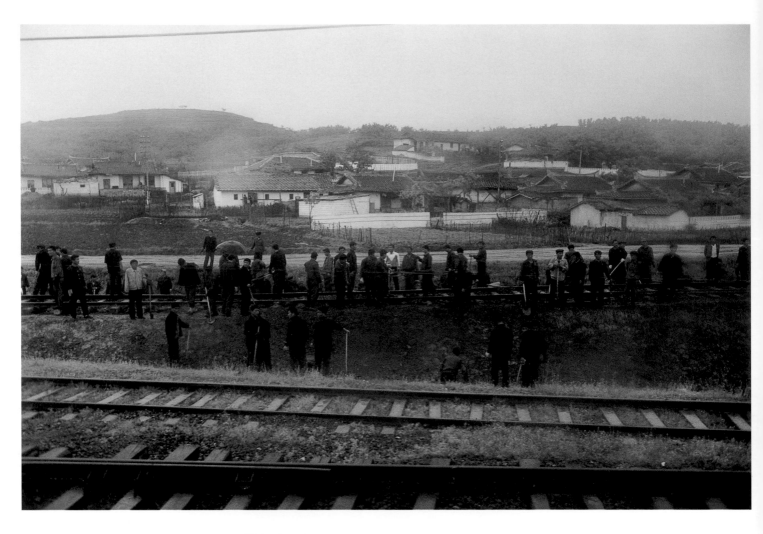

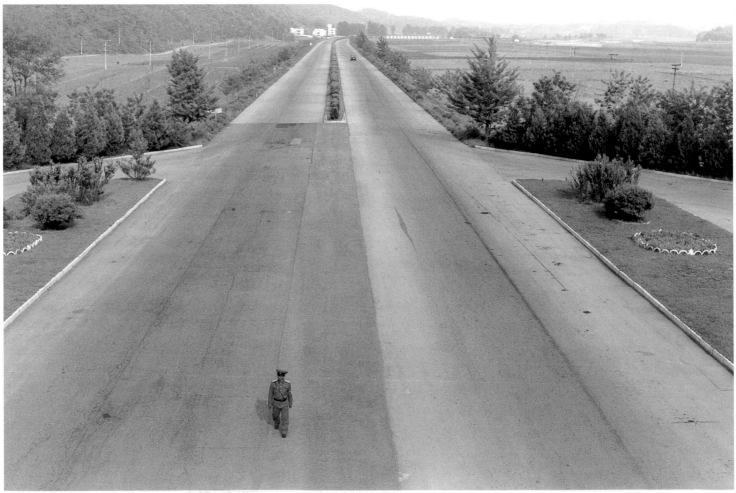

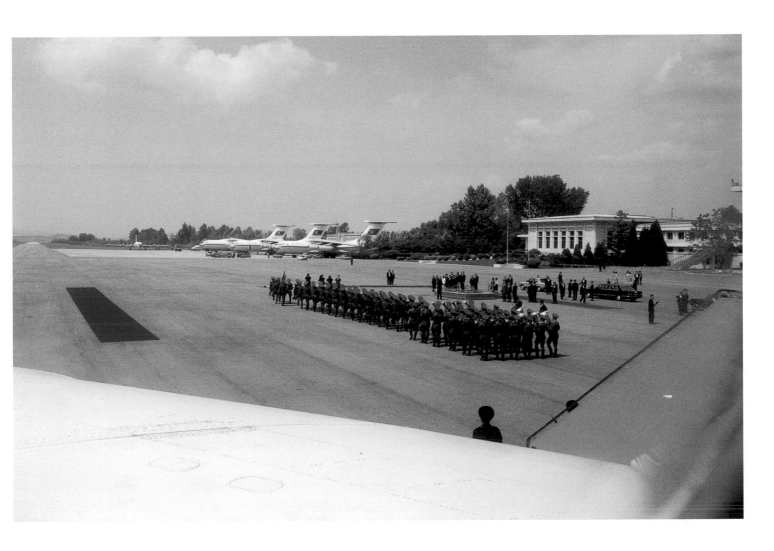

(continued) Observers say the North Korean leadership is locked in debate about how far and how fast the country should open up. International relations were dealt a blow in late 2002 during controversy surrounding North Korea's alleged nuclear weapons program. Talks about re-opening road and rail links with South Korea stalled. Above: A military guard-of-honor waits to greet the prime minister of Laos at Pyongyang airport. Facing page, top: Laborers near the Chinese border repair a derelict railway line that runs from China, through North Korea and on to South Korea. Below: A policeman patrols a deserted motorway that runs from Pyongyang to South Korea.

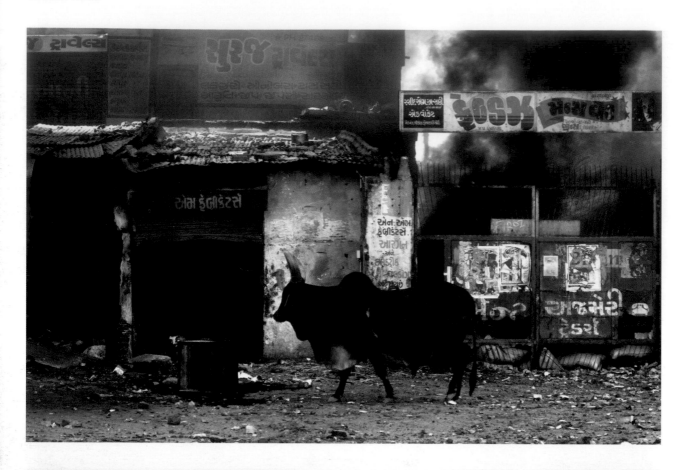

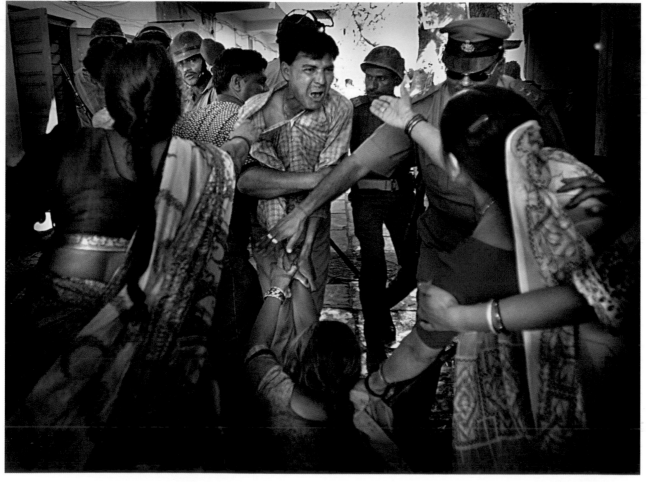

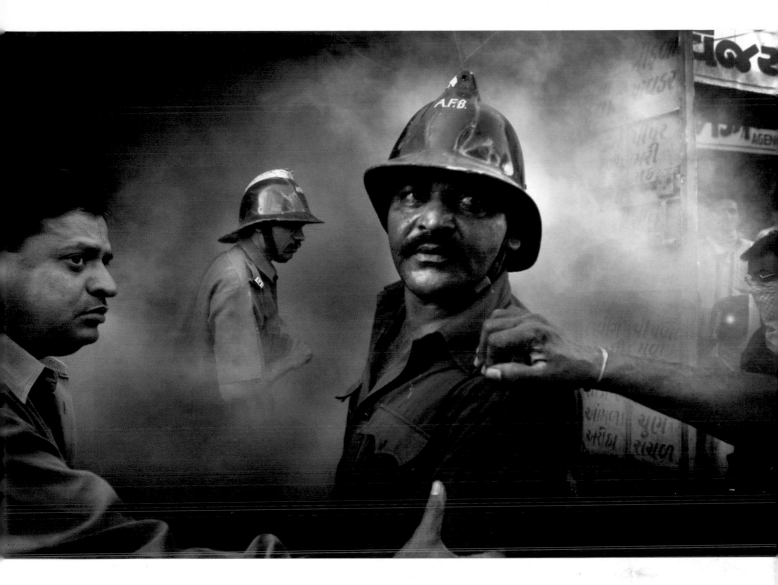

Ami Vitale

USA, Getty Images

3rd Prize Stories

In February, the city of Ahmadabad in the state of Gujarat was the scene of some of the worst communal violence in India for a decade. In retaliation for an earlier Muslim attack on a train carrying mainly Hindu pilgrims, which left 58 dead, people rampaged through city streets setting fire to Muslim homes and businesses. Above: Indian firemen battle to put out a blaze in a Muslim neighborhood in central Ahmadabad. Facing page, top: An ox walks through streets ravaged by riots. Below: Police in Ahmadabad drag away a man accused of instigating violence. (story continues)

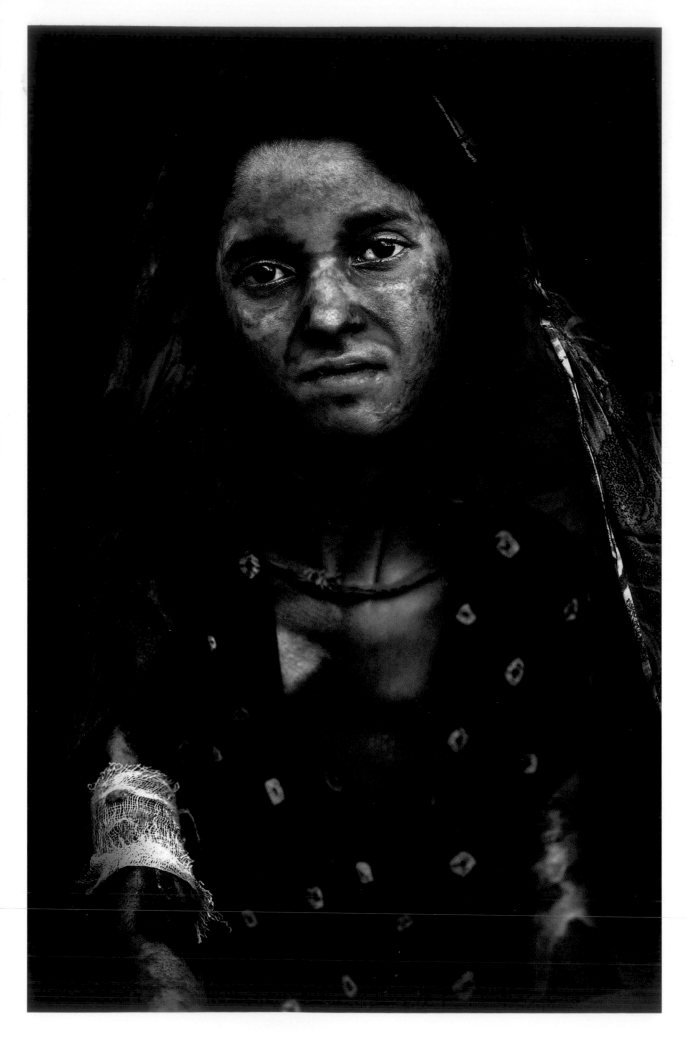

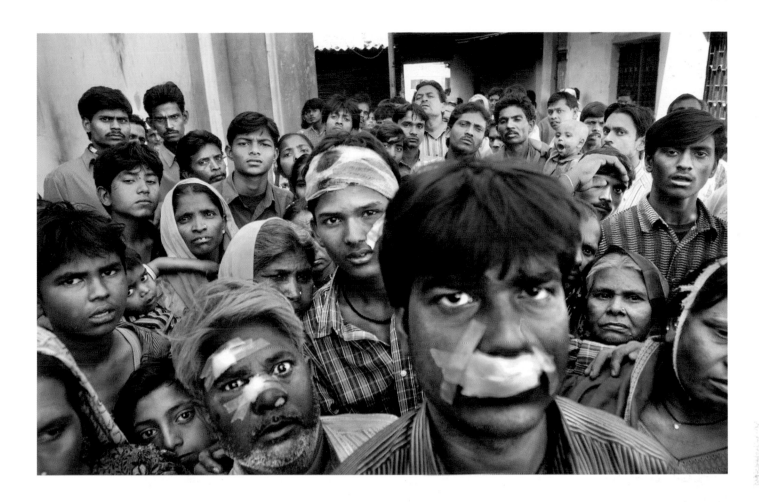

(continued) Violence continued into May. Thousands fled their homes, and the official death toll was over 900, though estimates by human rights groups placed the figure much higher. Above: Muslims gather in the wreckage of their burned-out homes in early March. They had been attacked by Hindu neighbors from across the street. Facing page: An 18-year-old girl who was burned by Hindu rioters in February recovers two months later at a refugee camp housed in a mosque in Ahmadabad.

Larry Towell

Canada, Magnum Photos

Honorable Mention Stories

The invasion of Jenin refugee camp by the Israeli defense force in April was on a scale surpassing most other operations the Israelis had carried out since the rekindling of the intifada in September 2000. Many homes were bulldozed, or scarred by shrapnel. Others were scorched by incendiary bombs that left household goods melted and charred. Over 140 houses were demolished and more than a quarter of the 14,000 Palestinians estimated to be living in the camp were left homeless.

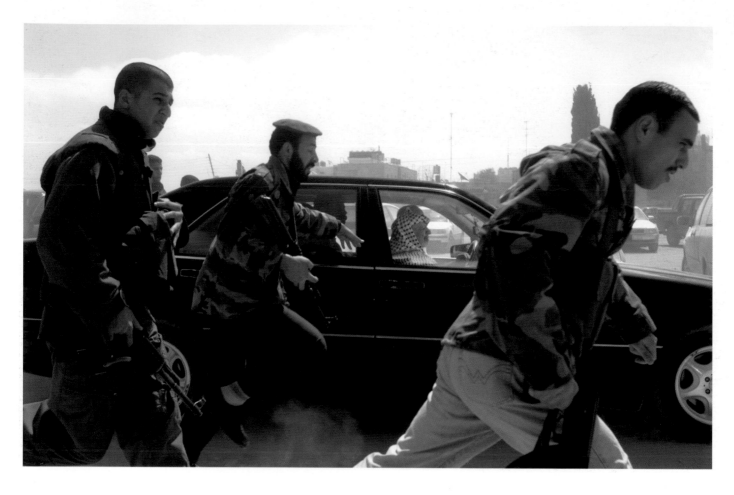

Scott Lewis
USA, The News & Observer

1st Prize Singles

Palestinian Authority Chairman Yasser Arafat is driven away under security from his compound at the Mukatah in Ramallah, West Bank, on May 2. Israeli military forces had held him there under siege since late March. A deal exchanging prisoners for Arafat's freedom had been made between the Palestinian Authority and the Israeli government the night before. The siege marked the start of Operation Defensive Shield, which had the stated aim of putting an end to Palestinian suicide bombing. During the ensuing operation a number of West Bank cities were occupied. Israeli forces again besieged the compound on September 19, and blew up most of the complex, except for Arafat's immediate offices.

Jan Anders Grarup
Denmark, Politiken/Rapho

2nd Prize Singles

Liberian refugees wait for transit permits to enter Sierra Leone and travel to safe camps away from the border region. They were fleeing Liberia during a civil war between rebel forces and the government of President Charles Taylor. Intense fighting in the border area led to some 8,500 people fleeing to Sierra Leone in late June. They included both Liberians and former Sierra Leonean refugees returning home after years of asylum in Liberia. Aid organizations struggled to cope with the influx, which included many who did not acquire permits and entered the country illegally.

Pablo Martínez Monsivais
USA, The Associated Press

3rd Prize Singles

US secretary of state Colin Powell receives a pat on the cheek from national security advisor Condoleezza Rice, in a rare off-guard moment in the Oval Office at the White House. They were attending face-to-face talks between President Bush and the Israeli prime minister Ariel Sharon in May. The meeting lasted more than an hour, but failed to bridge differences on major Middle East issues, such as the formation of a separate Palestinian state.

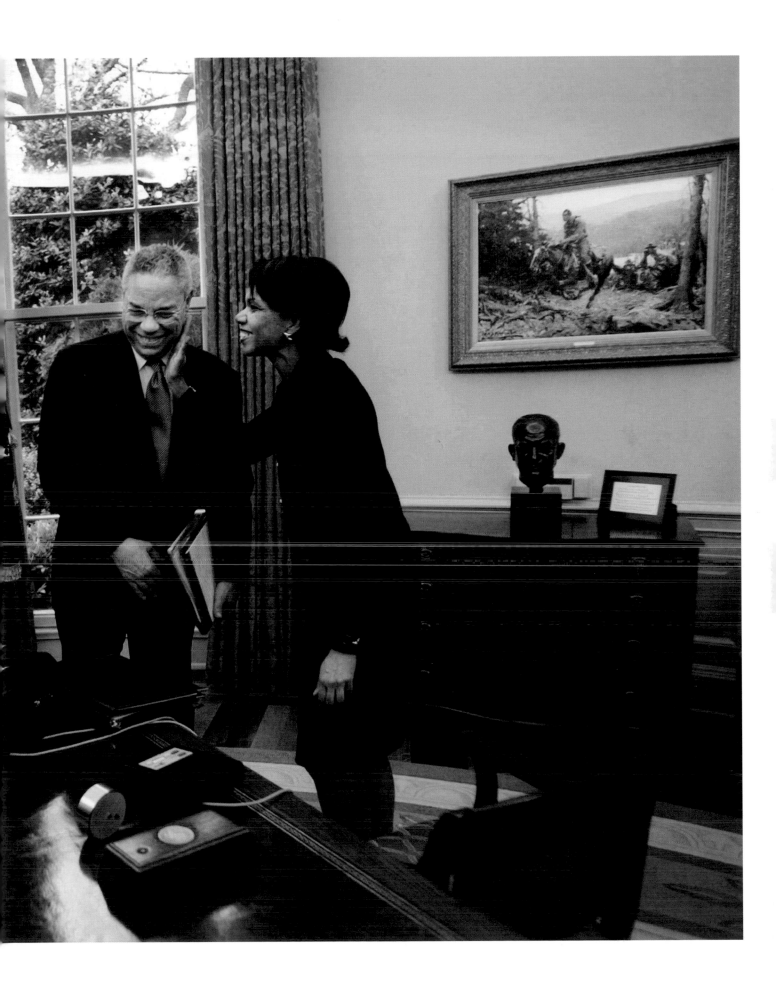

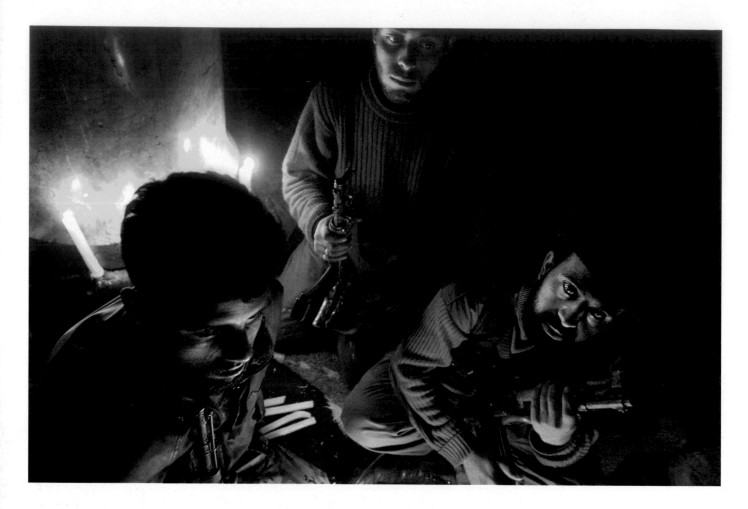

Carolyn Cole
USA, Los Angeles Times

1st Prize Stories

Israeli military forces occupied the city of
Bethlehem on April 2, as part of Operation
Defensive Shield. Some thirty Palestinian
militants, together with civilians and Palestinian
police officers, sought refuge in the Church of the
Nativity, which is built over the spot revered by
Christians as the birthplace of Christ. The
militants included men accused by Israel of direct
involvement with terrorism, and a stand-off
ensued which lasted for 39 days. Above: Members
of the Palestinian Al Aqsa Martyrs Brigade guard
the entrance of the church against a possible
nighttime attack. Facing page: Najee Abu Abed
holds the hand of Allah Barakat, a Palestinian police
officer who became ill from lack of food during the
siege. Following pages: People slept in blankets
discovered in a hotel linked to the church
complex. (story continues)

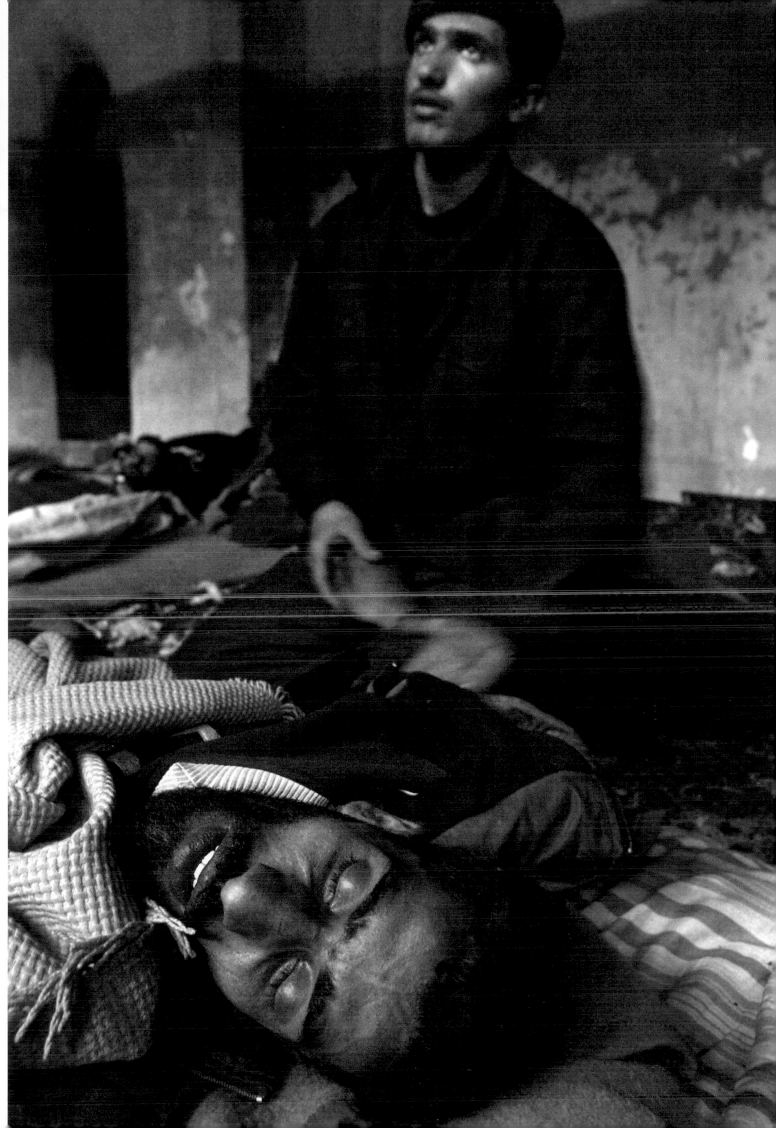

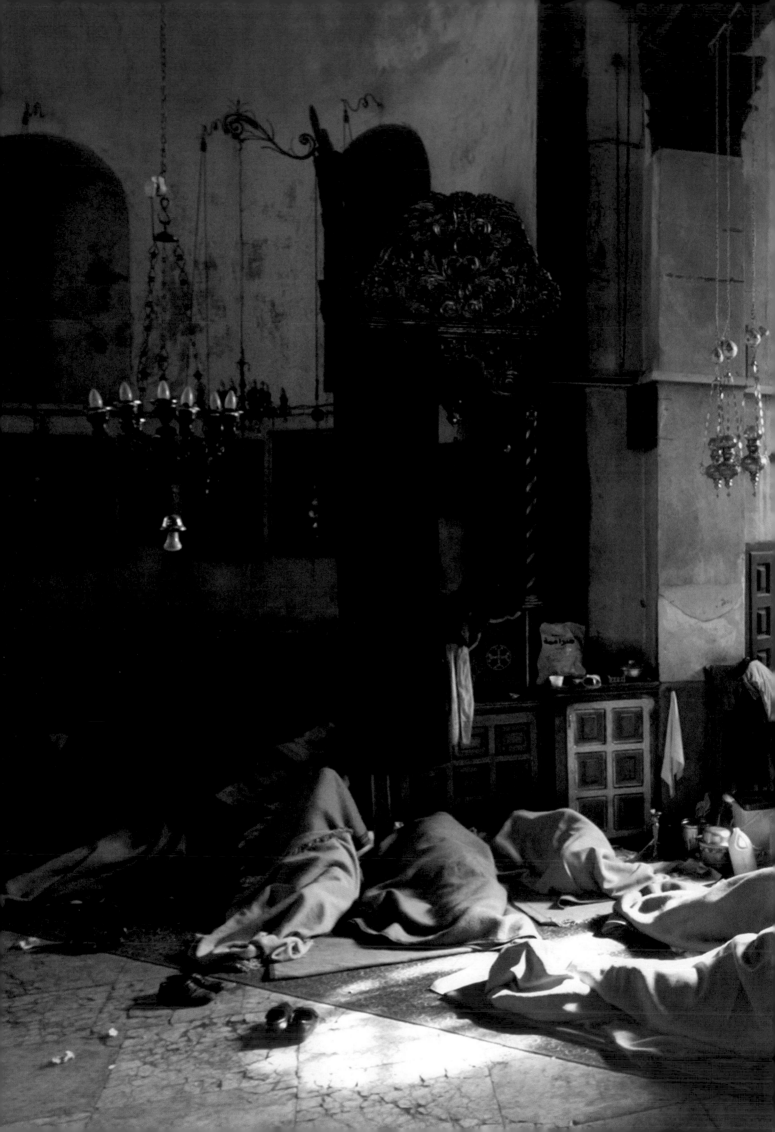

(continued) Israeli snipers shot and killed eight men inside the compound before a settlement was reached in which 13 militants were exiled to Europe and 26 others were sent to the Gaza strip. The remaining people were freed. Above: Palestinians crouch in the Door of Humility, the entrance to the church, for a glimpse of the outside world. Facing page, top: For many days there was little or nothing to eat in the church. Men fried greens picked from a courtyard. Candles were used for light and heat. Below: Facing Mecca instead of the altar, Muslim men bow in prayer. Although this was against church rules, the Christian priests gave permission for daily prayers.

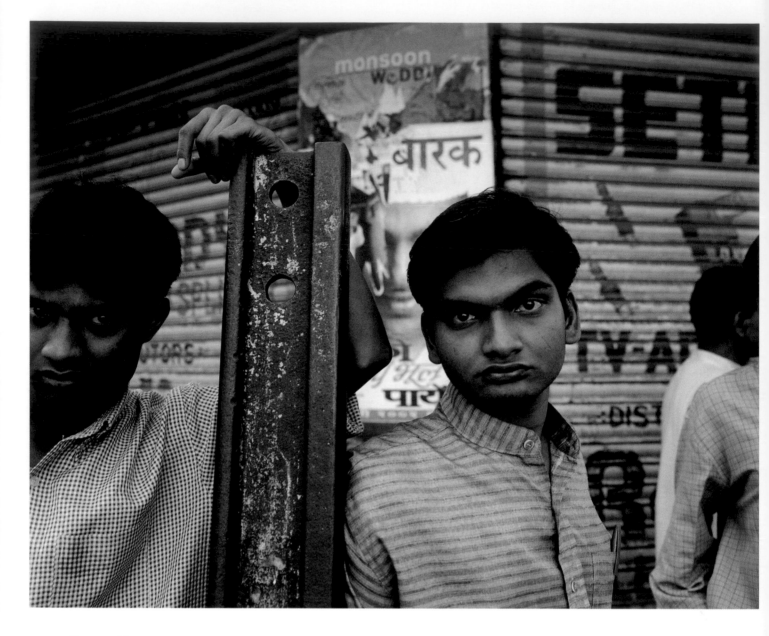

Bruno Stevens
Belgium, for Newsweek

2nd Prize Stories

Tension between Hindus and Muslims, a minority who form ten per cent of Gujarat's 50 million population, erupted in riots in the first part of the year. Communal violence has been spreading throughout the Indian state for decades, as the decline of the moderate Congress party led to the growth in popularity of Hindu nationalist political parties, which in turn opened the way to extreme nationalist groups and Muslim fundamentalism. In Ahmadabad, Hindus sacked Muslim homes and businesses in reprisal for an earlier attack on a train carrying mainly Hindu pilgrims. Police were accused of not intervening effectively. Facing page, top left: The sister and mother of a Hindu man grieve minutes after he is stabbed to death by a Muslim neighbor in retaliation for the burning of his home. Top right: A Muslim child recovers from burns suffered during an attack on the family home. Bottom left: In some areas of the city, Muslims erected iron gates to prevent Hindu rioters from entering the streets.

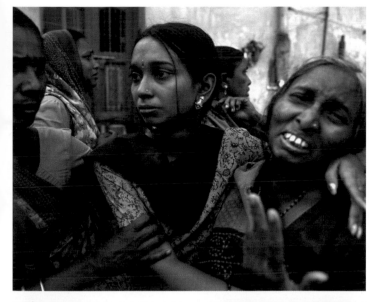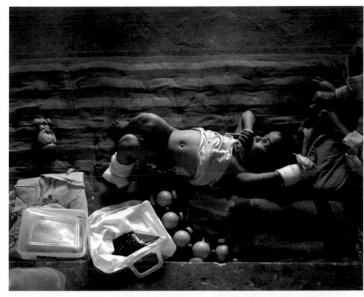

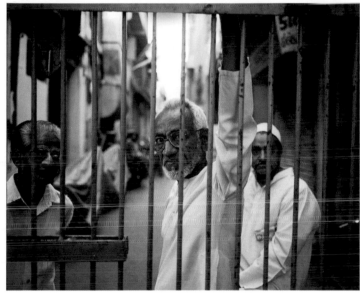

Peter Dench
United Kingdom, IPG

3rd Prize Stories

From festivals and picnics to pubs and private parties, alcohol is an integral part of British life. In November the government announced plans to end the long-standing law requiring pubs to close at 11pm. Proposed new licensing laws will allow 24-hour opening, yet will introduce a range of conditions to reduce anti-social behavior. One of the aims of the new regulations is to reduce binge drinking at closing time.

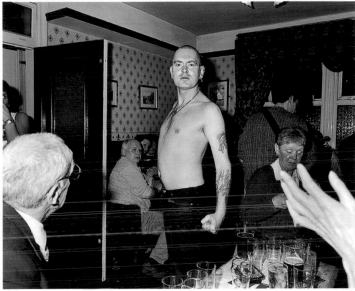

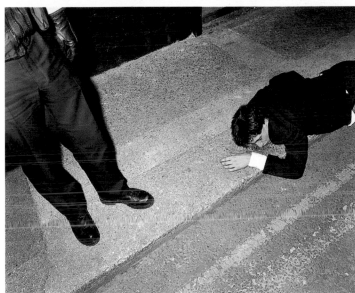

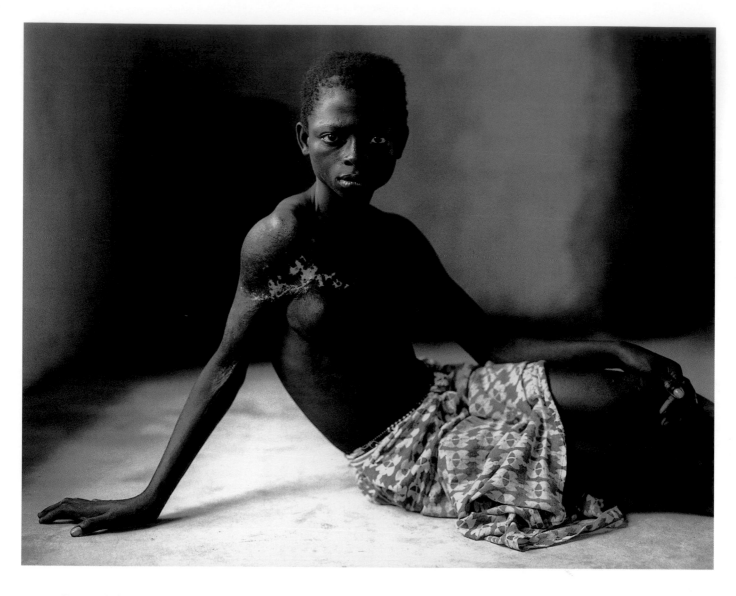

Brent Stirton
South Africa, Getty Images/RPM for
UN Office for Humanitarian Affairs

1st Prize Singles

A former 'bushwife' in Sierra Leone is depicted here at the age of 12. She was ten
when R.U.F. (Revolutionary United Front) rebels abducted her. The soldiers used
children and young women as porters, cooks and sex slaves, hence the term
'bushwife'. The scars on this girl's body are as a result of burns made by caustic
soda. She was caught trying to escape and tortured as an example to other
abductees. The long-running conflict in Sierra Leone finally came to an end in the
first months of 2002, leaving many thousands of deeply traumatized women.
Very few counseling services are available, and women have begun to form their
own groups to address their experiences.

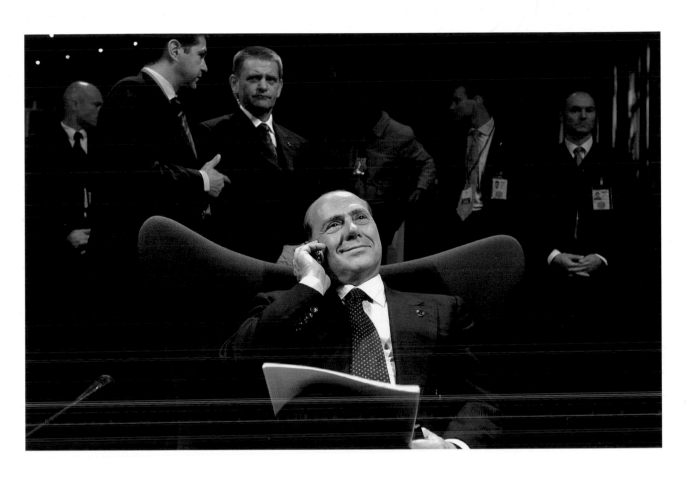

Lars Krabbe
Denmark, Morgenavisen Jyllands-Posten

2nd Prize Singles

Italian prime minister Silvio Berlusconi relaxes during a break at the Asian-European summit in Copenhagen in September. The billionaire business-man and media magnate had shrugged off corruption allegations to win the premier's post the previous year. The aim of the conference was to bring together the 15 European Union member states with ten prominent Asian countries, in order to strengthen political, cultural and economic ties.

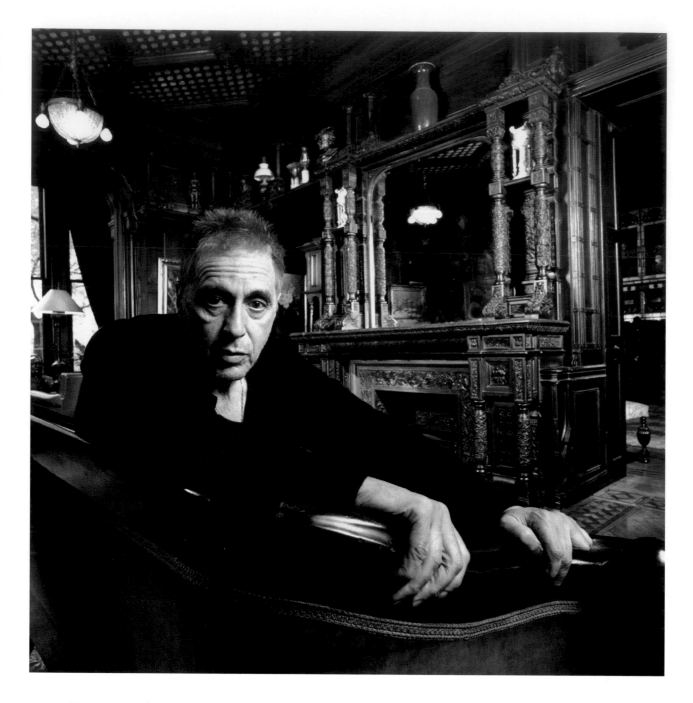

Bruce Davidson
USA, Magnum Photos for Newsweek

3rd Prize Singles

The actor Al Pacino is pictured here at the National Arts Club in Manhattan, his hair cropped and bleached for the role of Roy Cohn in the film adaptation of Tony Kushner's Pulitzer Prize and Tony Award-winning play, *Angels in America*. The role also required him to go on a strict diet.

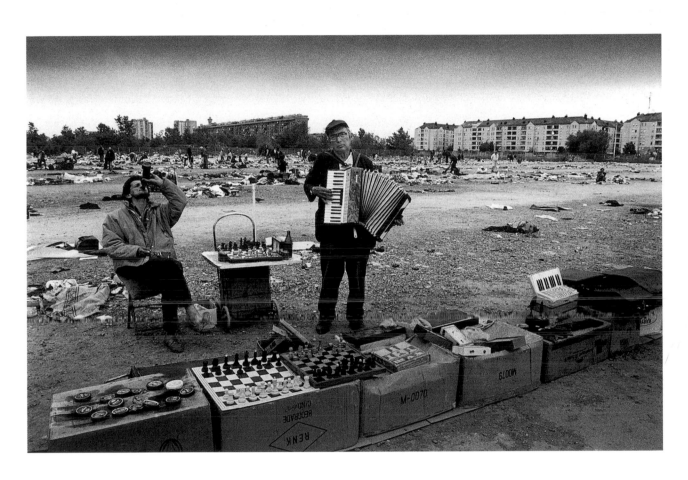

George Georgiou
United Kingdom, Panos Pictures

1st Prize Stories

Three years after the cease-fire in Serbia, the people in the region still suffer economic hardship and await further international aid. A perception that they have been betrayed by the West is growing, leading to a sense of isolation. Disillusionment that democracy is not producing the desired results appeared to express itself in voter apathy. Serbian presidential elections in October failed, and moved the country towards a political crisis. Above: A man plays an accordion in a deserted flea market on the outskirts of Belgrade. Following page: A nurse relaxes for a minute in the reception room of a clinic in Niska Banja, a spa town in southern Serbia. (story continues)

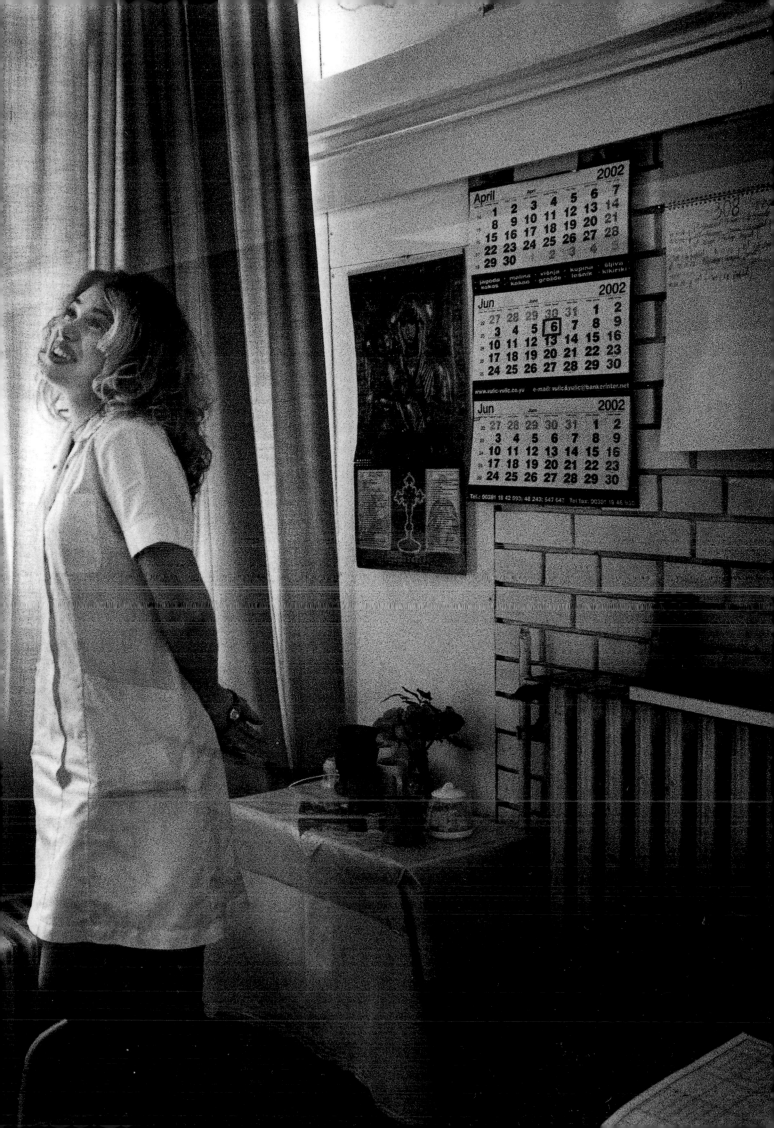

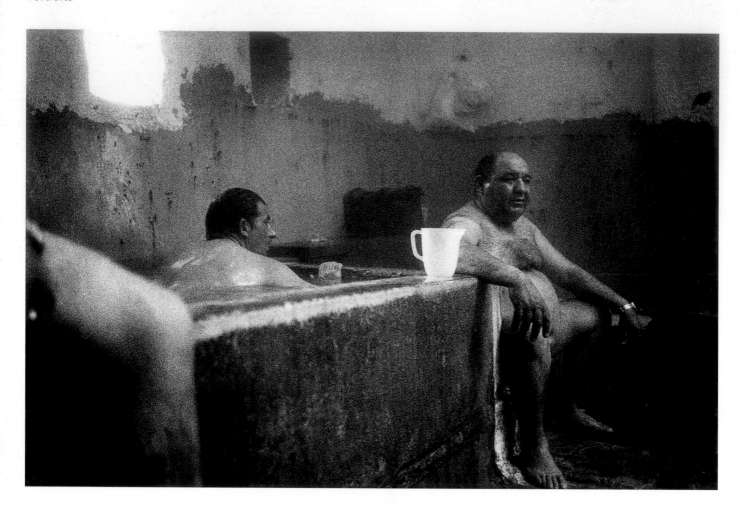

(story continues) In February 2003 parliament voted to dissolve a 74-year-old federation, finally consigning the name 'Yugoslavia' to history. The federation was replaced by the two republics of the Union of Serbia and Montenegro, which share a common foreign and defense policy, but are otherwise independent. Above: Men sit in the steam room of a Turkish bath near the predominantly Muslim town of Novi Pazar, which has rediscovered its traditional role as a major trade route to the Balkans. Facing page, top: A shop assistant waits to serve customers in a privately owned fashion boutique. Below: A woman descends an escalator in a state-owned department store in Belgrade.

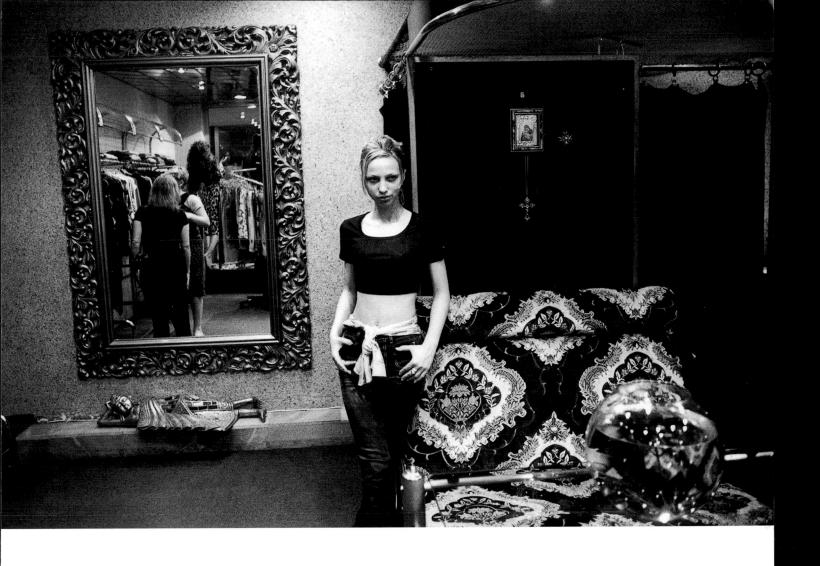
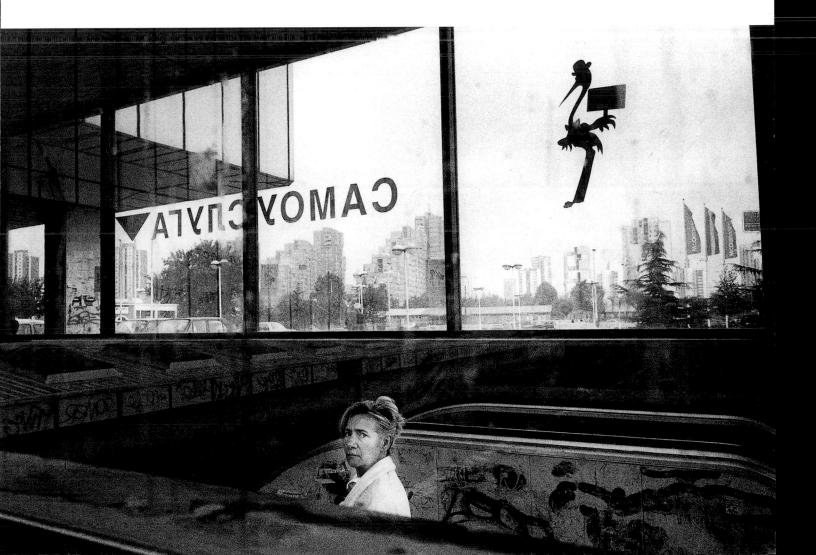

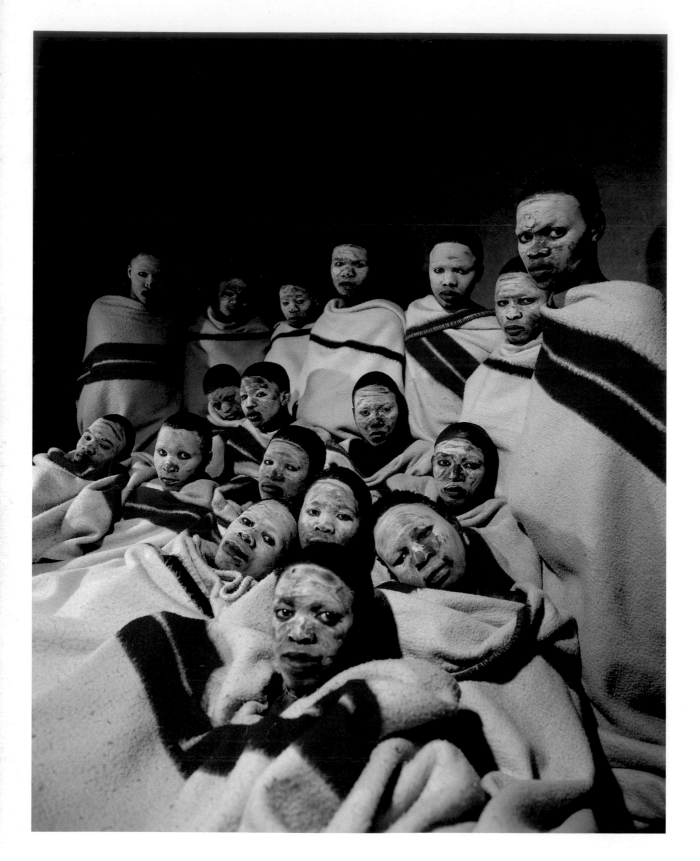

Brent Stirton
South Africa, Getty Images/RPM for Royal
Geographic Society/Le Monde 2

2nd Prize Stories

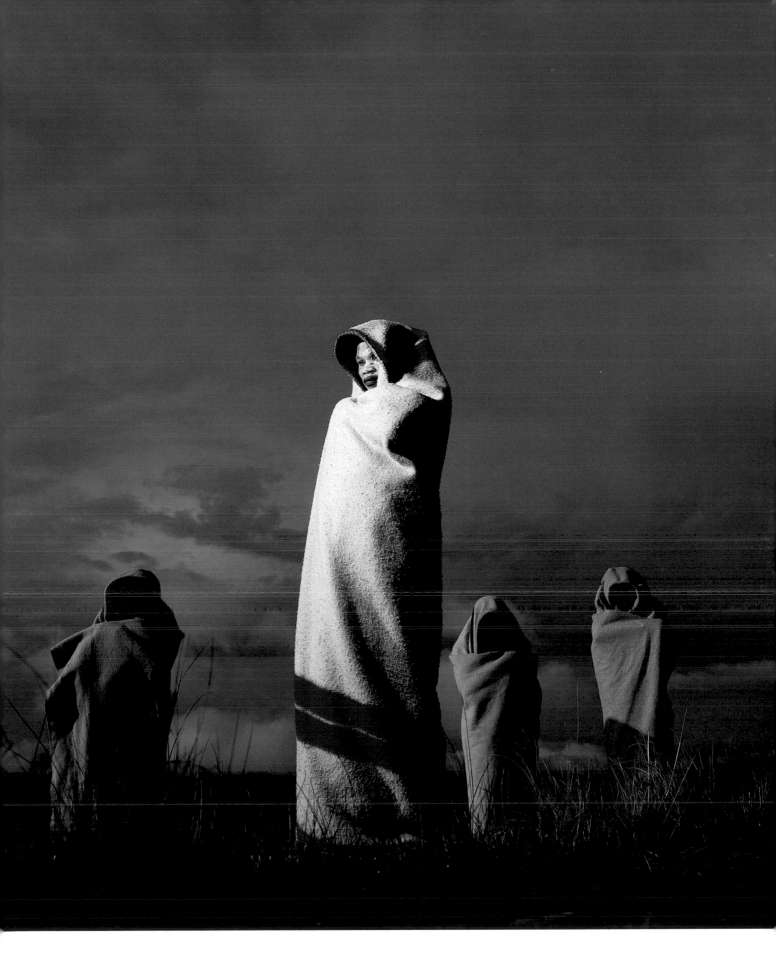

Boys belonging to the Xhosa ethnic group in South Africa are expected to undergo a circumcision ritual to mark the transition to manhood. Thousands of young men from all over the country, many of them leaving their city lives, attend circumcision schools such as this one in the Eastern Cape. They are circumcised soon after arrival, and spend the next three to four weeks in seclusion with fellow initiates, learning Xhosa history and what is expected of them as an adult member of the tribe. Above: Initiates spend much of the day in contemplation in the fields. Facing page: Camaraderie and mutual support are reinforced by life in a communal hut. (story continues)

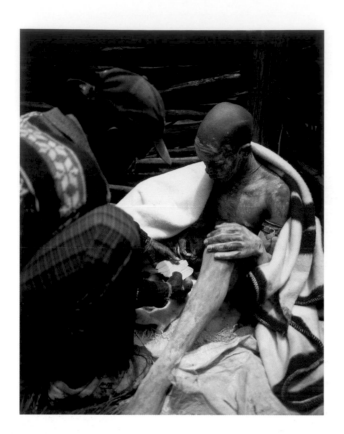

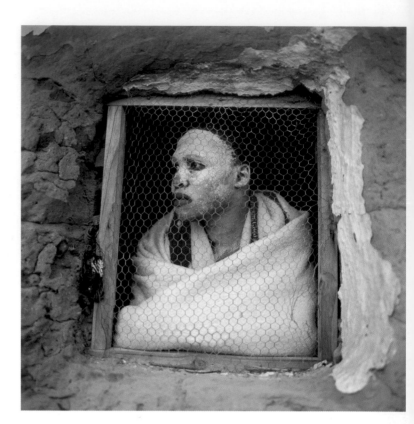

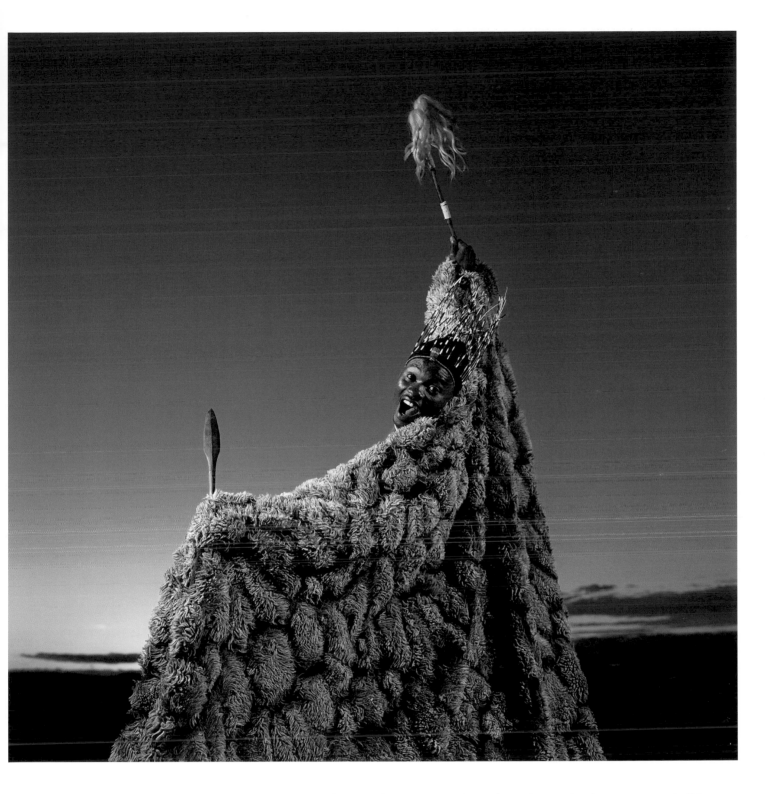

(continued) A boy's stoicism during the ritual is considered an important part of his passage into adulthood. The ceremony also aims to instill a sense of heritage and tribal tradition, and village elders give the boys daily lessons through song and spoken word. At the end of the ceremony the boys attend a ritual bathing and are welcomed back into the Xhosa tribe as men. The ceremony is a highly private affair. The photographer was granted special access to this one by the king of the Xhosa people. Above: Nelson Mandela's official Praise Poet, Zolani Mkiva, recites the history of the Xhosas to initiates. Facing page, left: A qualified male nurse attends the boys throughout the ceremony. Both traditional and modern medicine is used in their care. Right: An initiate looks out from the communal hut.

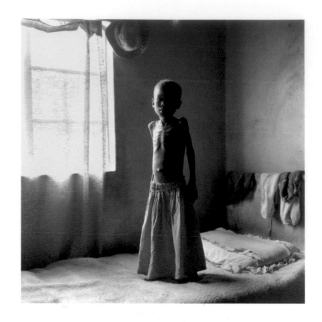

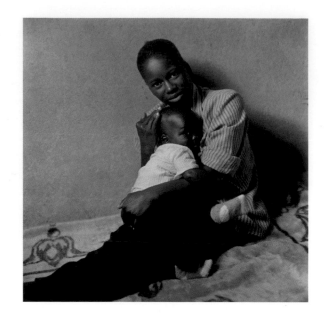

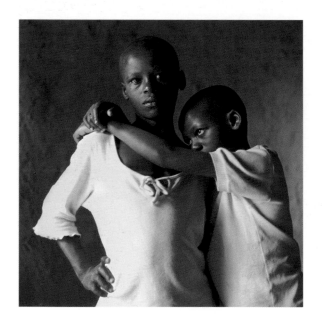

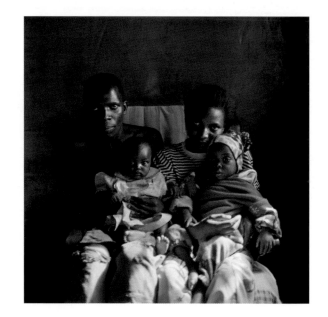

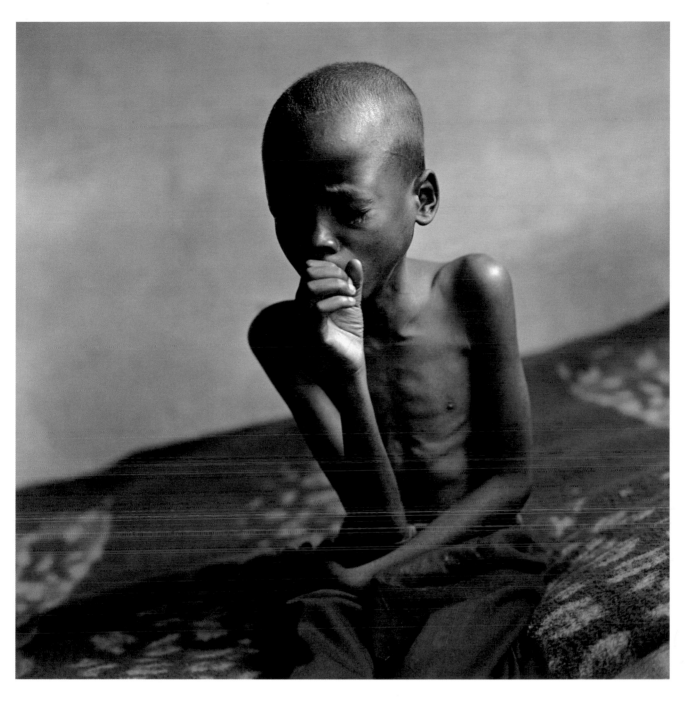

Kristen Ashburn
USA, Contact Press Images

3rd Prize Stories

Sub-Saharan Africa is now home to 29.4 million people living with HIV/Aids. There were approximately 3.5 million new infections in 2002. Zimbabwe is one of most severely affected countries, with a national adult HIV prevalence of 33.7 per cent. Much of the support for people living with HIV, or who are ill with or bereaved by Aids, comes from within family and community groups. Facing page, top right: A 19-year-old single mother, who is HIV positive, nurses her baby in St Mary's Hospital in Harare. Below, left: Sisters, orphaned by their parents' death from Aids-related diseases, comfort each other. Right: An HIV-positive family sit together on a family-room chair in St Mary's Hospital.

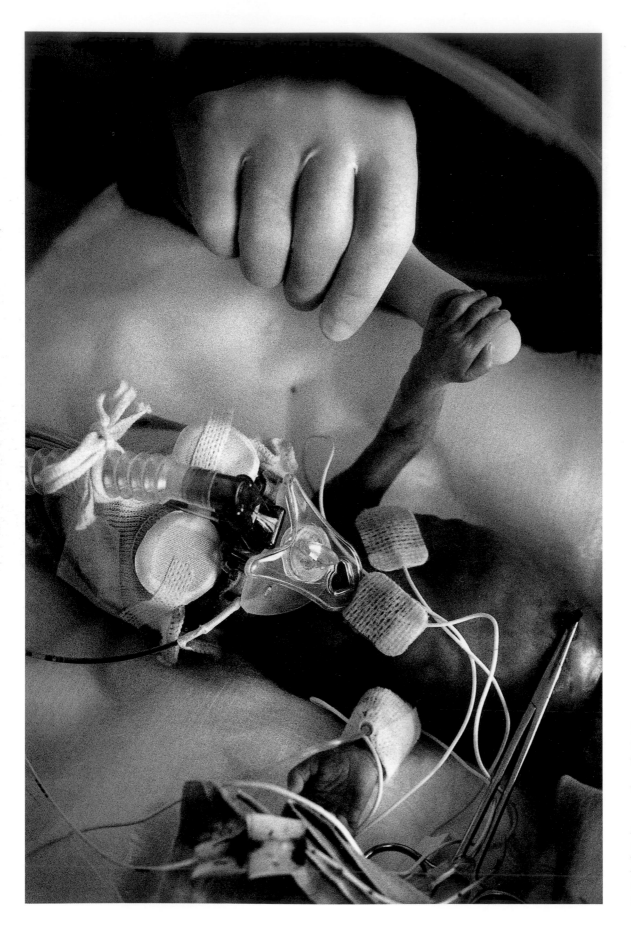

Matias Costa
Spain, Agence Vu/Agenzia
Grazia Neri

1st Prize Singles

A premature baby, born after
six months of pregnancy, is
treated in an incubator at
the Gregorio Marañón
University General Hospital
in Madrid, Spain.

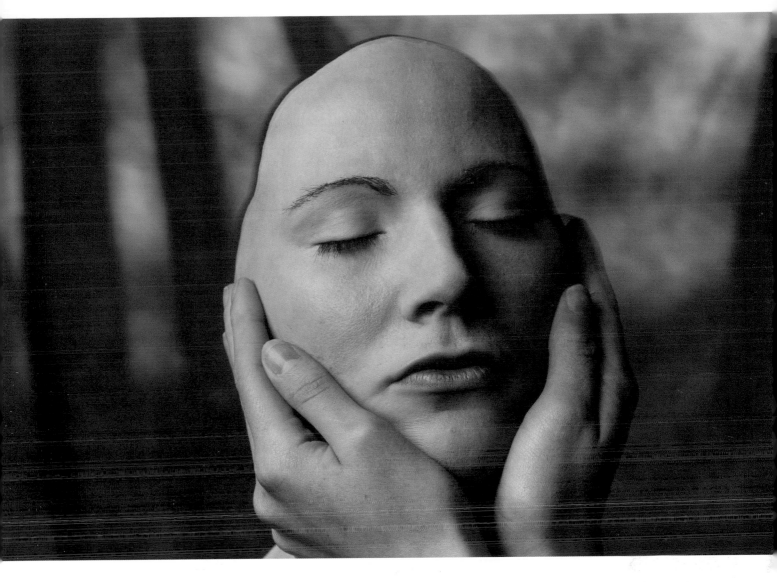

Sarah Leen
USA, for National Geographic Magazine

2nd Prize Singles

A silicone mask of the face of Cassandra Wheatley captures the texture and appearance of real skin. It is being held by the model herself, and was made by the British firm Hybrid Enterprises. She sat immobile for 40 minutes while technicians painted silicone material on to her face, then covered it in plaster to make a mold. A second, flexible, mold was made over this cast. The two surfaces were separated and liquid, flesh-toned silicone injected between them. Peeling away the flexible mold revealed the final mask. False hair was applied using hypodermic syringes. This technology is primarily used to create prosthetics for the film industry, but is also being considered for medical applications.

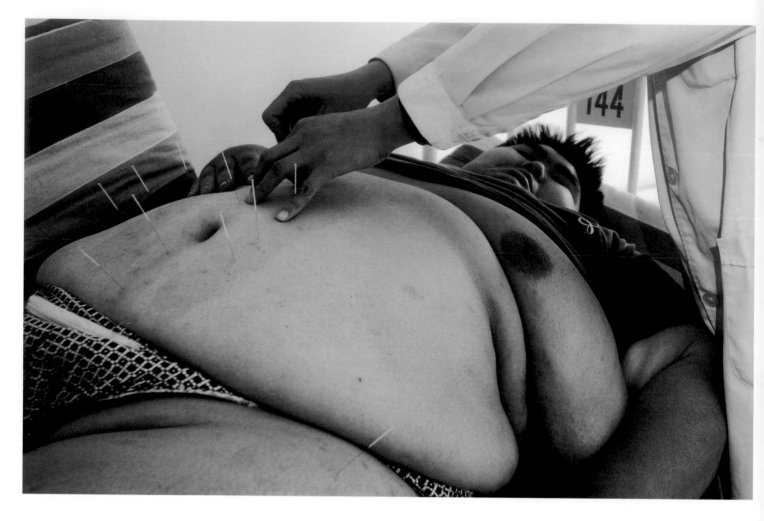

Qi Xiaolong
People's Republic of China, Tianjin Daily

3rd Prize Singles

A patient is treated using acupuncture at the Ai Min Weight Reduction Clinic in Tianjin, China. The clinic, which is known for its high success rate, uses a synthesis of traditional Chinese medicine, dietary programs and exercise to achieve weight loss. Acupuncture is officially accepted as a technique for weight reduction in China, but is not common because the treatments are more time-consuming than other methods.

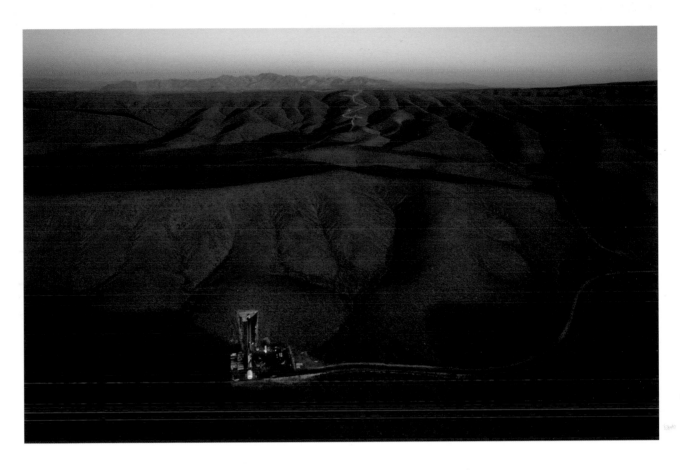

Peter Essick
USA, National Geographic Magazine

1st Prize Stories

A long-awaited cleanup is underway at 114 of the USA's nuclear facilities. The nuclear age has produced 52,000 tons of spent fuel from commercial, military and research nuclear reactors, as well as some 91 million gallons of waste from plutonium processing – both are classified as high-level waste, the most dangerously radioactive kind. Disagreement exists as to how, or even whether, safe disposal is possible. Radioactivity can last for millions of years. Depleted uranium, contaminated tools, and plutonium itself, which is used to trigger thermonuclear weapons, are among other products of the nuclear industry requiring safe storage. Above: A high-level waste repository at Yucca Mountain in Nevada has met with local opposition. Some 50 miles of tunnels could hold 77,000 tons of waste, but Nevada officials contest the safety of the design, and the site is not yet licensed. (story continues)

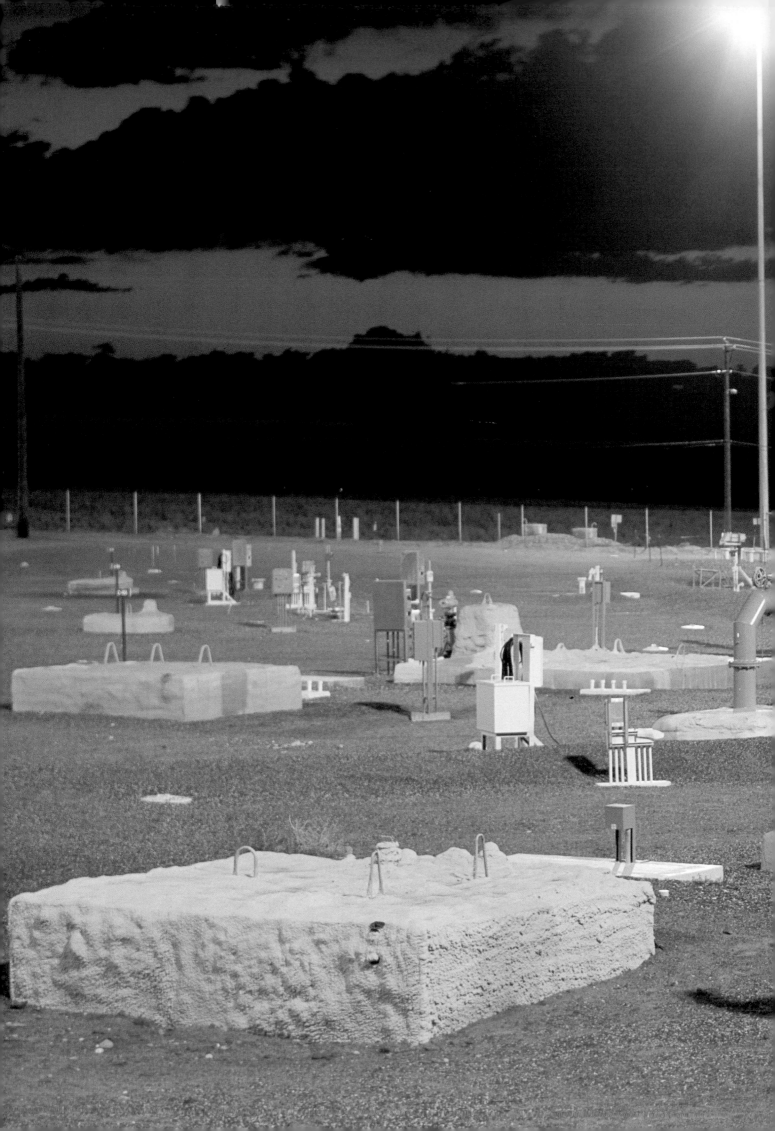

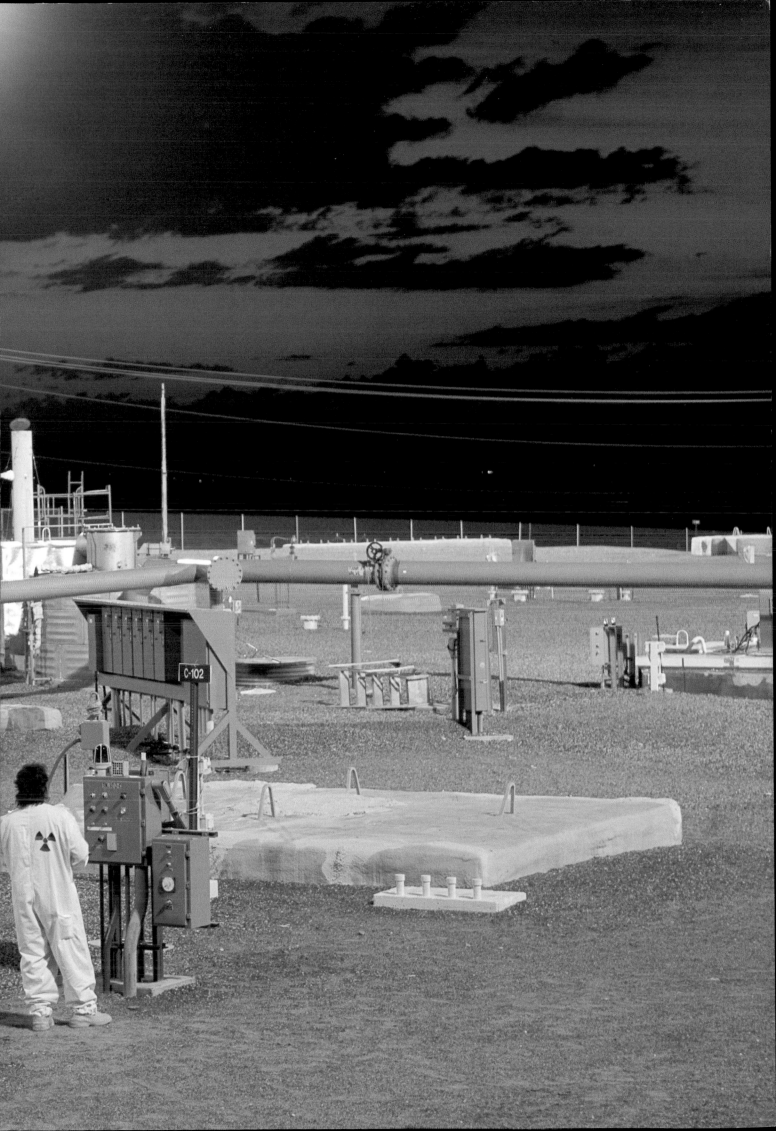

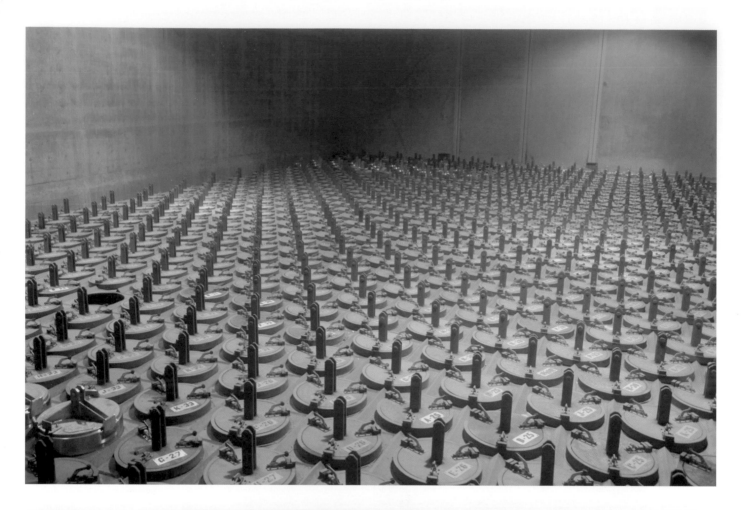

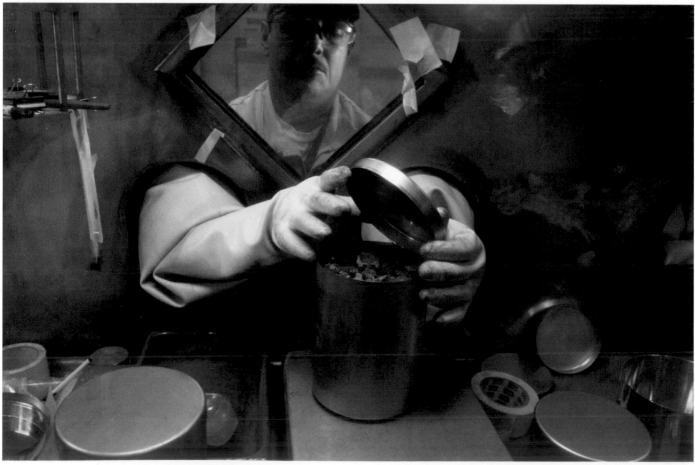

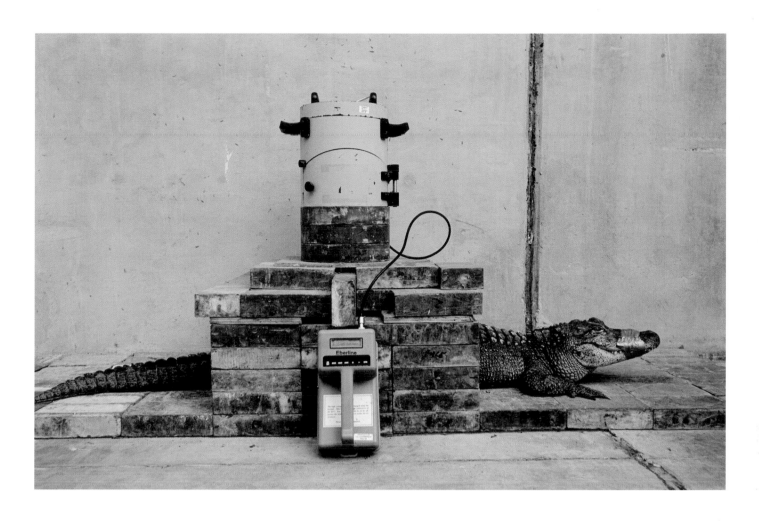

(continues) Despite a slowing of the arms race
and the end of the Cold War, high-level waste is
accumulating in the USA at a rate of more than
2,000 tons a year. In addition to waste storage,
contaminated soil and groundwater must be
cleaned up, and nuclear reactors decommissioned.
Above: An alligator is tested for radiation acquired
from eating contaminated fish. Facing page, top:
Spent nuclear reactor fuel is kept sealed in steel
cylinders behind glass walls, at a government
facility in Idaho. Below: A worker handles
plutonium using protective lead-lined gloves.
Previous pages: At the Department of Energy's
Hanford Site, in Washington, underground tanks
hold radioactive waste from plutonium processing,
Hanford's specialty from 1943 to 1989.

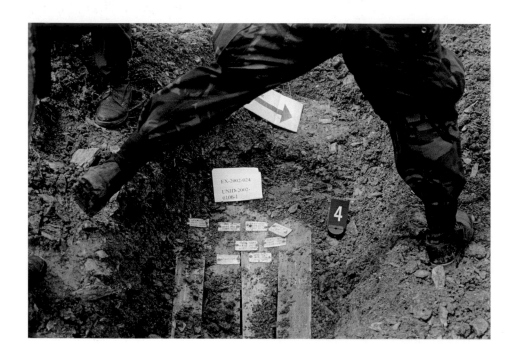
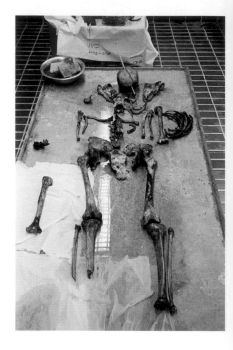

David I. Gross
USA

2nd Prize Stories

Some 3,800 people are still missing in relation to the former armed conflict in Kosovo. Bereft families continue to seek information about the fate of their relatives. Forensic scientists helping to identify remains are hindered by the fact that many corpses are incomplete, and often the remains of a number of people are buried together. Above, left: The International Tribunal for the Former Yugoslavia reburied many of the bodies it used in its investigations in 'graveyards of the unidentified'. A single grave may contain up to 40 sets of remains. Right: A skeleton in the morgue in Orahovac/Rahovec shows signs of death from a bullet through the head, as well as severe beating and shrapnel wounds from a grenade. Facing page, top: X-rays are used to check bodies for evidence of bullets or shrapnel, before other work is carried out. Below: Because body bags often contain more than one corpse, forensic scientists must piece together remains to see how many they have found.

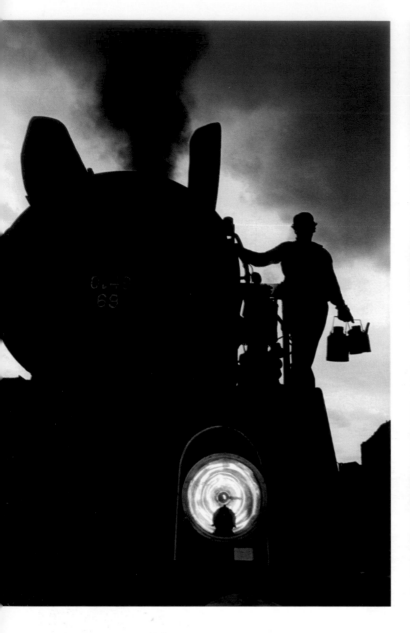

Witold Krassowski

Poland, Network Photographers for National
Geographic Magazine Poland

3rd Prize Stories

The locomotives that ply the route from Wolsztyn
to Poznan in western Poland form one of the last
scheduled steam-train services in Europe. Huge
OL-49 engines, more than half a century old,
consume up to 18,000 liters of water, three tons
of coal, and eight liters of oil on the 180-kilometer
round trip. It takes one-and-a-half hours for the
drivers to ready the train for the journey, stoking
up the boiler to build up steam. Above, left: A
driver tops up an OL-49 locomotive with oil before
a run. Right: The driver rebuilds the grates
beneath the boiler. Facing page, top: An engine
works up steam, ready for departure. Below: A
railway worker helps a passenger aboard.

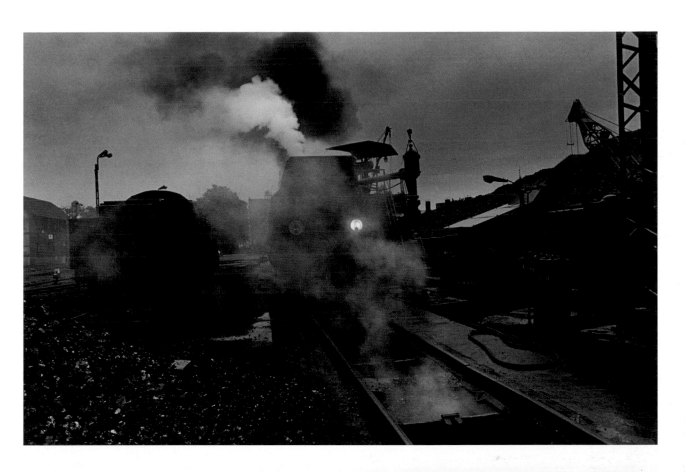

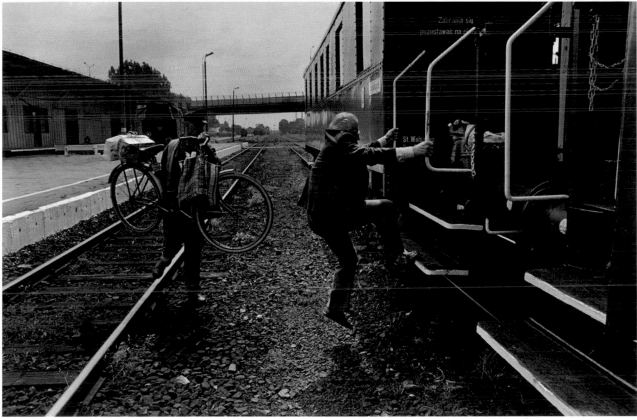

Nature and the Environment

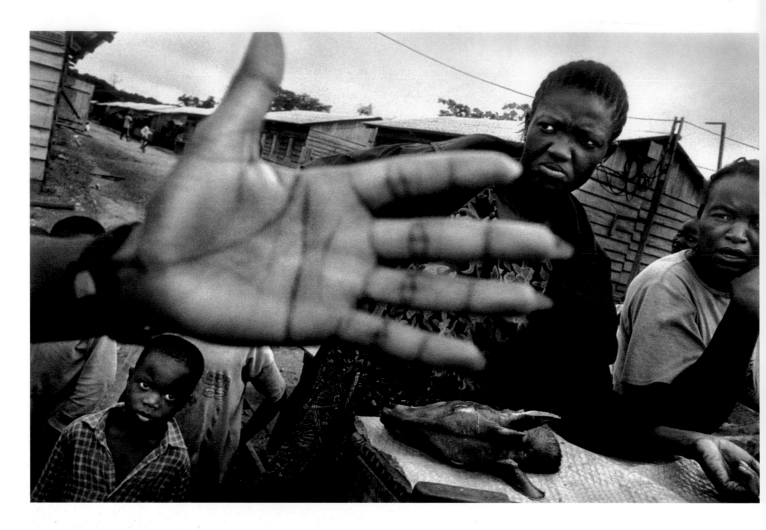

Antonin Kratochvil
Czech Republic, VII for Discover

1st Prize Singles

A woman sells 'bushmeat' at a logging village on the fringes of the Ndoki national reserve in northern Congo. Animals hunted for bushmeat include antelope, crocodiles, elephant and primates. Over a million tons of wildlife, the equivalent of 4 million cattle, are killed annually in Central Africa alone, seriously depleting stocks of some species. Poorer rural peoples in the Congo Basin have traditionally relied on wildlife for between 60 per cent and 80 per cent of their protein. But in recent years hunting for bushmeat has accelerated beyond sustainable levels, as demand from cities and logging settlements has grown. Illegal commercial hunting has burgeoned, threatening a number of animal populations in the area. Species with slow reproductive patterns, such as gorillas and elephants, are especially threatened as they are often killed before reaching maturity.

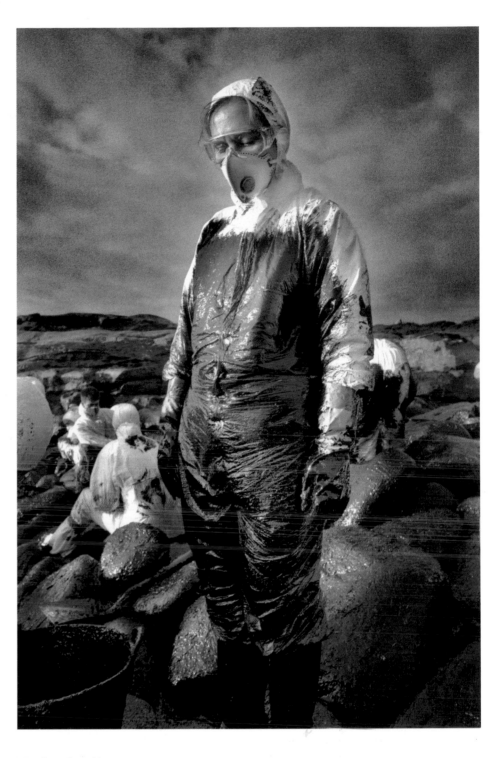

Carlos Spottorno
Spain

2nd Prize Singles

An oil-spill volunteer assists in clean-up operations at Malpica on the Galician coast in Spain in December. Some weeks earlier, the Bahamas-registered tanker *Prestige*, carrying 70,000 tons of heavy fuel oil, had begun to break up in bad weather, 250 kilometers off the coast. The Prestige was towed out to sea after both Spanish and Portuguese governments refused permission for the ship to enter their ports. At first, oil spillage was minimal, as most compartments remained intact. But six days later the tanker broke in half, its bow and stern sinking within hours of each other and releasing an oil slick nearly 200 meters wide and 30 kilometers long. The slick washed ashore within days, damaging a coast that was not only rich in wildlife, but along which whole communities depended on fishing for their livelihoods. Clean-up work was conducted largely by volunteers. Environmentalists accused the Spanish authorities of a slow response to the disaster.

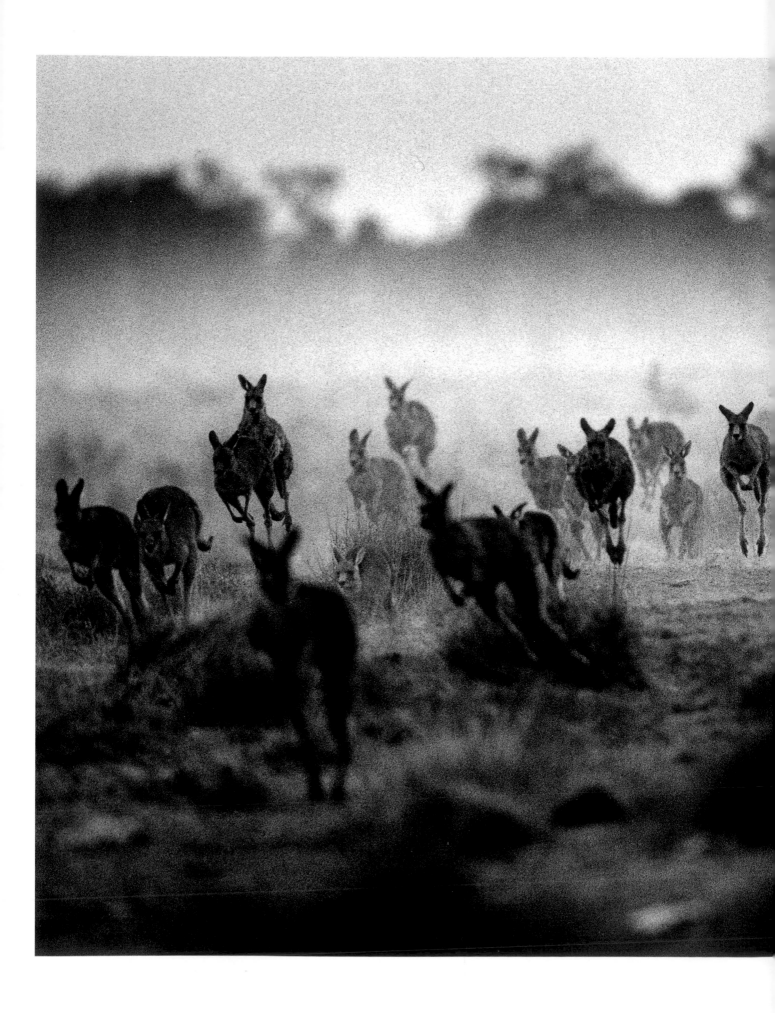

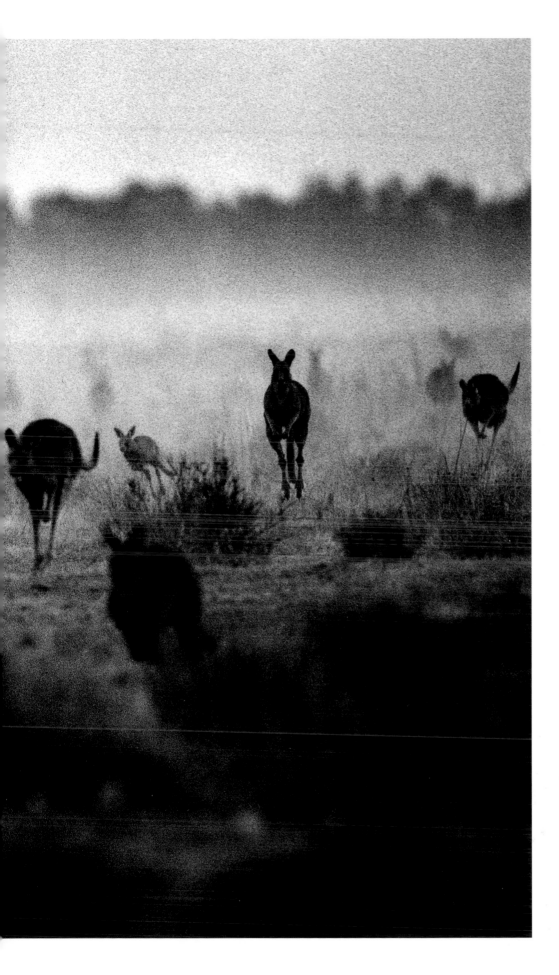

Michael Amendolia
Australia, Network Photographers

3rd Prize Singles

Kangaroos roam across Oxley Station in drought-stricken New South Wales, in Australia. In times of drought the animals move across the country in large groups, in search of water and food. The quest brings them into towns and on to cattle stations and sheep farms, where well-water is available and where they compete with the livestock for resources. This has led to an increasing demand by property owners for kangaroo populations to be culled. Culling is generally carried out by licensed 'harvesters', but meets opposition from animal rights activists.

Michael Nichols
USA, National Geographic Magazine

1st Prize Stories

Theropithecus gelada, a grass-eating, baboon-sized primate that is the last of its genus, lives only in the Simen mountains in the Ethiopian highlands. The male gelada has one chance in his lifetime to mate with females. Once he loses his dominant position, he will never get it back. A dominant male must mate with all females in the group to avoid being replaced. Facing page, top: Every evening at dusk the leading male in a gelada group puts on a ritual display to attract a chase by bachelor males. This is done to impress group females and assert his position. Below: Three females bare gums in aggression. Following pages: A young gelada greets his father with a playful lip-flip, a sign of aggression in older males.

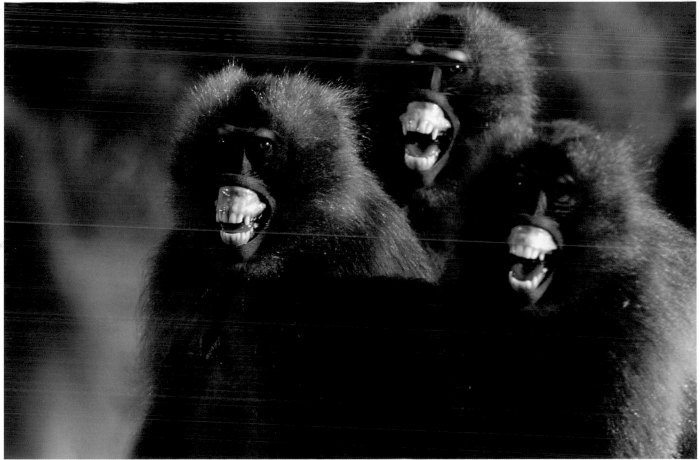

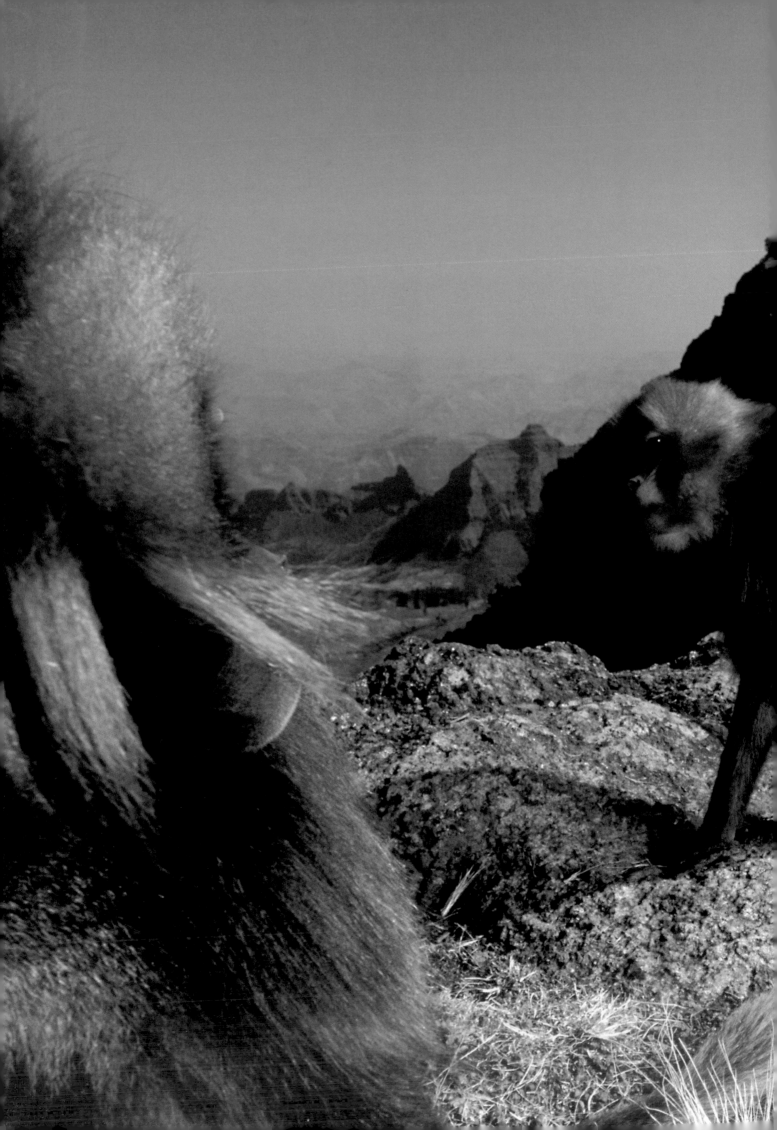

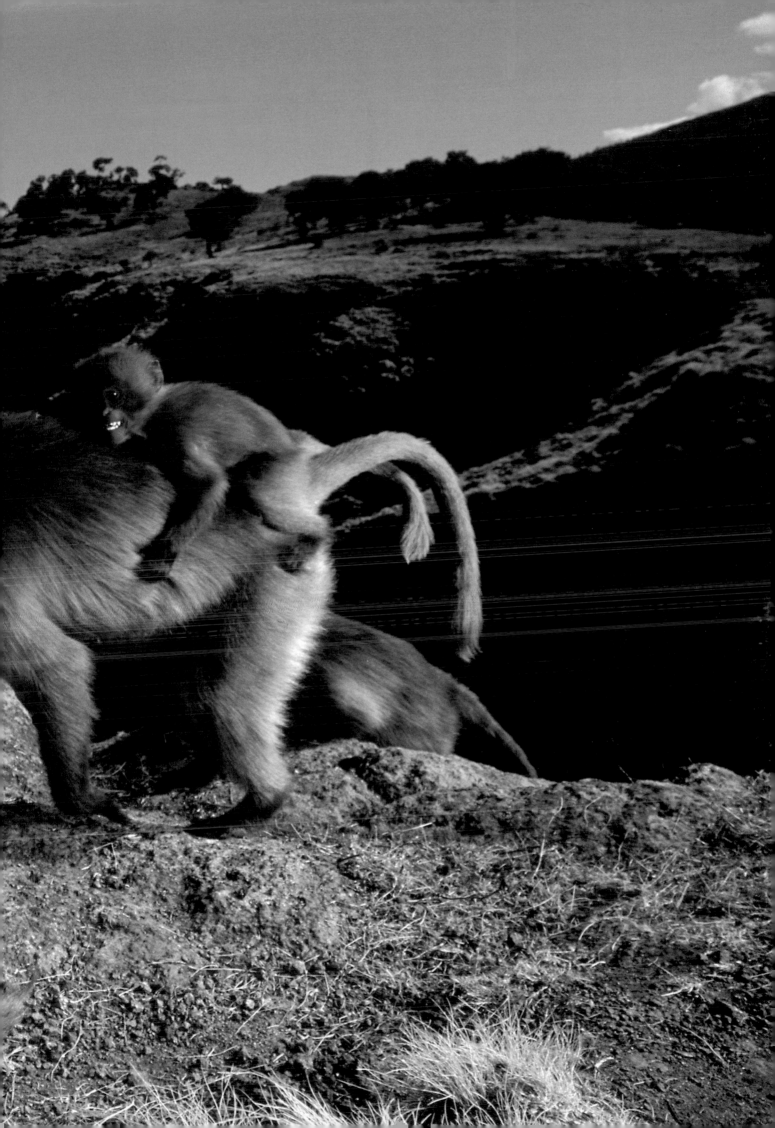

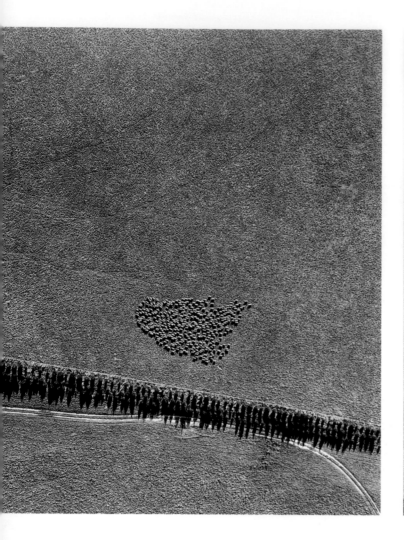

Jackie Ranken
Australia

2nd Prize Stories

Australia is a dry continent, in which water is precious and topsoil fragile. Deforestation and land clearance have led to soil erosion and problems with soil salinity. Deforested areas are being replanted with pine, one of the few trees that will grow in these denuded areas. Some environmentalists would prefer the use of native eucalyptus, as they recover better from fire and don't make the soil acidic. But pine trees grow faster, and if planted in rows more than five deep can offer farmers an economic payoff. This page, left: A mob of sheep is on the move beside rows of pine trees in the Goulburn area of New South Wales. Sheep and cattle grazing is the primary land use in the area. Right: In places, paddocks are ploughed and grazing pasture improved. Facing page, left: Trees that encircle paddocks offer a little protection from the eroding elements. Right: Lines of trees are planted in the contours of hills to prevent erosion.

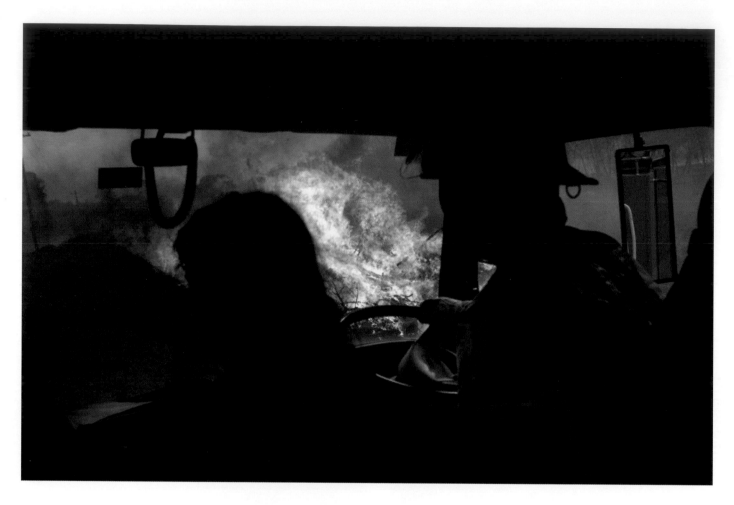

Nick Moir
Australia, The Sydney Morning Herald

3rd Prize Stories

After Australia's most prolonged drought on record, its bushland was at heightened risk of burning during the fire season. A combination of high temperatures and strong winds in the October to December summer months resulted in intense, fast-moving conflagrations. Some were started by arsonists. Huge fires on the land surrounding outer suburbs of Sydney, and later also the capital Canberra, destroyed property and homes. Above: Volunteer firefighters of the Rural Fire Service drive through flames to reach threatened properties in the Mittagong area to the south of Sydney, in November. Facing page, top: Fire crews run from a blaze as the hoses they are fighting with prove inadequate against the strength of the flames. Below: During a quieter moment, an Erickson Air-Crane dumps water on a fire outside Sydney. (story continues)

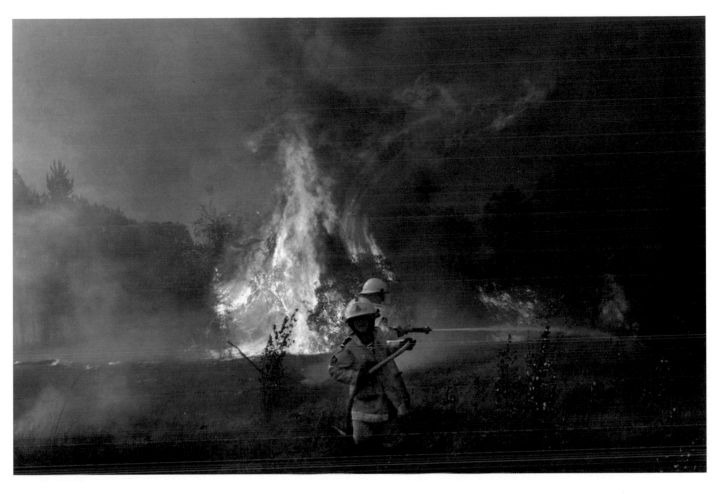

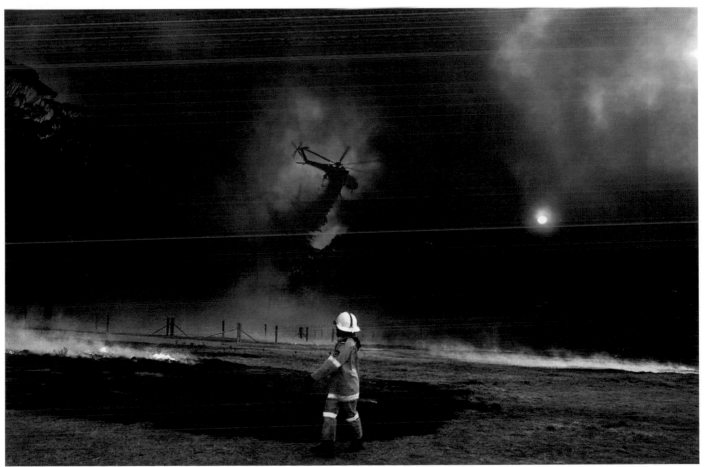

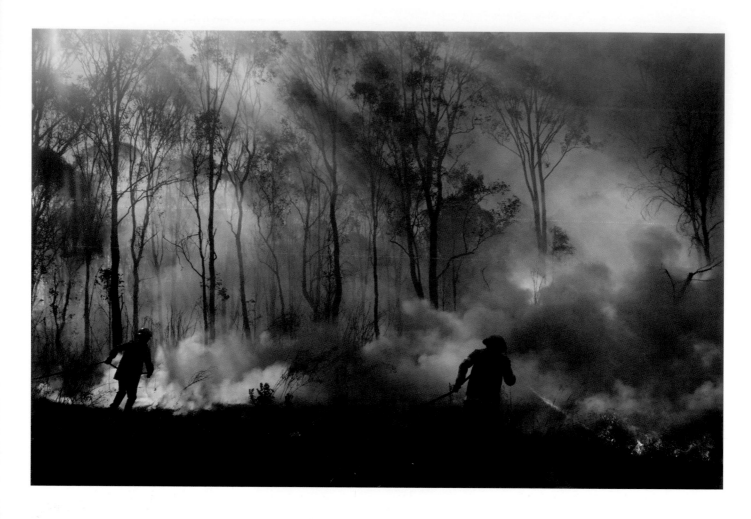

(continued) Rough terrain, thick bushland and eucalyptus forests often hampered operations. Above: Firefighters mop up after a blaze west of Sydney in October.

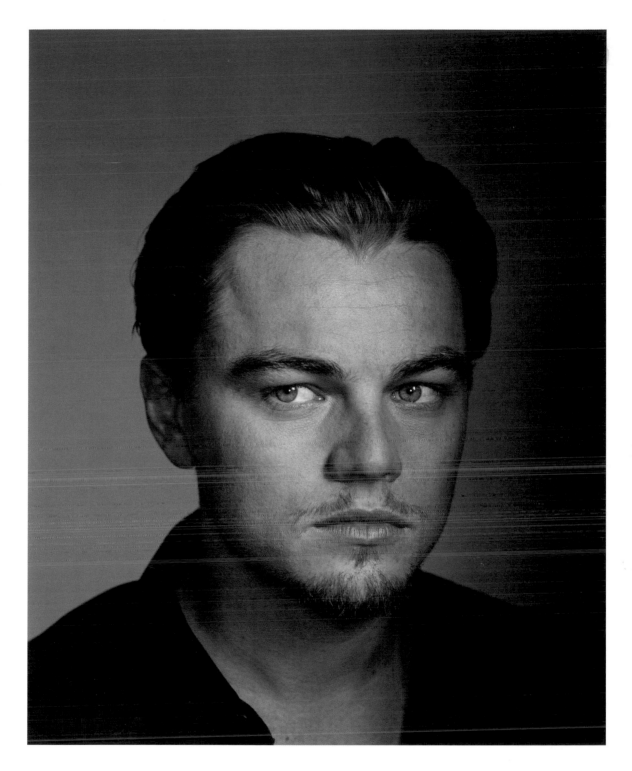

Dan Winters
USA, for The New York Times Magazine

1st Prize Singles

Leonardo DiCaprio starred in two major films in 2002. Martin Scorsese's *Gangs of New York* and Steven Spielberg's *Catch Me If You Can* opened within five days of each other at the end of the year. In the first, set in 1860s New York, DiCaprio plays a young Irish man out to avenge the death of his father. The second is based on the story of a real-life teenage con artist. After the hype surrounding *Titanic* in 1997, DiCaprio appeared to slip from public favor and critical esteem, and for a while took something of a background role. Appearing in two major films, released so close together, shot him back into the limelight.

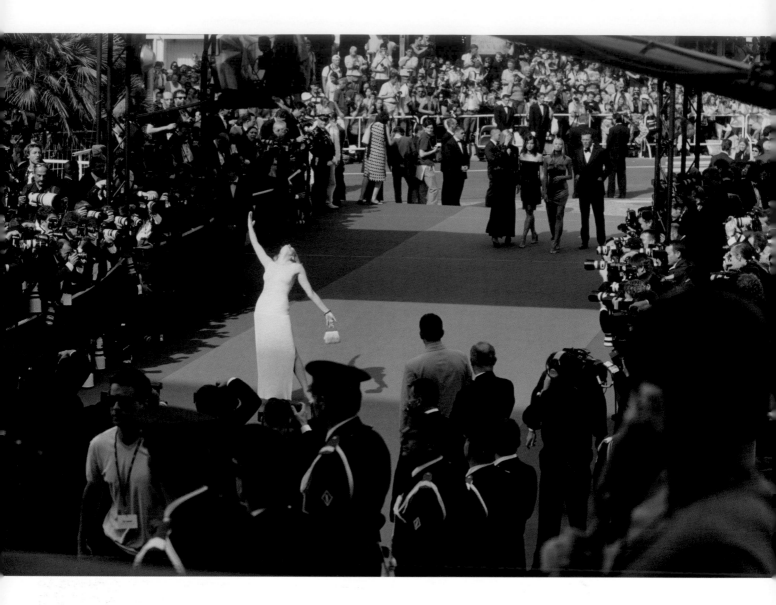

Emmanuel Scorcelletti
Italy, Gamma

2nd Prize Singles

Sharon Stone puts on a show for
photographers at Cannes, in May. She
was at the French coastal resort as a
jury member for the Cannes Film
Festival. During the day she would
judge films with jury members, and in
the evening attend public screenings,
such as the one depicted here.

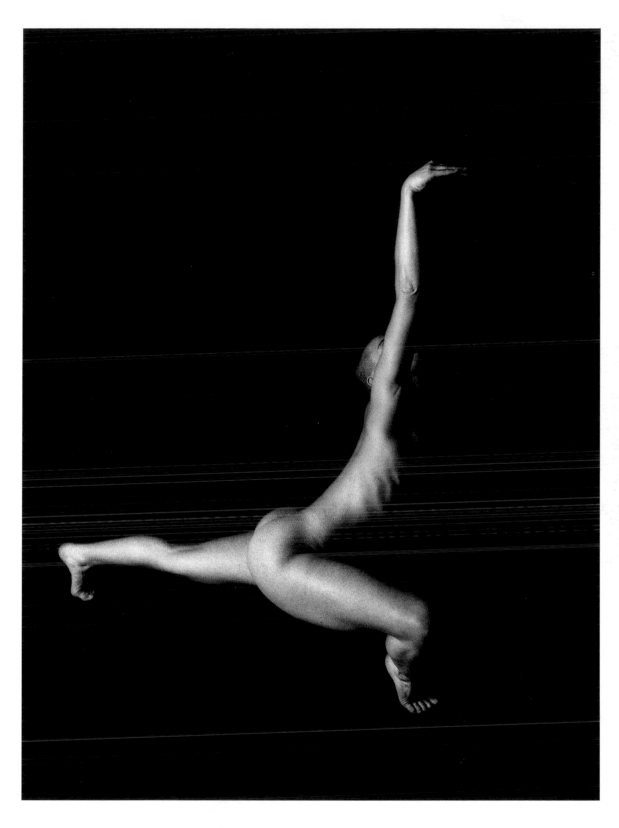

Paolo Porto

Italy, for Thor Productions

3rd Prize Singles

Ines Cera of the Belgian dance troupe Compagnie Thor improvises in the studio
for a photographic project focusing on the dancer's body.

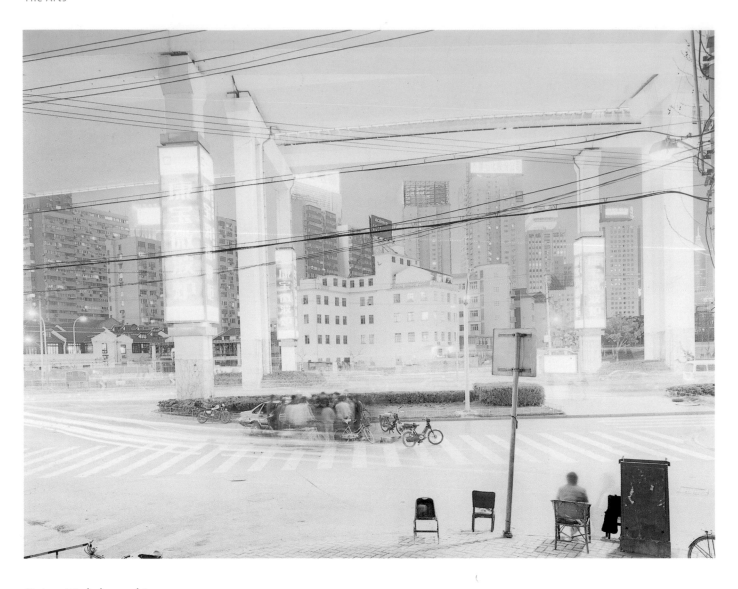

Peter Bialobrzeski
Germany, Laif Photos & Reportagen for Geo

1st Prize Stories

Asian cityscapes have undergone radical change in recent years. Above: Shanghai.
Facing page: Singapore. Following pages: Hong Kong. (story continues)

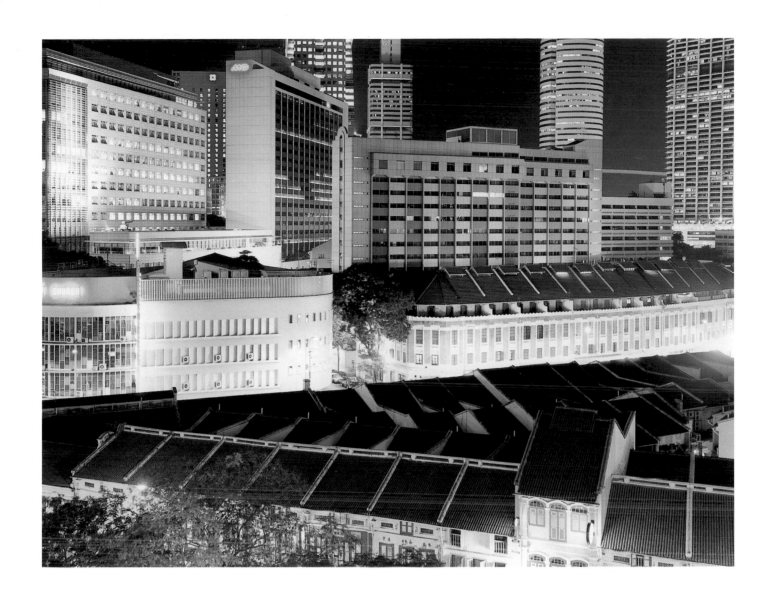

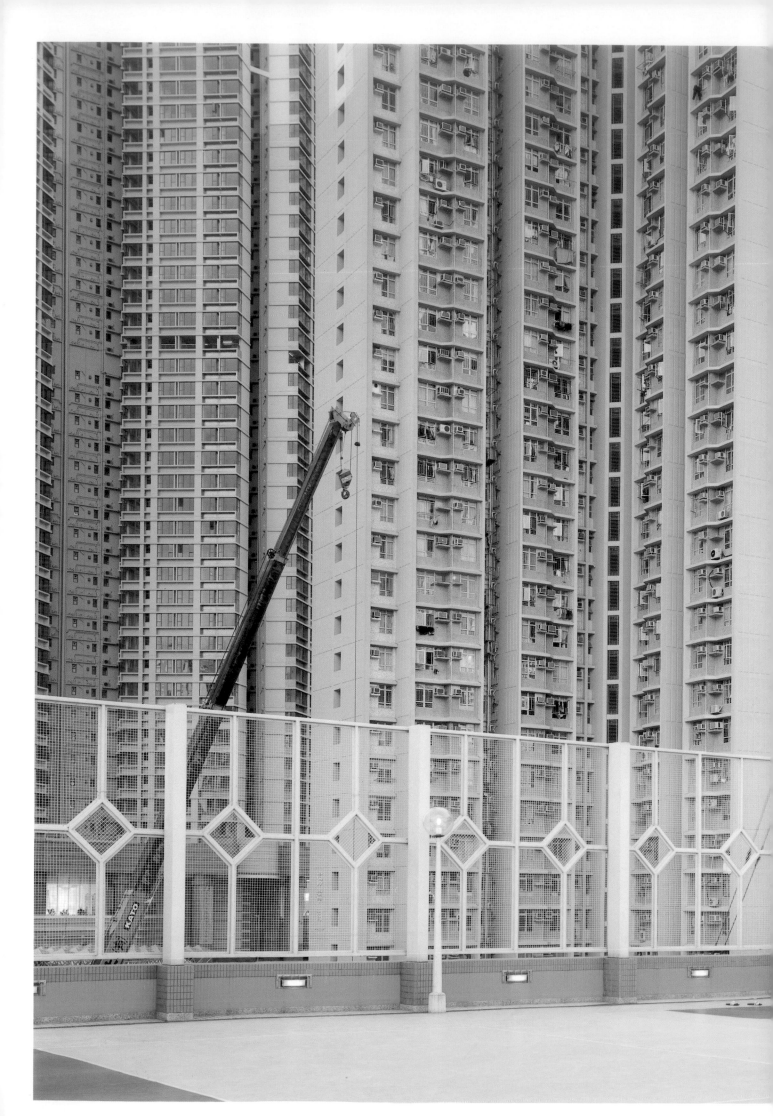

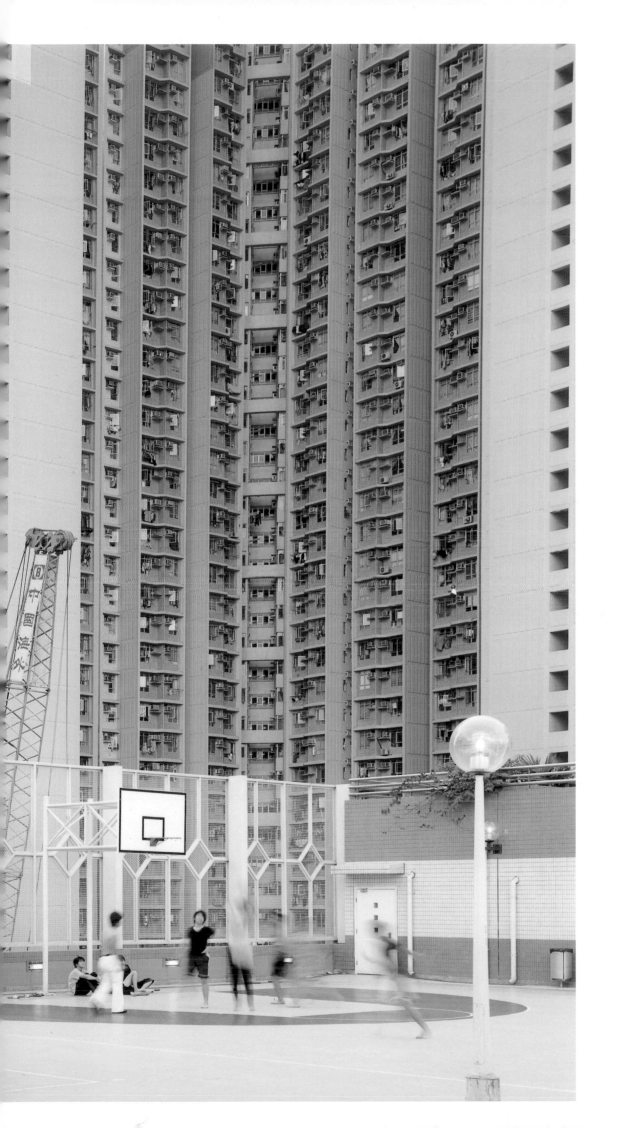

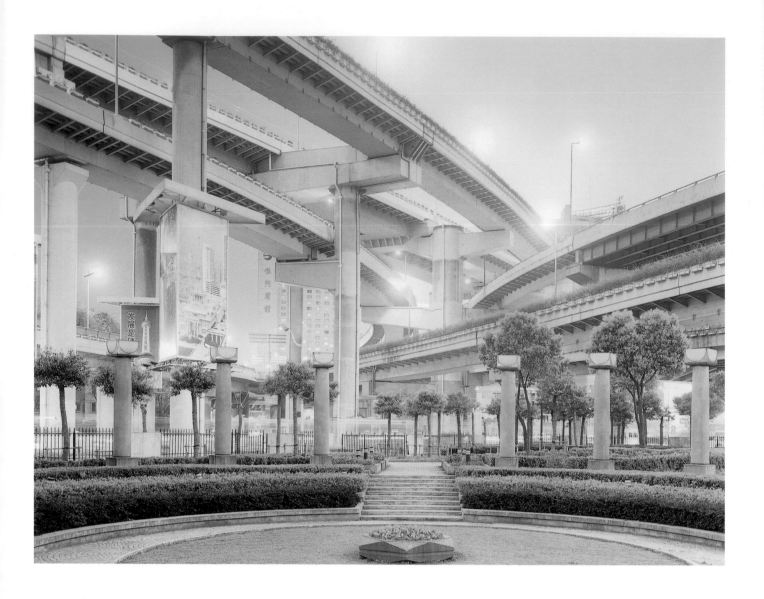

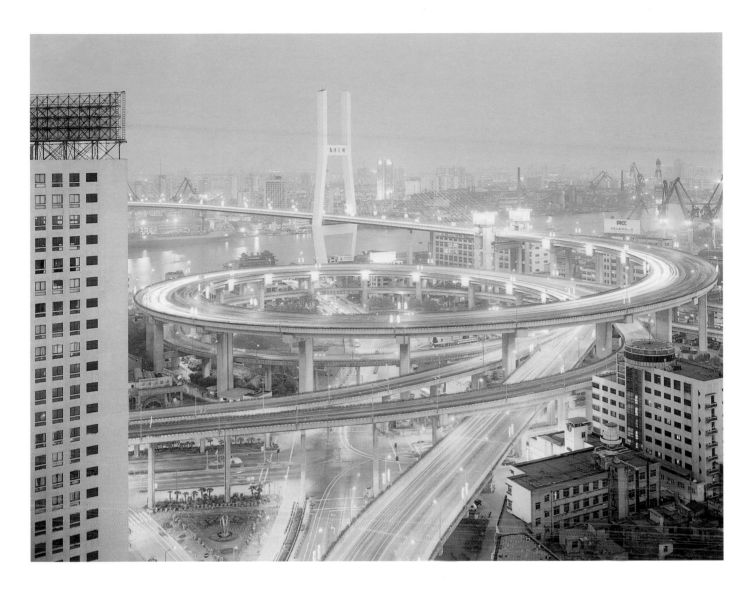

(continued) The Nanpu Bridge in Shanghai spans the Huangpu river to the new tourist and business district of Pudong.

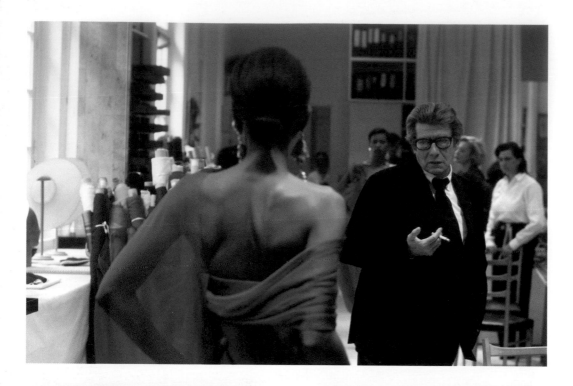

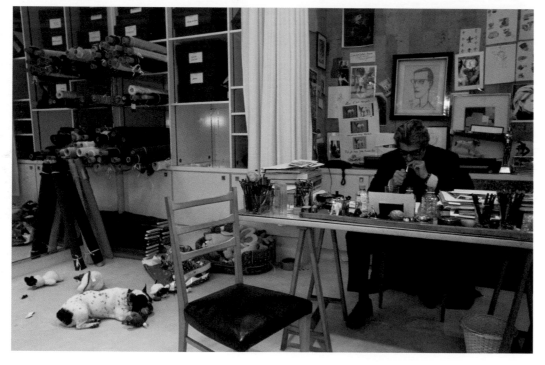

Alexandra Boulat
France, VII for Paris Match

2nd Prize Stories

The veteran French designer Yves Saint Laurent closed his offices after 40 years as a leader on the fashion scene. He gave his final *haute couture* show at the Centre Georges Pompidou in Paris in January. Top: At his Paris studio on the Avenue Marceau, Yves Saint Laurent assesses one of the gowns to be presented at his last show. Below: He works on the last show at his desk in the Avenue Marceau studio. Facing page: The designer takes a smoke break, alone with his dog Moujik III in his Paris fashion house. Following pages: Yves Saint Laurent lunches at home.

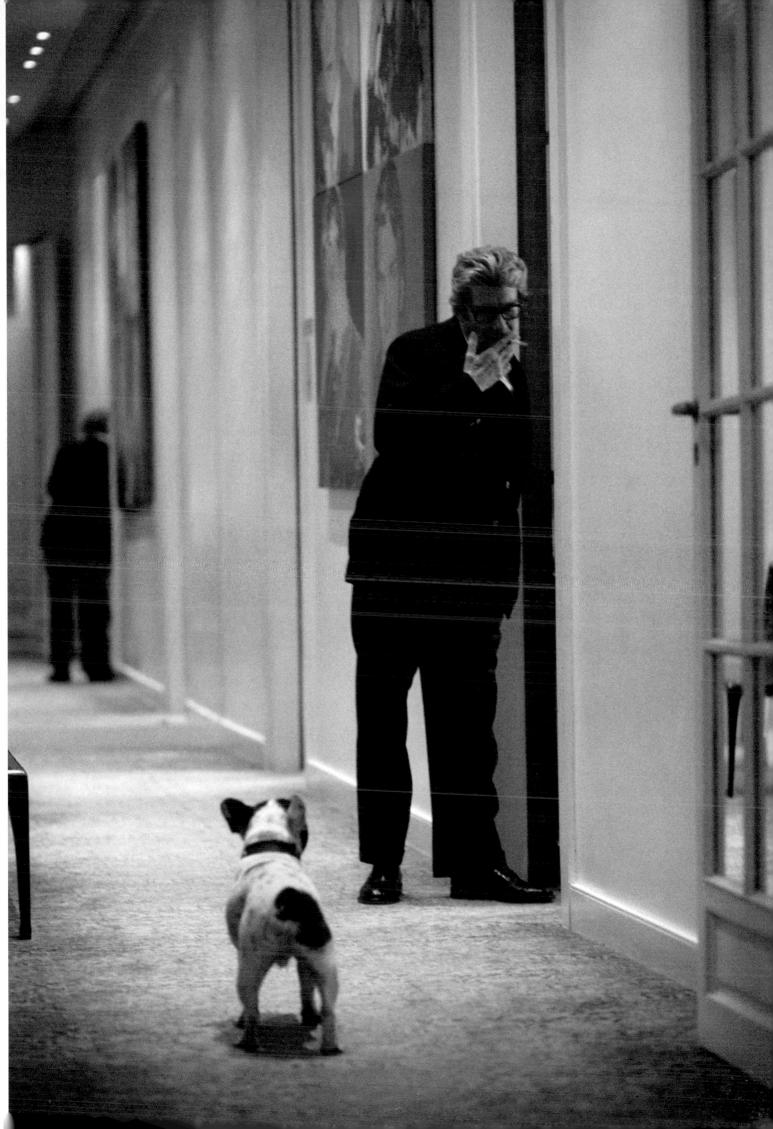

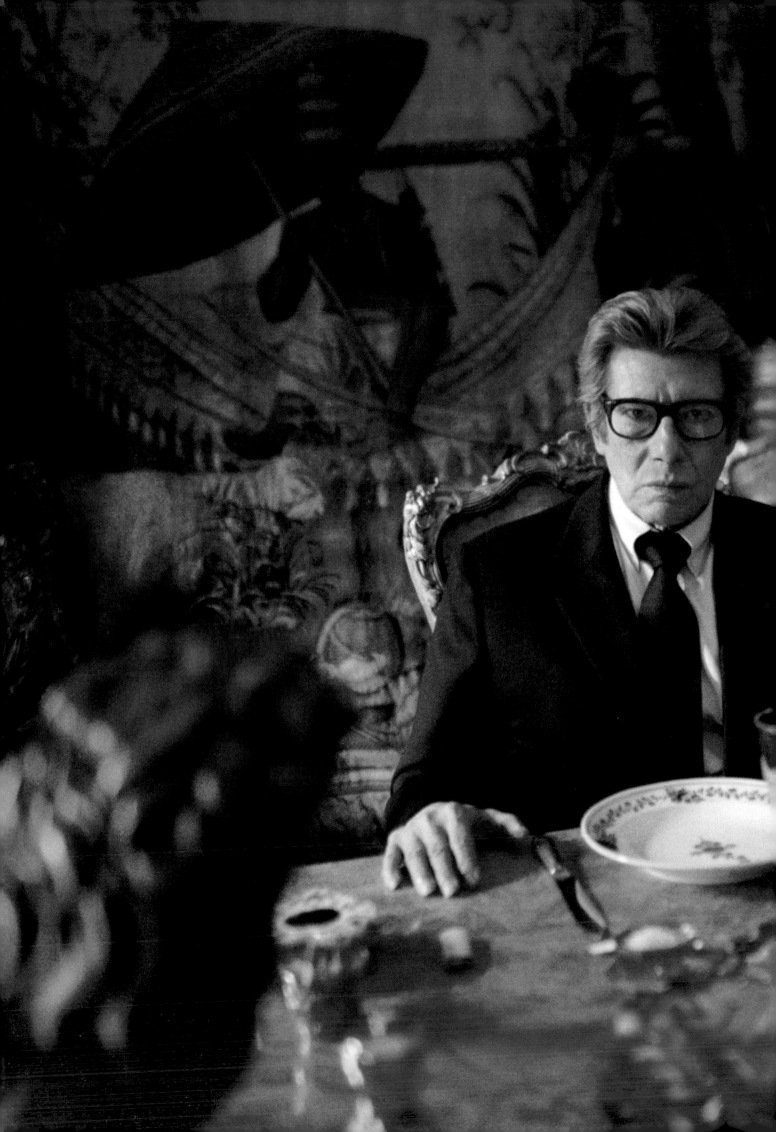

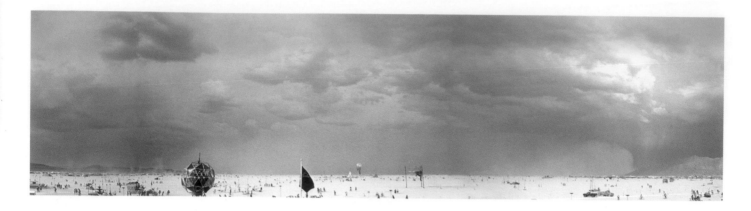

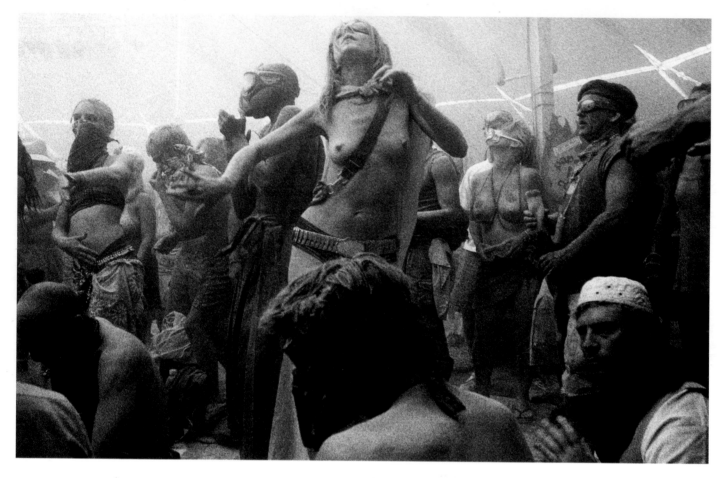

Fernando Moleres Alava
Spain

3rd Prize Stories

A record 29,000 people from 20 different countries attended the annual Burning Man festival in Nevada, USA. Billed as a week-long celebration of art, counterculture and radical self-expression, the festival began in 1986 in San Francisco, but in 1990 moved to its present location in the Black Rock Desert. It culminates with the ceremonial torching of a gigantic wooden statue of a man. Top: Most of the artwork and events during the festival take place in an area called the 'playa', at the center of a semicircular Black Rock City. Below: Celebrants dance spontaneously in the central tent during a sandstorm. Facing page: Self-expression through costume, or lack of it, is a feature of the festival.

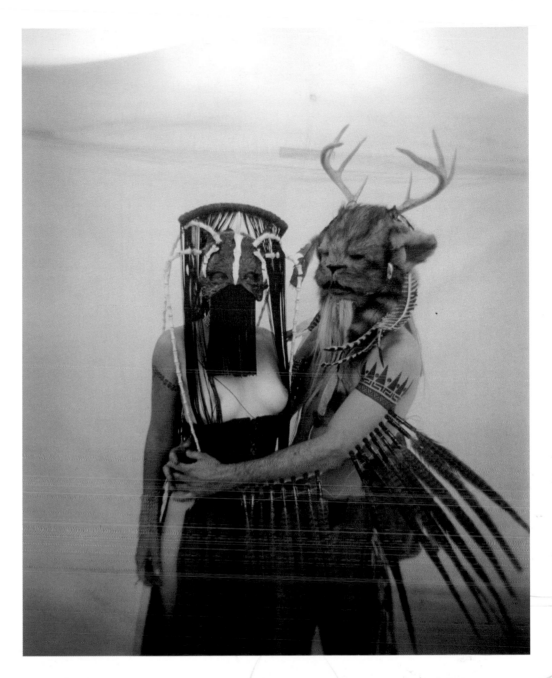

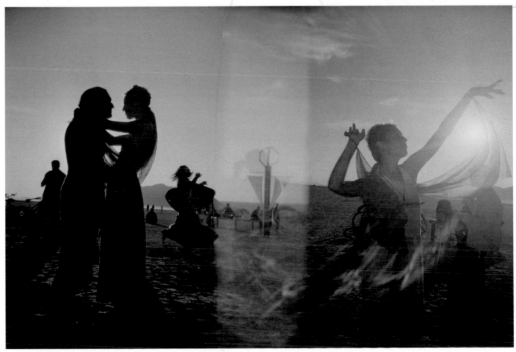

Sports

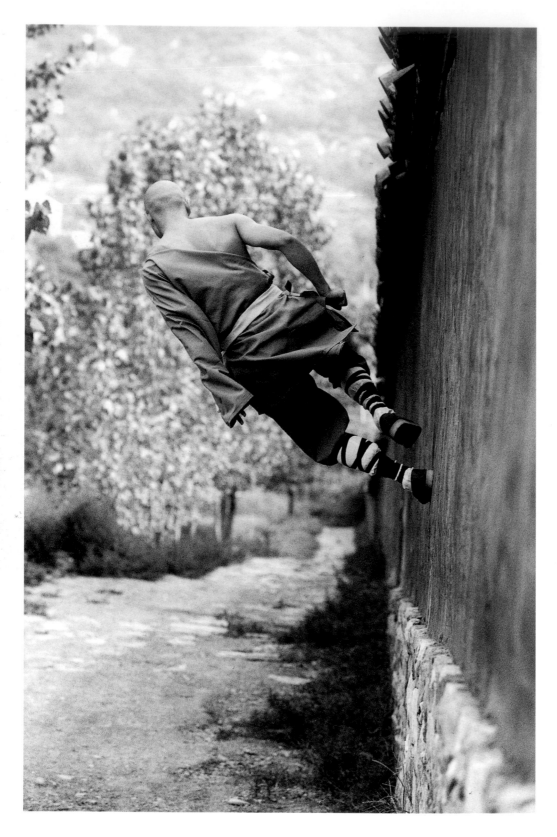

Tomasz Gudzowaty & Robert Boguslawski
Poland, TGP/Focus

1st Prize Singles

At Shaolin temple in the Henan province of China, monks practice China's best-known traditional *wushu* ('war art'). Like many other oriental martial arts Shaolin Kung Fu, as it is sometimes called, demands a rigorous combination of mental prowess and physical strength. Its 18 basic positions are inspired by the movement and agility of animals.

Tim Clayton
Australia, The Sydney Morning Herald

2nd Prize Singles

A shower of late-afternoon rain drenches Papua New Guinea goalkeeper Tapas Posman, as he kicks the ball clear during a match against New Zealand as part of the Oceania Nations Cup Championships in Auckland in July. His team lost the match nine goals to one.

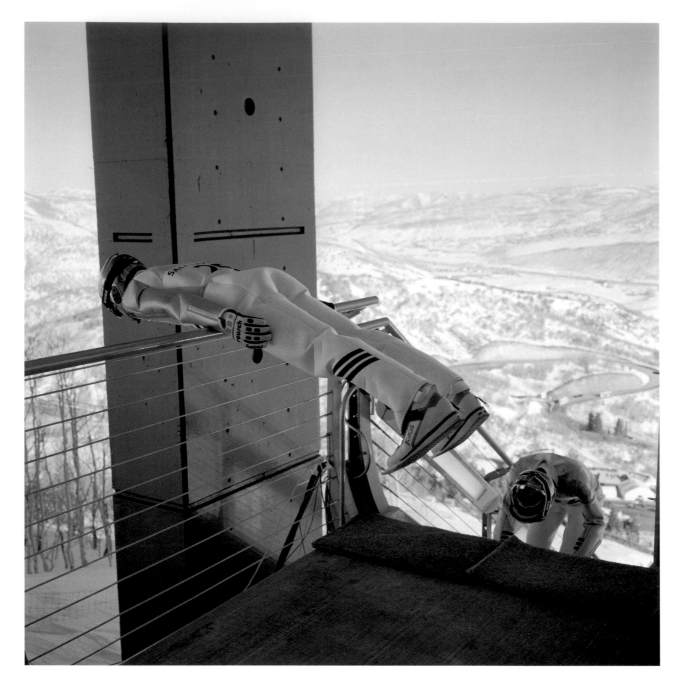

David Burnett

USA, Contact Press Images for Salt Lake City Olympic Committee

3rd Prize Singles

Michael Uhrmann of Germany prepares for the K120 Individual
Ski Jumping event at the Salt Lake Winter Olympics in February.
Athletes must have a strong mental grasp of how aerodynamics
affects their flight, and the physical control to keep their bodies
rigid and parallel to the skis. The perfect flight position is with
the back flat, and the heels slightly lower than the hips.

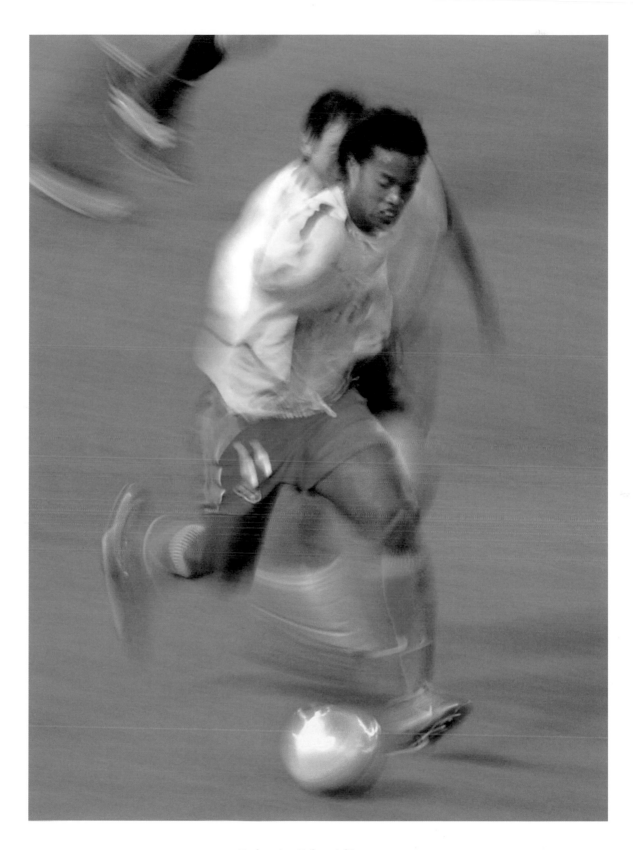

Roberto Schmidt
Colombia, Agence France-Presse

Honorable Mention Singles

Brazilian midfielder Ronaldinho runs with the ball ahead of German player Jens
Jeremies during the final match of the FIFA World Cup, in Yokohama, Japan, in June.
The Brazilian team became world champions, winning the match two goals to nil.

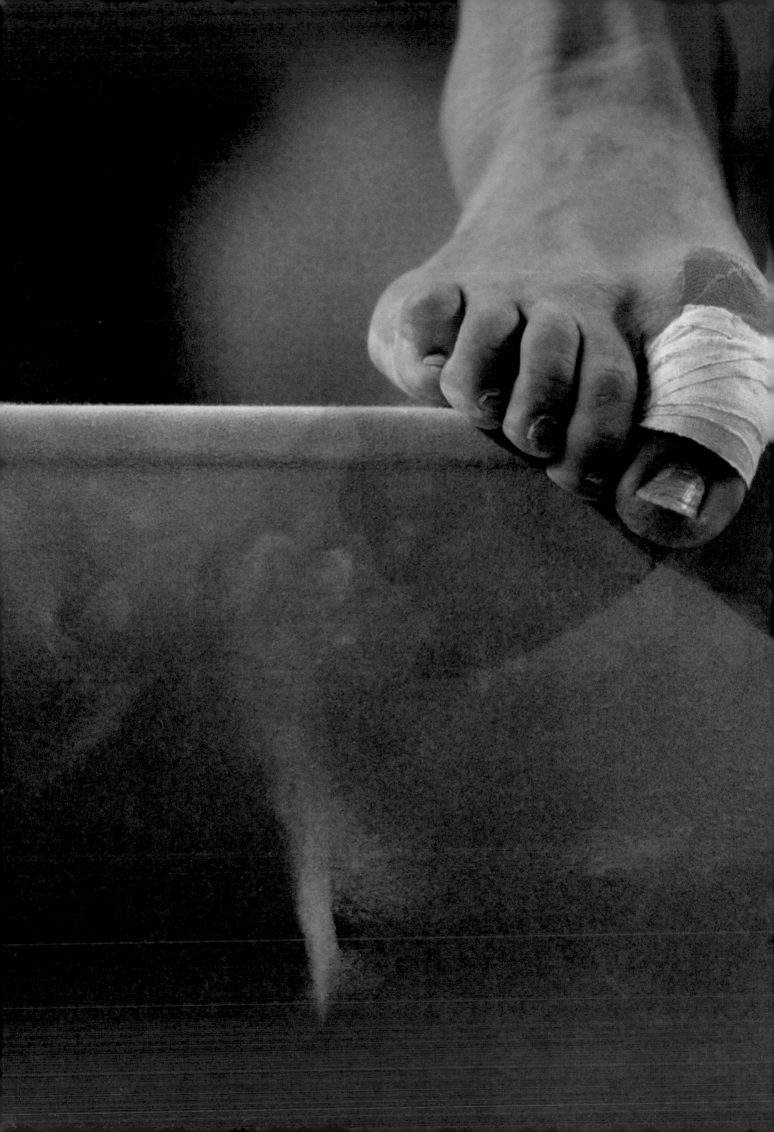

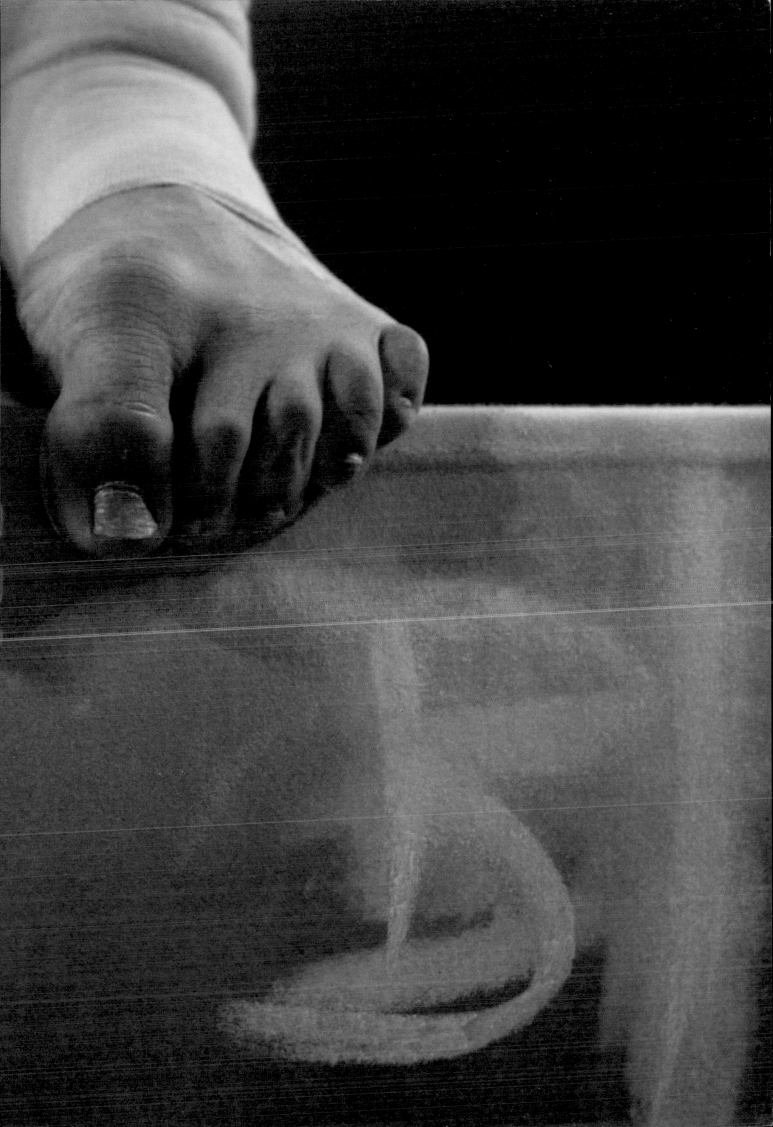

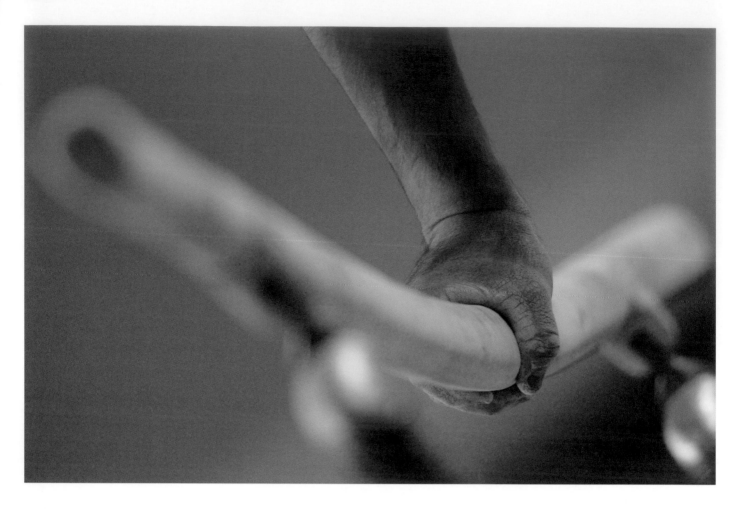

Balázs Gardi
Hungary, Népszabadsag

1st Prize Stories

Gymnastic success depends on a perfect grip, both
physically and mentally. Some of the world's top
gymnasts compete at the 36th World Gymnastics
Championships in Debrecen, Hungary, in November.

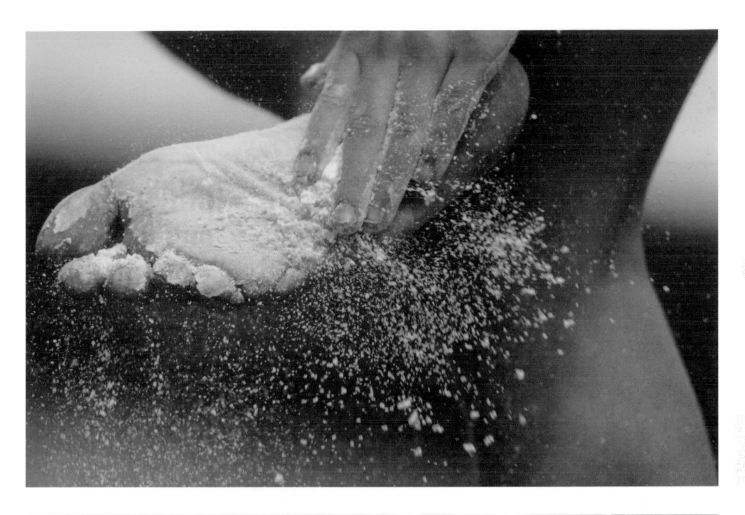

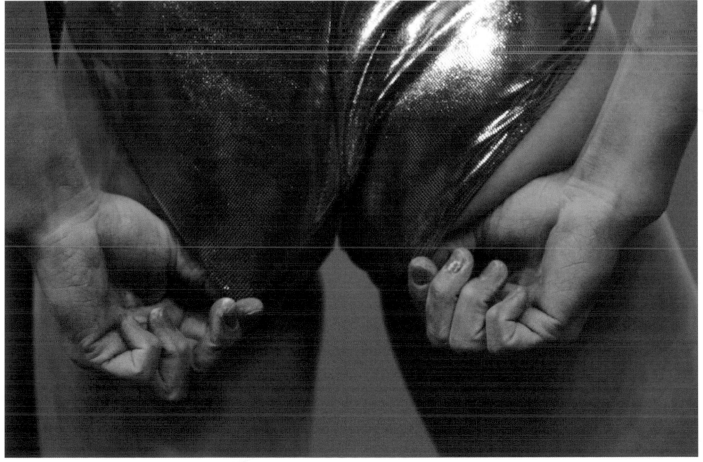

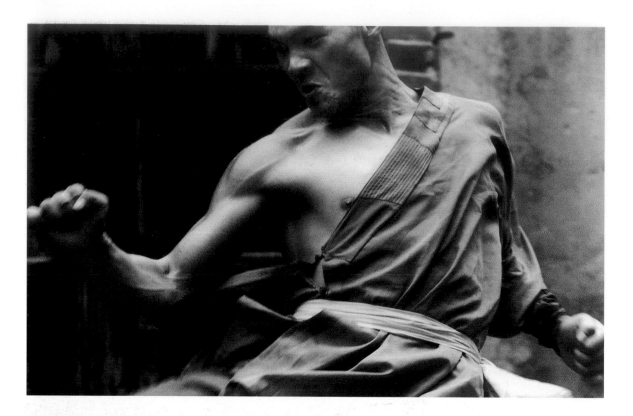

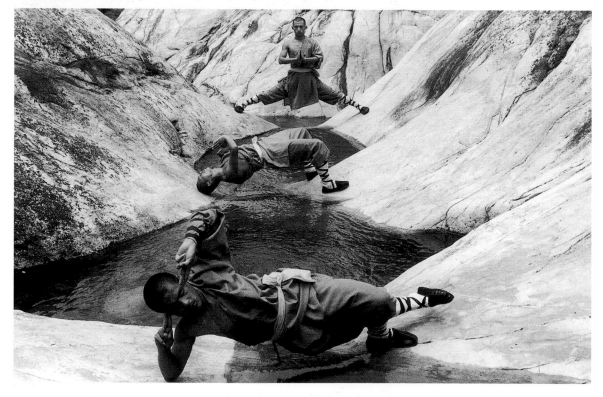

Tomasz Gudzowaty & Robert Boguslawski
Poland, TGP/Focus for PKN Orlen

2nd Prize Stories

Monks of the Shaolin temple in Henan province, China, now teach their particular form of Kung Fu (also known as *wushu*, or 'war art') in schools, and a large martial arts academy has opened beside their temple in response to growing public interest in the tradition. Since 1990 wushu has been an official medal event in the Asian Games, and there is a bid for it to be included in the 2008 Olympic Games in Beijing. Two other martial arts, taekwondo and judo, already feature in the Olympics.

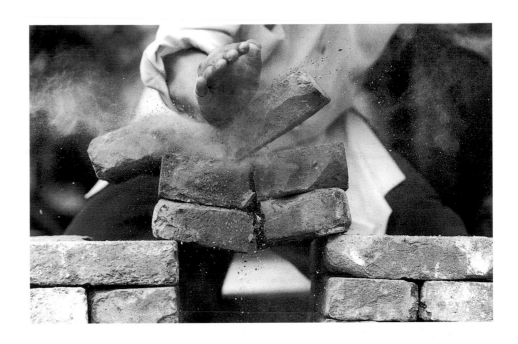

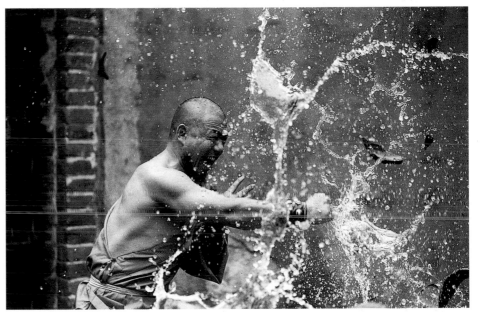

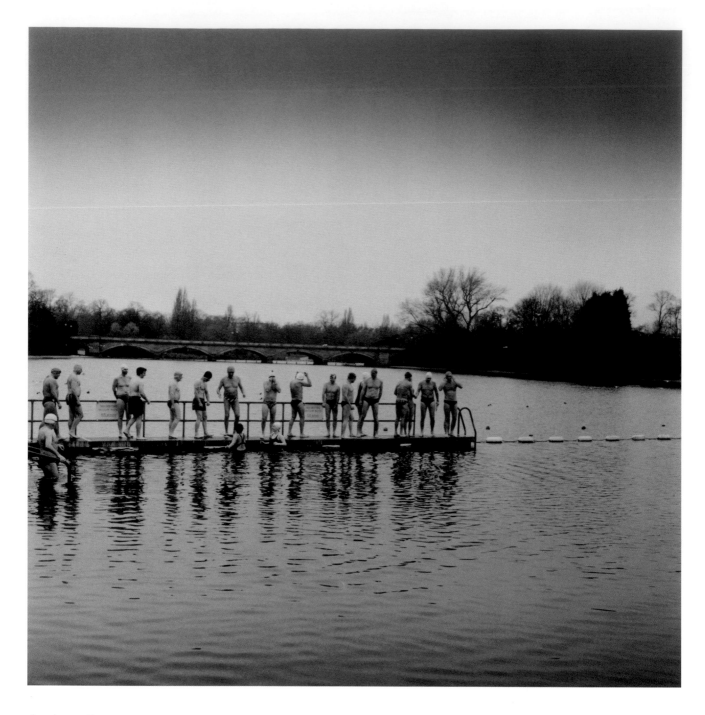

Andrew Buurman
United Kingdom, Eyevine

3rd Prize Stories

Members of the Serpentine Swimming Club meet every Saturday morning, regardless of weather conditions, for a dip in the Serpentine Lake in London's Hyde Park. If the lake has frozen over, they break a hole in the ice, and then go for a swim. Members come from all walks of life, and range from people in their twenties to those in their eighties. An annual highlight is the Peter Pan Cup, a 100-yard race swum every Christmas morning. Above: Participants line up on Christmas day for the start of the race. Facing page, below left: Freezing February temperatures don't deter swimmers. Right: Judges record times in January. (story continues)

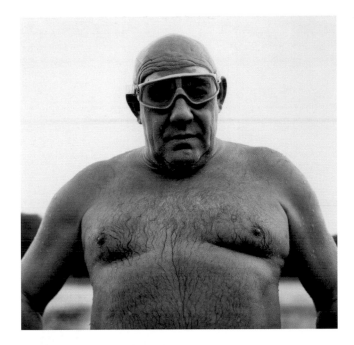
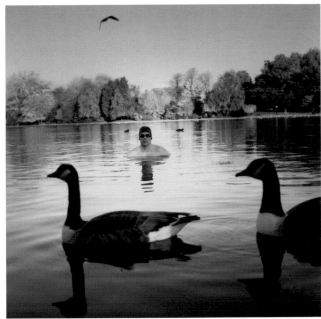
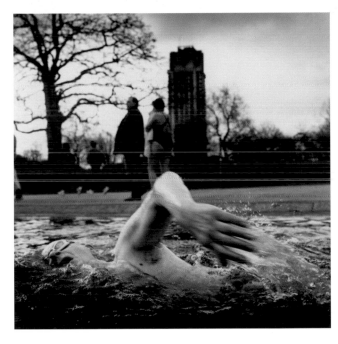
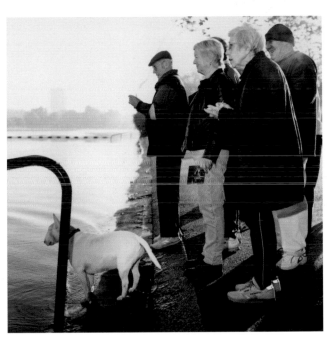

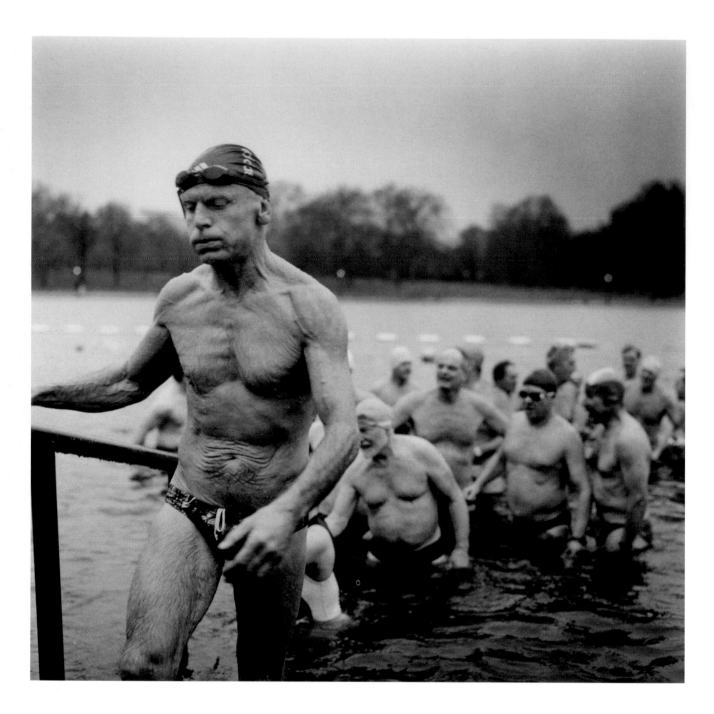

(continued) The club was founded in 1864 and includes both amateurs and people who have swum the Channel. Its famous Christmas-morning race begins at nine o'clock, and is named after a trophy presented in 1903 by J.M. Barrie, author of *Peter Pan*. Above: Competitors leave the water for a traditional post-race glass of port on Christmas morning.

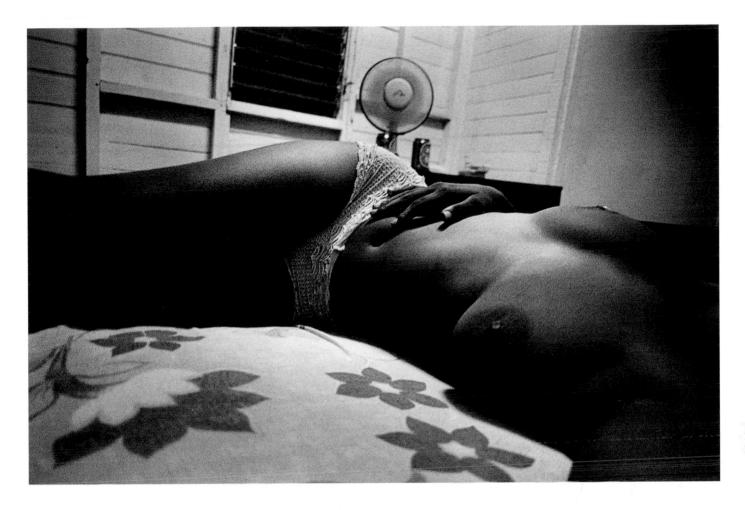

Christophe Gin
France, Agence Vu for Cosmopolitan

1st Prize Singles

Every night, 'Samantha', aged 15, crosses from Surinam to work as a prostitute on the French Guianese side of the river Maroni. The banks of the Maroni river have become something of an El Dorado in recent years, after the local government began selling licenses for small scale mining, an expansion on existing commercial operations. 'Garimpeiros' flocked from neighboring countries such as Brazil to prospect for gold, setting up camp on both sides of the river. Uncontrolled mining activity has disrupted local life, leading to increased violence, alcohol abuse and prostitution.

Joachim Ladefoged
Denmark, Agence Vu for Geo

2nd Prize Singles

Boys, reflected in the windscreen of a parked car, play in the streets of Sanaa, the capital of Yemen. Once at the crossroads of ancient spice routes, Yemen has for centuries been a meeting-point for Africa, Asia and the Middle East. The country maintains much of its tribal character and many traditional ways. Blood feuds and vendettas between rival family groups still arouse local passions, and a number of foreigners have been kidnapped by groups making demands on the authorities. The Yemeni government has expressed support for the American campaign against terrorism, yet on the streets there have been public protests against such issues as Israel's occupation of the Palestinian territories.

Mona Reeder
USA, The Dallas Morning News

3rd Prize Singles

Workers make clay bricks in a wood-burning kiln outside Kabul, in Afghanistan. After being fired in the kiln, the bricks are sun-dried, then loaded by hand into trucks. Many brick factories had been lying idle because conflict in Afghanistan had ravaged the economy. But as rehabilitation programs fostered rebuilding and the construction of schools, the brickyards began to re-open.

Casper Dalhoff
Denmark

1st Prize Stories

Residents of Sølund, a special village in Denmark for people with a mental disability, live in small group homes and come and go freely within the community. Each group has its own management, which is responsible for a budget, hiring staff and coordinating with the rest of the village. Since 1998, Danish legislation has given disabled people rights to the same life-style and services as able-bodied people, and placed the obligation on local authorities to ensure this. The system has to adapt to the individual, rather than the individual being forced to adapt to the system. (story continues)

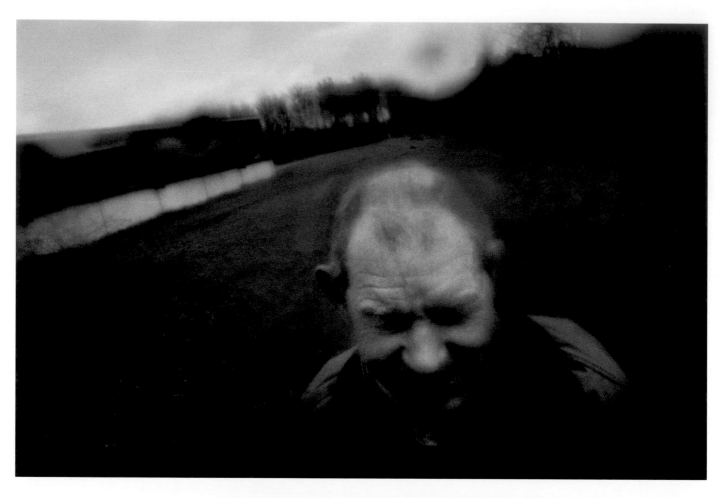

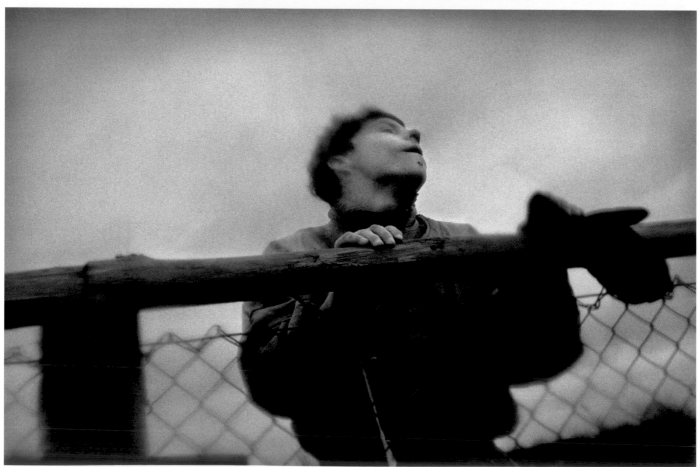

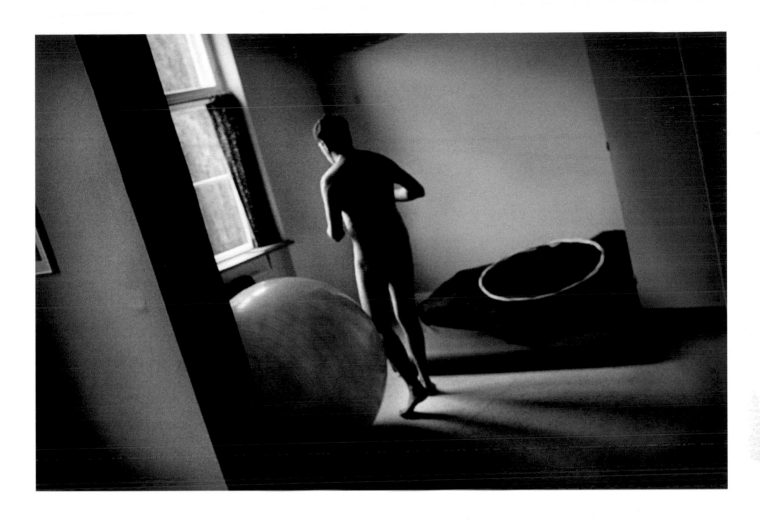

(continued) Sølund residents include people with Alzheimer's as well as those with autism, learning difficulties and psychiatric problems, ranging in ages from 18 to 100. A health-center in the grounds offers full medical services and therapy, and the village employs some 550 people overall for its 220 inhabitants.

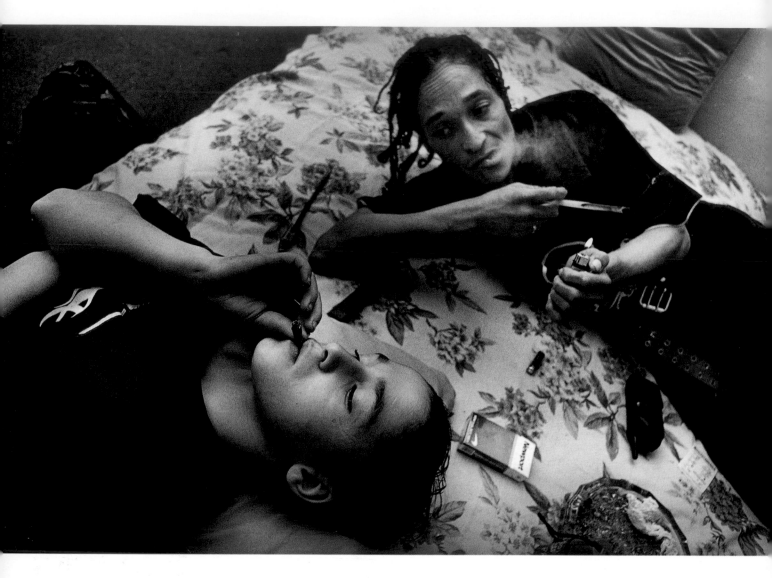

Brenda Ann Kenneally
USA, for The New York Times Magazine

2nd Prize Stories

Drew lives in Brooklyn, New York. His mother Tata smokes crack and has a long record of arrests and convictions for drug offences. Drew had to leave the family apartment where his father and four siblings lived because of problems connected with his truancy from school. He spent the next few years of his life moving around the neighborhood, sometimes staying with friends, sometimes with Tata in the rooms where she sold drugs and got high, occasionally in abandoned buildings where he looked after stray dogs. Above: Drew draws on a joint of marijuana, while his mother smokes crack. Since running into trouble over truancy, he feels that he and she are equal fugitives from the law, so no longer finds it necessary to hide his smoking. Facing page: When Drew was nine, he began to take in stray dogs. Here he sits in the doorway of an abandoned house where he keeps them. Beside him is a bucket of the rice and beans he uses for dog food. (story continues)

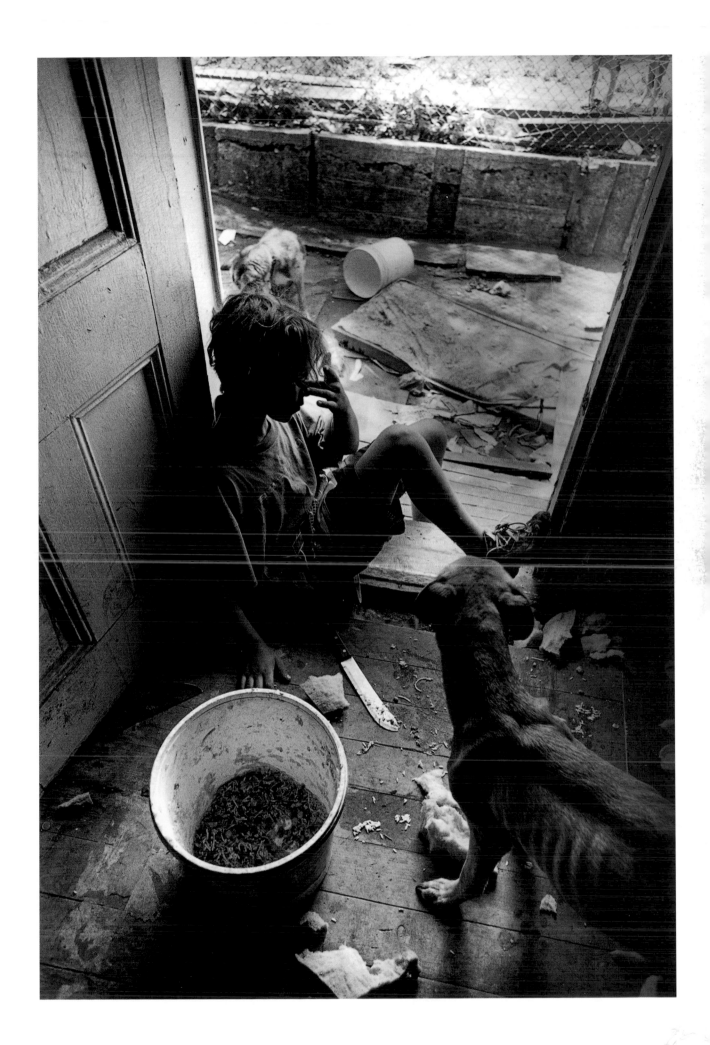

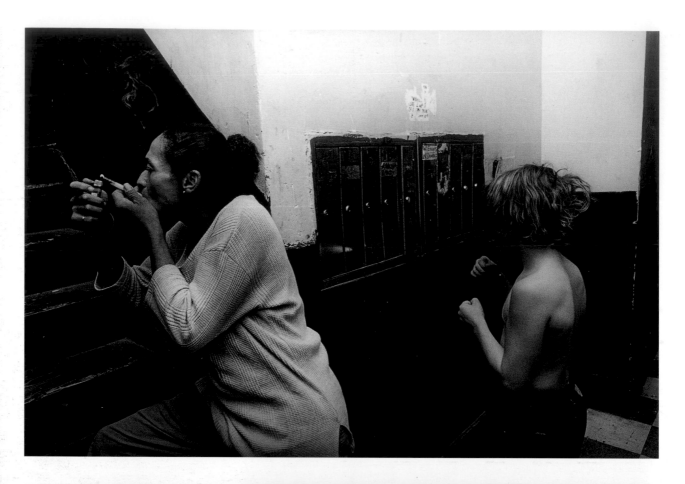

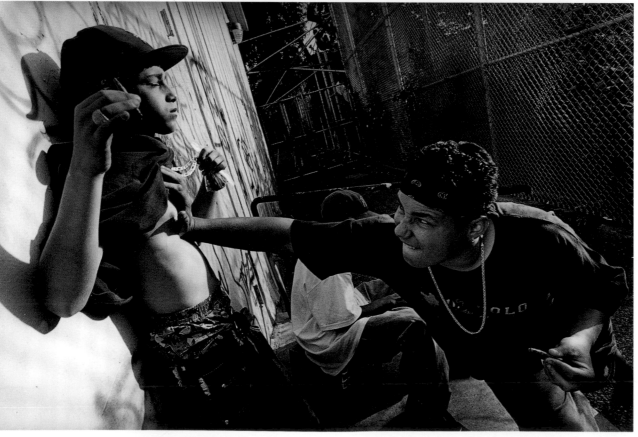

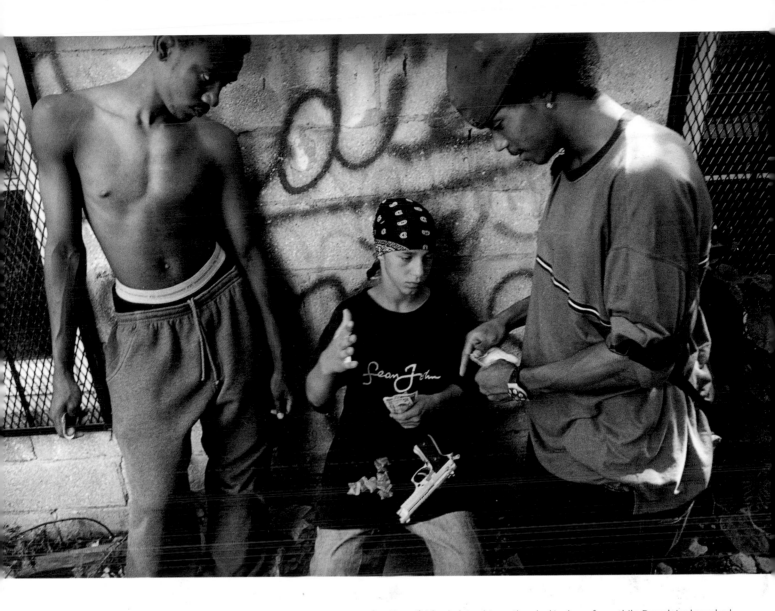

(continued) After helping his mother deal in drugs for a while, Drew later branched out on his own. Above: Drew's best friend Jordan is trading him a pellet gun in return for marijuana. Facing page, top: A younger Drew starts punching mailboxes, as his mother lights up the stem of crack she has just bought from him. Below: Drew and his brother Pepe do 'wall-shotties'. Pepe is pushing against Drew's chest to give him a bigger high.

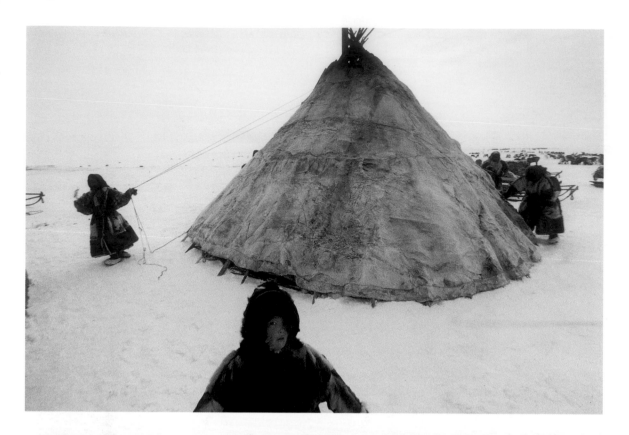

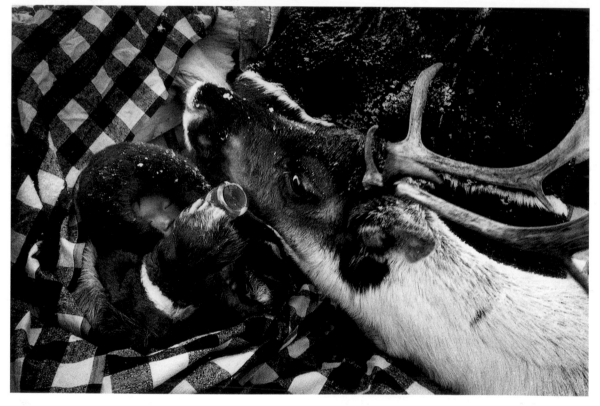

Heidi Bradner
USA, Panos Pictures

3rd Prize Stories

Members of the 34,000-strong Nenets ethnic group lead a nomadic life on the Yamal
Peninsula in northwest Siberia. The Nenets' life revolves around raising reindeer. Nenets men
go out onto the tundra every day to herd the deer, which are trained to pull the sleds that
transport each family's home and possessions. Reindeer provide food, clothing, transport
and shelter to the Nenets, whose tepee-like tents, called *chum*, are made of reindeer pelts.

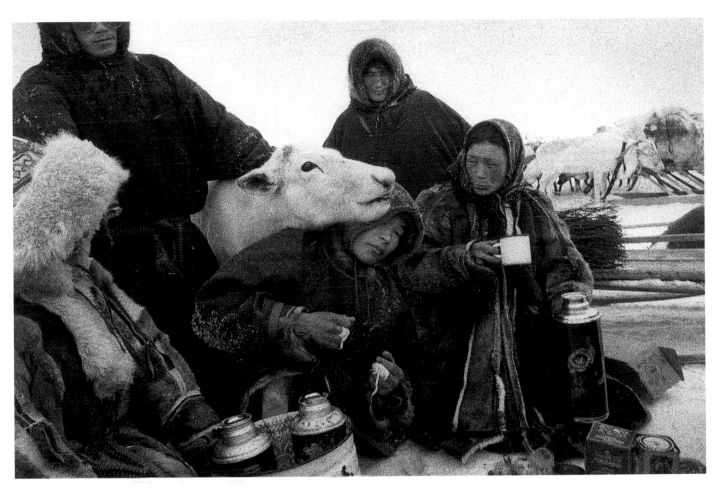

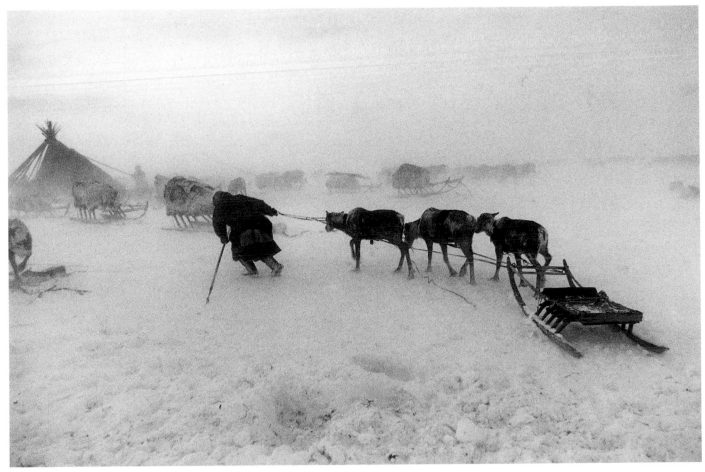

Spot News

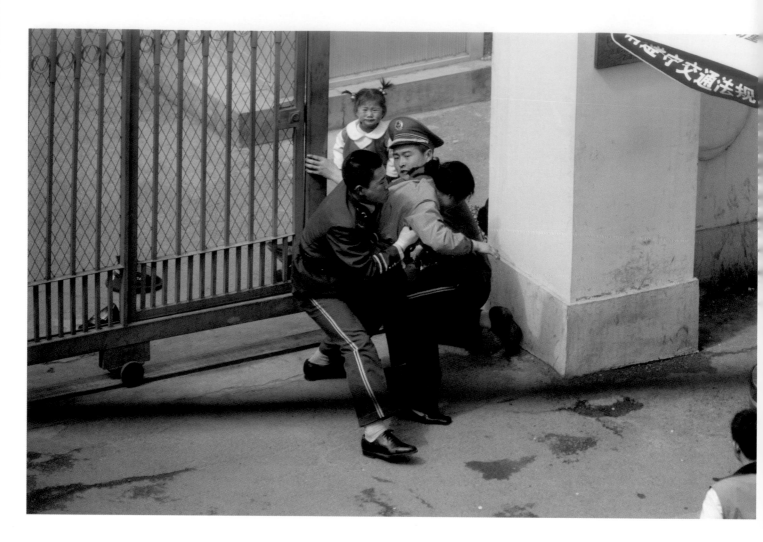

Tomohisa Kato
Japan, Kyodo News

1st Prize Singles

Chinese police grapple with a North Korean woman at the gate to the Japanese consulate in Shenyang, as her daughter looks on. The family of five were attempting to seek political asylum at the consulate in May, in order to be able to move to South Korea. China is bound by treaty with North Korea to repatriate asylum seekers, who are regarded as traitors, but it has sometimes granted them passage to Seoul via third countries. This incident caused some diplomatic tension between the governments concerned. After being held by the Chinese authorities for two weeks, the family was released and allowed to go to South Korea.

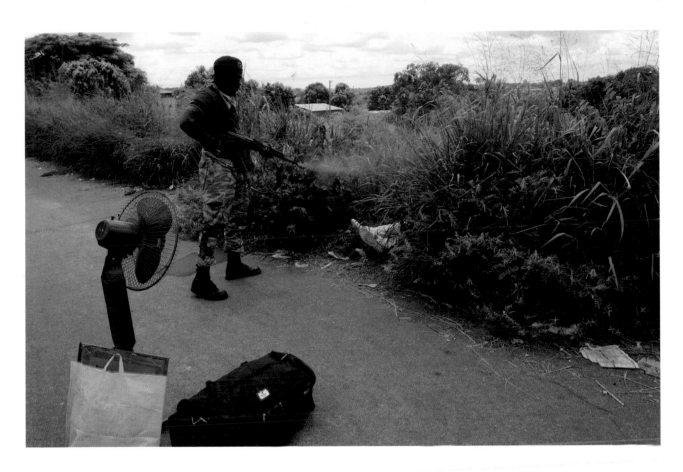

Noël Quidu
France, Gamma for Paris Match

2nd Prize Singles

A rebel fighter shoots dead a man suspected of looting a fan and sports bag from an abandoned house outside the town of Bouaké, in central Ivory Coast. Unrest had broken out in Ivory Coast some weeks earlier, in September. A military mutiny among troops unhappy at being demobilized had developed into a full-scale national rebellion. Previously, Ivory Coast had been seen as a bulwark of stability in a conflict-torn region.

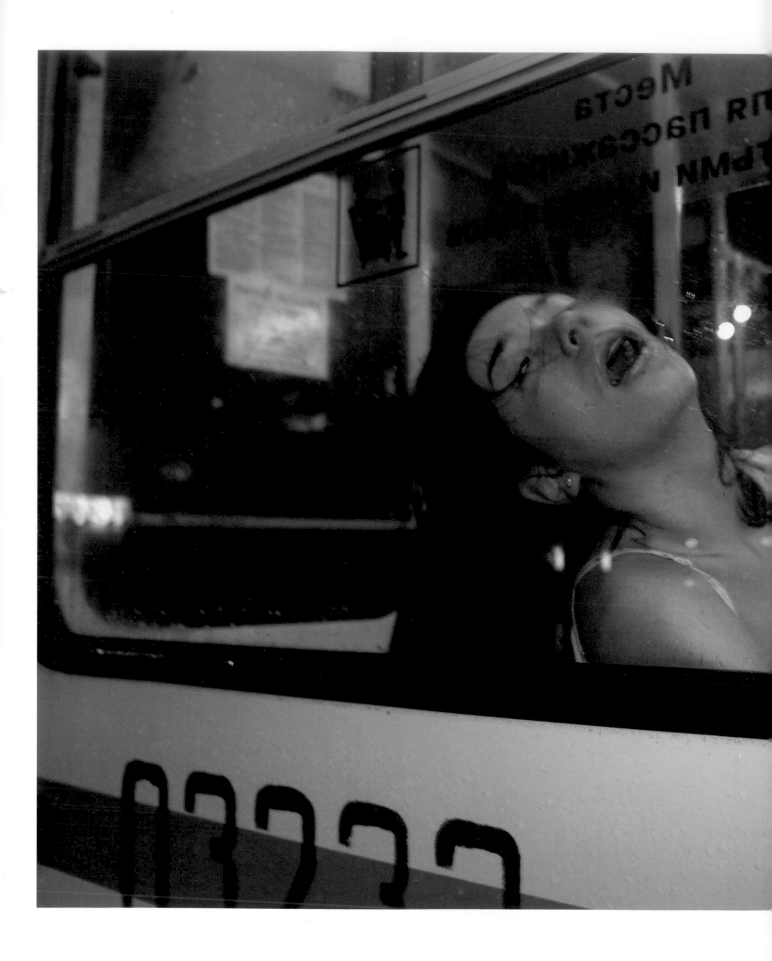

Justin Sutcliffe
United Kingdom, The Sunday
Telegraph/Images Sans Frontières

3rd Prize Singles

A woman overwhelmed by gas is
taken to hospital after the siege of
the Palace of Culture theatre in
Moscow in October. Fifty Chechen
separatists, including 18 women, had
seized control of the theatre during
a performance. They held more than
600 Russian and foreign audience
members hostage, demanding
withdrawal of Russian troops from
Chechnya. After three days of
negotiations with the captors, and
following the killing of two
hostages, Russian troops stormed
the building, having permeated it
with a knock-out gas. All the rebels
and at least 90 hostages died during
the operation, and hundreds were
hospitalized with breathing
difficulties. Authorities refused to
identify the gas, so doctors did not
know what antidotes to administer
and the death toll continued to rise.

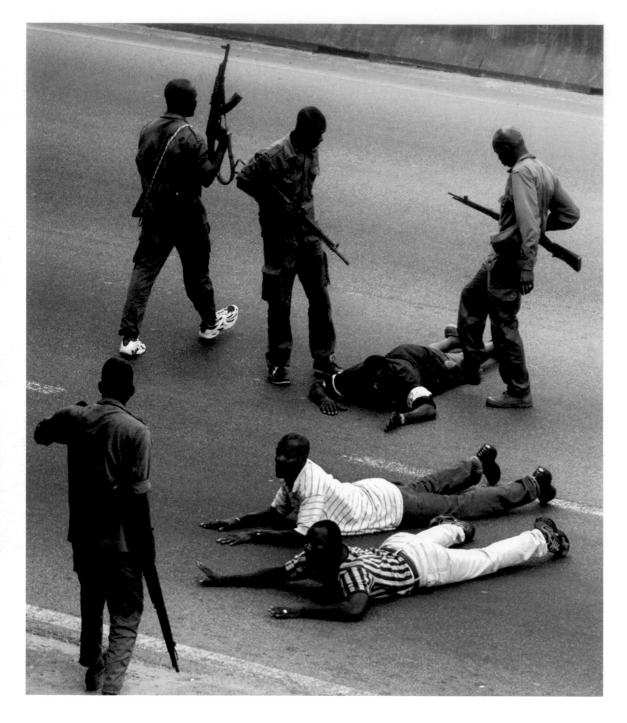

Georges Gobet

France, Agence France-Presse

1st Prize Stories

A military uprising in Ivory Coast in September broadened to encompass others opposed to the government of President Laurent Gbagbo. The mutinous soldiers were joined by northern Muslims, who voiced discontent at what they saw as government discrimination against them. New laws prevented Ivorians with foreign backgrounds from voting, and barred opposition leader Alassanne Ouattara, a northern Muslim, from standing in presidential elections, as it was claimed he was born in Burkina Faso. After the first day of fighting in the original uprising, the mutineers were in control of the northern part of the country, but were later driven out of Abidjan in the south. Above: Soldiers constrain residents of Abidjan on the first day of the military mutiny, close to the camp where the uprising began. Facing page: Demonstrators in Bouaké protest against President Gbagbo. (story continues)

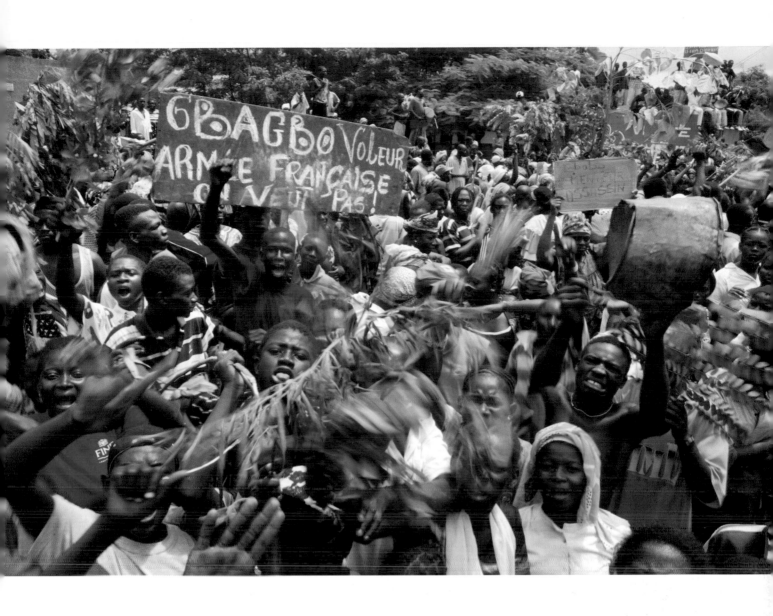

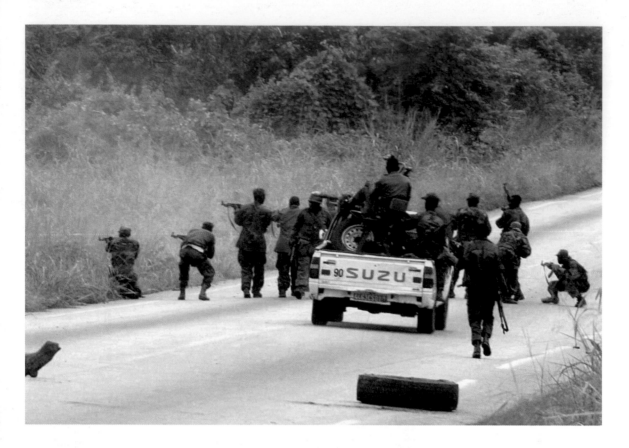

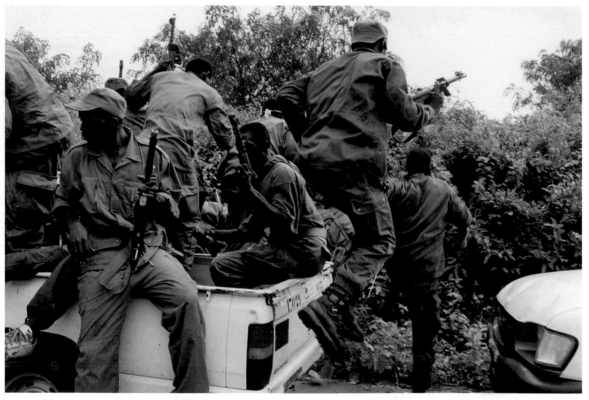

(continued) As the conflict spread, it grew to encompass a number of different rebel groups, mostly based in the north and west of the country. Some reports indicated that fighters from other west-African wars were joining the rebels. France, the former colonial power, later attempted to broker a settlement between government and rebels, and to monitor a cease fire. Top: Rebel forces lead an offensive near the village of Tiebissou, south of Bouaké. Below: New recruits to the rebel movement train in the bush. Facing page: Rebels threaten a government loyalist.

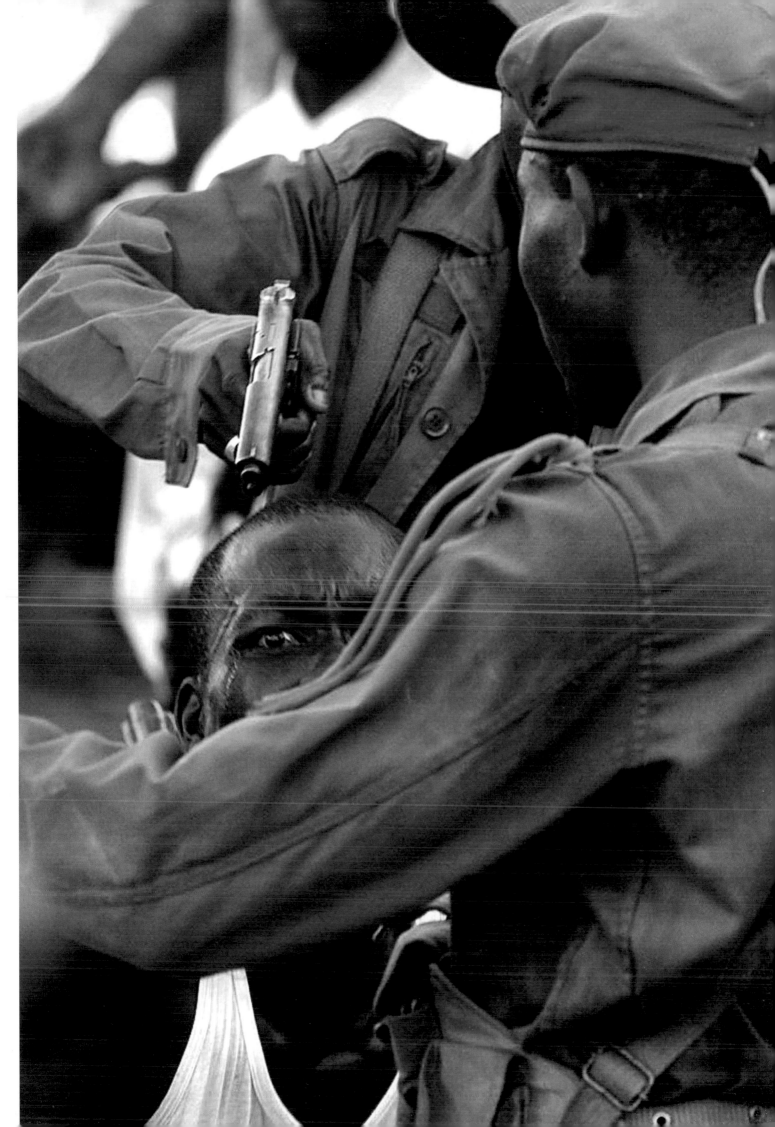

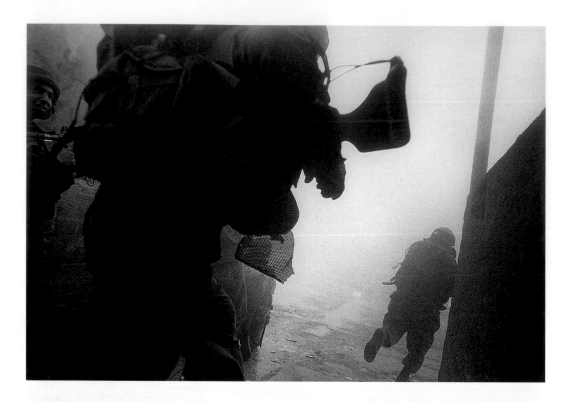

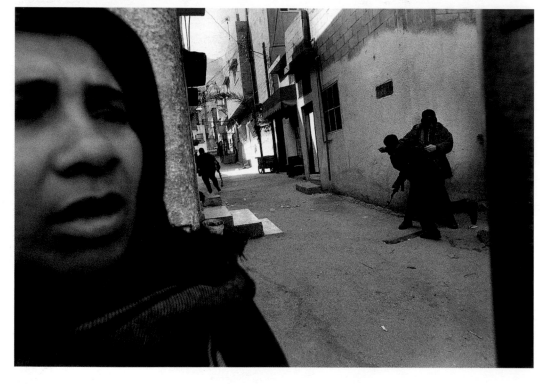

Ilkka Uimonen
Finland, Magnum Photos for Newsweek

2nd Prize Stories

Backed by tanks and helicopter gunships, Israeli troops launched an attack on the Balata Refugee Camp in the West Bank town of Nablus in late February. Nine Palestinians and one Israeli soldier were killed, and more than 90 Palestinians were wounded. Top: Israeli soldiers enter the camp. Below: Palestinian gunmen run towards a school occupied by Israeli soldiers. Facing page, top: Women take cover during fire, outside a house in the Balata camp. Following pages: Israeli soldiers conduct a house-to-house weapons search, and mark searched premises with a Star of David.

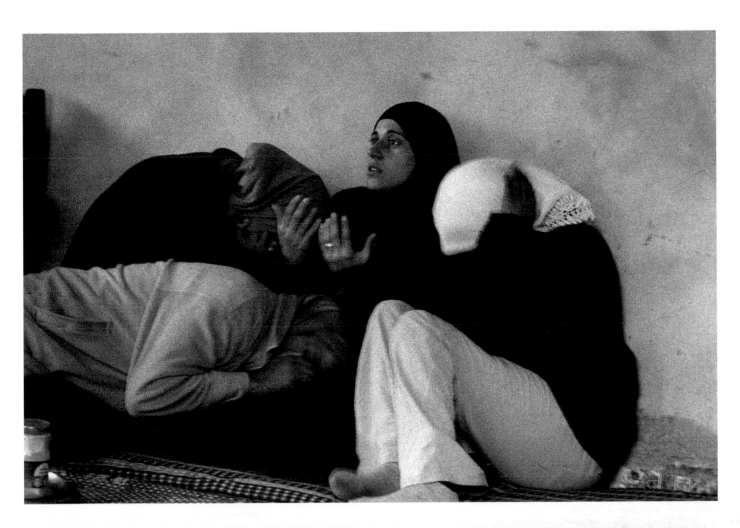

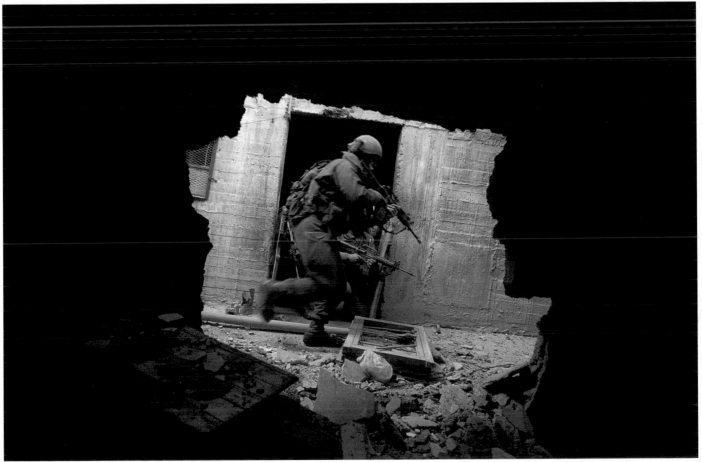

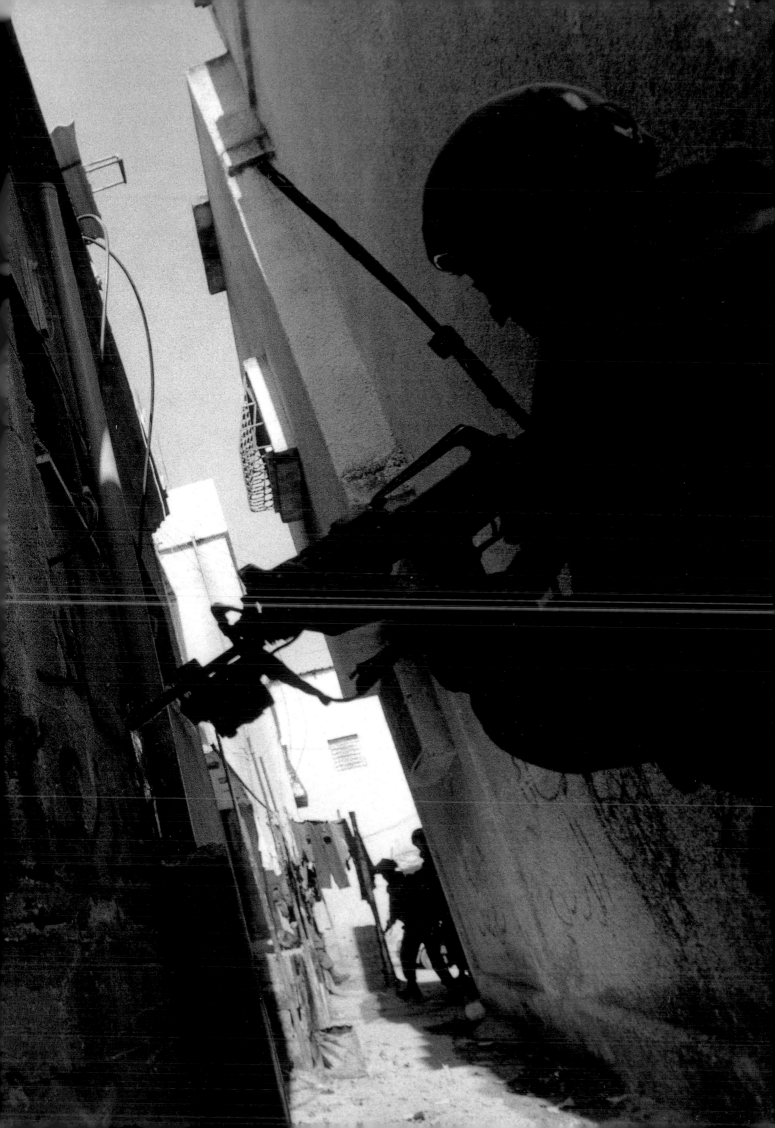

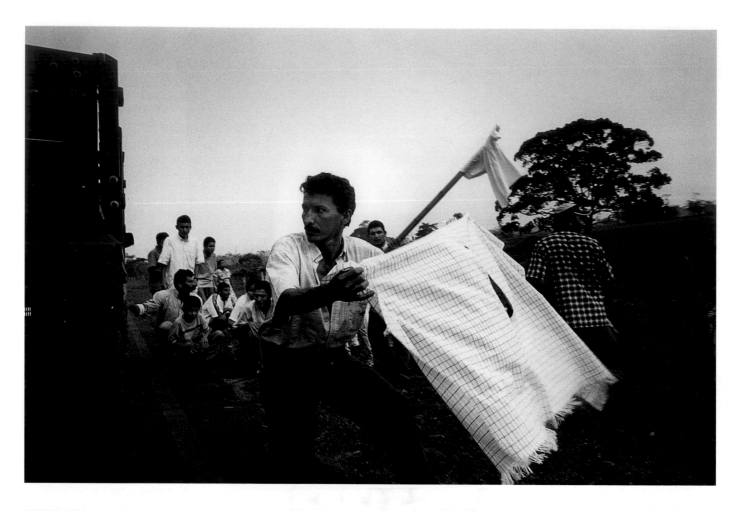

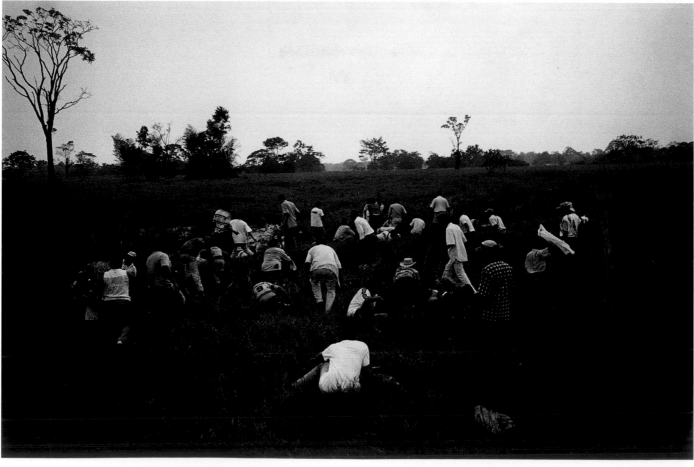

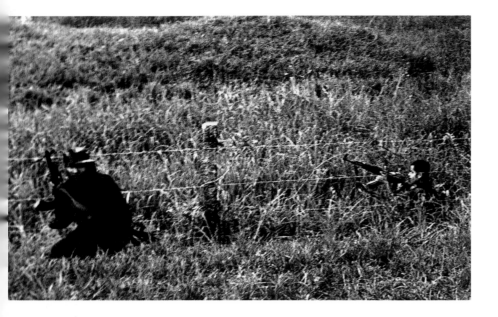

Hector Emanuel
Peru, Agenzia Grazia Neri

3rd Prize Stories

Civilians held at a guerilla roadblock in Colombia in March are caught in crossfire when government troops arrive on the scene. The guerillas of the Revolutionary Armed Forces of Colombia (FARC) form the main left-wing rebel group in the country's 39-year-old civil war. In February, Colombian president Andres Pastrana had ended three years of peace talks with FARC, and government troops had moved to retake the former safe haven, an area officially given over to the FARC during the peace process. The FARC retaliated by launching attacks against urban targets and disrupting infrastructure. Roadblocks such as this one, on the main highway out of the de facto FARC capital San Vicente del Caguán, continued. Far page, top: Civilians wave white flags during crossfire. Below: As fighting intensifies, people run for cover in tall grass nearby. This page, top: FARC guerillas take cover. Below: As FARC guerillas retreat, a father and son flee the scene, leaving their car and belongings behind.

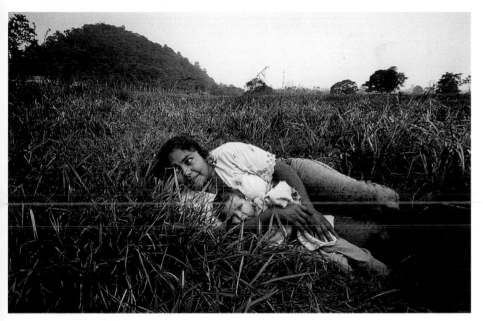

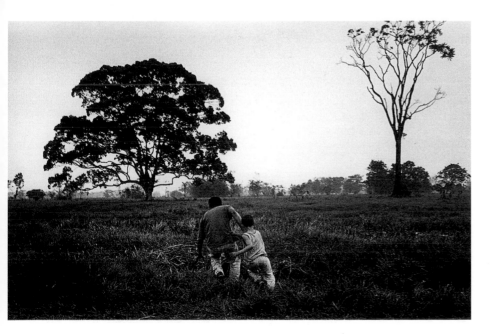

Prizewinners

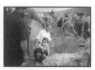

World Press Photo of the Year 2002
Eric Grigorian, Armenia/USA, Polaris Images
Boy mourns at his father's graveside after earthquake, Qazvin Province, Iran, 23 June

Page 4

The World Press Photo of the Year 2002 Award honors the photographer whose photograph, selected from all entries, represents an event, situation or issue of great journalistic importance in that year, and demonstrates an outstanding level of visual perception and creativity.

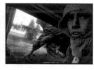

World Press Photo Children's Award
Patrick Andrade, USA, Gamma for Newsweek
Scrambling for charcoal, Kabul, 15 February

Page 12

An international children's jury selects the winner of the Children's Award from the entries for the contest. The jury of schoolchildren is composed of winners of national educational contests, organized by leading media in nine countries.

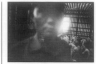

General News Singles
1 Antonin Kratochvil, Czech Republic, VII for The New York Times Magazine
Myanmar prison, May

Page 10

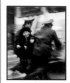

2 Vladimir Pirogov, Kyrgyzstan, Moya Stolitsa/Reuters
Arrest of a demonstrator, Kyrgyzstan, 15 November

Page 11

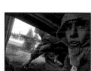
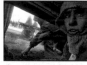

3 Patrick Andrade, USA, Gamma for Newsweek
Scrambling for charcoal, Kabul, 15 February

Page 12

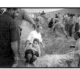
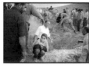

**Honorable mention
Eric Grigorian, Armenia/USA, Polaris Images**
Boy mourns at his father's graveside after earthquake, Qazvin Province, Iran, 23 June

Page 4

General News Stories
1 Jan Dago, Denmark, Magnum Photos/ Alexia Foundation for World Peace
Sierra Leone

Page 14

2 Olivier Mirguet, France, for Le Monde 2
North Korea: a different journey

Page 18

3 Ami Vitale, USA, Getty Images
Riots in Gujarat, India

Page 22

**Honorable mention
Larry Towell, Canada, Magnum**
Jenin: Traces of invasion, May

Page 26

People In The News Singles
1 Scott Lewis, USA, The News & Observer
Yasser Arafat

Page 28

2 Jan Anders Grarup, Denmark, Politiken/Rapho
Liberian refugees in Sierra Leone

Page 29

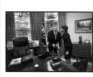
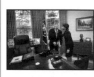

3 Pablo Martínez Monsivais, USA, The Associated Press
Colin Powell and Condoleezza Rice in the Oval Office

Page 30

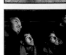

People In The News Stories
1 Carolyn Cole, USA, Los Angeles Times
Inside the Church of Nativity, Bethlehem, May

Page 32

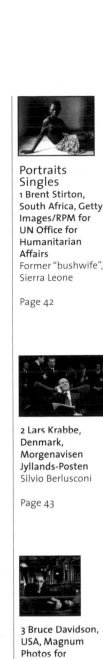

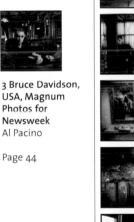

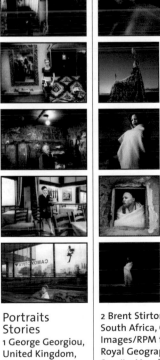

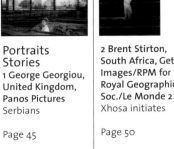

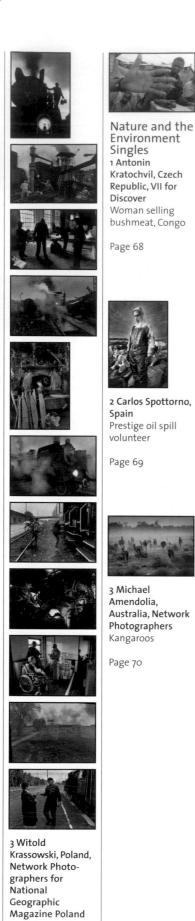

2 David I. Gross, USA
Missing persons: identification of remains, Kosovo

Page 64

3 Witold Krassowski, Poland, Network Photographers for National Geographic Magazine Poland
Last steam railway line

Page 66

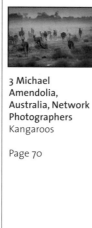

Nature and the Environment Singles
1 Antonin Kratochvil, Czech Republic, VII for Discover
Woman selling bushmeat, Congo

Page 68

2 Carlos Spottorno, Spain
Prestige oil spill volunteer

Page 69

3 Michael Amendolia, Australia, Network Photographers
Kangaroos

Page 70

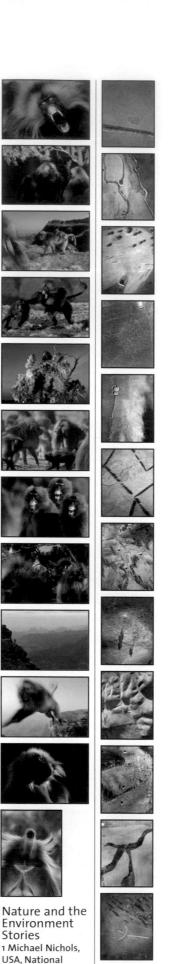

Nature and the Environment Stories
1 Michael Nichols, USA, National Geographic Magazine
Gelada baboons, Ethiopia

Page 72

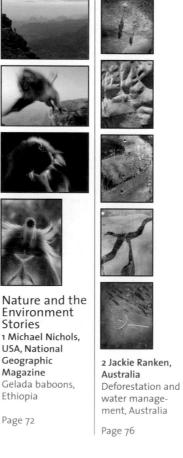

2 Jackie Ranken, Australia
Deforestation and water management, Australia

Page 76

3 Nick Moir, Australia, The Sydney Morning Herald
Sydney fire storm

Page 78

The Arts Singles
1 Dan Winters, USA, for The New York Times Magazine
Leonardo DiCaprio

Page 81

2 Emmanuel Scorcelletti, Italy, Gamma
Sharon Stone at Cannes film festival

Page 82

3 Paolo Porto, Italy, for Thor Productions
Dancer Ines Cera

Page 83

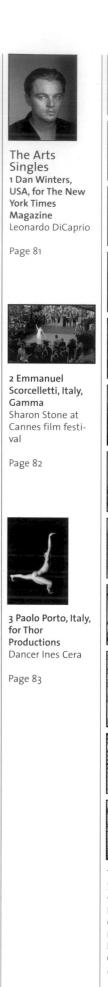

The Arts Stories
1 Peter Bialobrzeski, Germany, Laif Photos & Reportagen for Geo
Megacities of A

Page 84

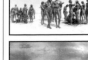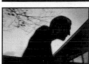

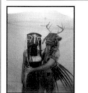

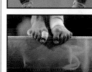

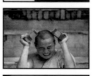

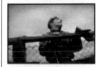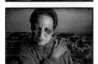

Spot News Singles

1 Tomohisa Kato, Japan, Kyodo News
North Korean asylum seeker at gate of Japanese Consulate General, Shenyang, People's Republic of China, 8 May

Page 124

2 Noël Quidu, France, Gamma for Paris Match
Rebel executes suspected looter, Ivory Coast, 7 October

Page 125

3 Justin Sutcliffe, United Kingdom, The Sunday Telegraph/Images Sans Frontières,
Hostage of Moscow theater siege, 26 October

Page 126

2 Brenda Ann Kenneally, USA, for The New York Times Magazine
Drew

Page 118

3 Heidi Bradner, USA, Panos Pictures
The Nenets of Yamal Peninsula, Russia

Page 122

Spot News Stories

1 Georges Gobet, France, AFP
Ivory Coast, September-October
Page 128

2 Ilkka Uimonen, Finland, Magnum Photos for Newsweek
Balata Refugee Camp, West Bank, 28 February

Page 132

3 Hector Emanuel, Peru, Agenzia Grazia Neri
Civilians caught in crossfire between FARC and government troops, Colombia

Page 136

Participants 2003 Contest

In 2003, 3,913 photographers from 118 countries submitted 53,597 entries. The participants are listed here according to nationality as stated on the contest entry form. In unclear cases the photographers are listed under the country of postal address.

AFGHANISTAN
Zalmaï Ahad
Abdullah Zaheeruddin

ALBANIA
Bevis Fusha
Petrit Kotepano
Marketin Pici
Namik Selmani

ALGERIA
Hamid Seghilani

ARGENTINA
Marcelo Francisco Aballay
Rodrigo Miguel Abd
Martin C.E. Acosta
Burafi Ali
Pablo Aneli
Mariana Araujo
Martin Arias Feijoo
Walter Adrian Astrada
Carlos Barria Moraga
Victor R. Caivano
Sandra Mariel Cartasso
Boris Cohen
Cecilia Fernanda Collia
Ana Carla D'Angelo
Daniel Dapari
Mariano Espinosa
Juan Manuel Ferrari Urrutia
Antonio Ferroni
Daniel Garcia
Anibal Adrian Greco
Claudio Marcelo Herdener
Javier Izuel
Daniel Jayo
José Luis Ledesma
Diego Levy
Alejandro Lipszyc
Martin Eduardo Lucesole
Marcelo Carlos Manera
Juan Medina
Miguel Angel Mendez
Luis Alberto Micou
Jose Abdala Nuno del Valle
Julio C. Pantoja
Natacha Pisarenko
Angel Roberto Pittaro
Mario Horacio Podestá
Ezequiel Pontoriero
Héctor Alejandro Rio Hacho
Graciela Roldán Schuth
Alfredo Raúl Sanchez
Juan Jesus Sandoval
Ricardo J. Santellan de Leon
Jose Enrique Sternber
Omar Torres
Antonio Valdez
Henry von Wartenberg
Hernan Zenteno

ARMENIA
Rustam Agasijnc
German Avagyan
Eric Grigorian
Zaven Khachikyan
Ruben Mangasaryan

AUSTRALIA
Michael Amendolia
Narelle Autio
Bill Bachman
Mark Baker
Robert Barker
Daniel Berehulak
Paul Blackmore
Philip Blenkinsop
Craig Borrow
Philip Brown
Patrick Brown
David Caird
Vince Caligiuri
Glenn Campbell
Ray Cash
Jason Childs
Steve Christo
Warren Clarke
Tim Clayton
Tom Cliff
Trevor Collens
William Crabb
Nick Cubbin
Ian Charles Cugley
Jeffrey Darmanin
Sean Davey
Howard J. Davies
Tamara Dean
Jenny Duggan
Stephen Dupont
Brendan Esposito
Marc Gafen
Rick Gentiluomo
Timothy Georgeson
Ashley Gilbertson
Craig Steven Golding
Steve Gosch
Philip Gostelow
John Grainger
David Gray
Lannon Harley
Lisa Hogben
Stephane-Arnold L'Hostis
Jessica Hromas
Glenn Hunt
Maylei Hunt
Martin Jacka
Quentin Cameron Jones
Wayne Jones
David Kelly
Dallas Ashton Kilponen
Dirk Arthur Klynsmith
Nicholas Laham
Tanya Lake
Ranoy Larcombe
Dean Lewins
Guy Little
Joe Mann
Jesse Marlow
Régis Martin
Belinda Mason-Lovering
Alex Massey
Robert McFarlane
Alistair McGlashan
Chris McGrath
Maree McLachlan
Justin McManus
Samuel McQuillan
Andrew Meares
Andrew Merry
Paul Miller
Palani Mohan
Nick Moir
Claire Michele Mossop
Donna Murty-Todd
Sandy Nicholson
Renee Nowytarger
Barry O'Brien
Norman Oorloff
Trent Parke
David Dare Parker
Geoff Parrington
Darren Pateman
Jack Picone
Jeremy Piper
Bruce Postle
Adam William Pretty
Peter Rae
Paul Raffaele
Jackie Ranken
Tony Reddrop
John Reid
Jon Reid
Simon Renilson
Ilana Rose
Kara Rosenlund
Moshe Rosenzveig
Craig Sadler
Roger Scott
Dean Sewell
Steven Siewert
Matthew Sleeth
Kylie M. Smith
Troy Snook
Kenneth Stevens
Tasso Taraboulsi
Mick Tsikas
Leisa Tyler
Ian Waldie
Colin Whelan
Clifford White
Thomas Wielecki
Gregory Wood
Jonathan Adley Wood
Andy Zakeli

AUSTRIA
Heimo Aga
Michael Appelt
Stephan Boroviczény
Angela Brachetti Tschohl
Rudolf Froese
Arno Gasteiger
Peter Granser
Karl Haimel
Barbara Krobath
Felicitas Kruse
Miro Kuzmanovic
Lois Lammerhuber
Christian Lapp
Franz Neumayr
Helmut Ploberger
Josef Polleross
Franz Reiterer
Reiner Riedler
Chris Sattlberger
Andreas Schaad
Petra Spiola
Wolf Steiner
Werner Thiele
Jozsef Timar

AZERBAIJAN
Haji Akif Agayev
Samedzadeh Chingiz
Rena Effendi
Rafail Ali Gambarov
Rima Gambarova
Mirnaih Hasanoglu
Ilgar Jafarov
Aliyeva Khadija
Abbasov Mehdi
Rafik Nagiyev
Azad Rzayev
Pirizadeh Aydin Sevinc
Shamil Talybov
Ibadov Vugar
Zaur Zeylanov

BANGLADESH
Babul Abdul Malek
Abir Abdullah
Syed Zainul Abedin
Akash
Mohammed Akhlas Uddin
K.M. Jahangir Alam
Abul Fazul MD. Ashraf
Nurjahan Chaklader
Chaw Sein Prue
Nazrul M.N.I. Chowdhury
Debaprasad Das
Shoeb Faruquee
Md Hassan Al-Mamun
Md Delowar Hossain
Md Shahadat Hossain
Shafayet Hossain Apollo
Ibrahim Mohammad Iqbal
Fakrul Islam
Shahidullah Kaiser
Md. Rezaul Quamar Sadi
Kazi Md. Golam Quddus
Mohammed Rafique
Jewel Samad
K. A. Sayeed-uz-Zaman
Rajib Sheikh Rajibul Islam
MD Siraj Miah
G.R. Sohail
Md. Main Uddin
A.K.M. Shehab Uddin
Jamal Uddin Jamal
A.N.M. Zia

BELARUS
Aliaksandr Halkevich

BELGIUM
Layla Aerts
Vincent Berg
Robert Vanden Brugge
Michael Chia
Jean Marc Cransfeld
Tineke D'Haese
Mine Dalemans
Christian Decloedt
Stijn Decorte
Marc Deville
Tim Dirven
Thierry Falise
Benny Fonteyne
Nick Hannes
Peter van Hoof
Tomas van Houtryve
Eddy Kellens
Wim Kempenaers
Catherine Lambermont
Didier Lebrun
Bart Lenoir
Firmin de Maitre
Dario Pignatelli
Philip Reynaers
Dominique Simon
Bruno Stevens
Dieter Telemans
John Thijs
Gaël Turine
Stephan Vanfleteren
Alex Vanhee
Louis Verbraeken
Eva Vermandel
Tim de Waele

BOLIVIA
Willy E. Cortés Hemgler
Patricio Crooker
Pedro Javier Laguna Vacaflor
Enzo Manuel De Lucca
Calderon de la Barca
David G. Ordonez Lozano
Hugo José Suarez Suarez
Max Juan Tancara
Ximena Vazquez Yutronic

BOSNIA-HERZEGOVINA
Andrej Derkovic
Amel Emric
Zijah Gafic
Muhamed Mujkic
Samir Pinjagic
Damir Sagolj
Tarik Samarah
Drago Vejnovic
Dejan Vekic

BRAZIL
George de Almeida Fant
Alan Kardec E. Alves
Reginaldo Alves de Castro
Euler Paixão Alves Peixoto
Debora Amorim
Paulo Amorim
Alberto Cesar Araújo
Bruno de Araújo Domingos
Fabricio Azambuja
Nário Barbosa da Silva
Caetano Barreira
Eduardo E. Bastos Viana
Jamil Bittar
Mario Borges Junior
Otavio Brazil
Oslaim Brito
Jose Caldas
Flavio Cannalonga
Rubens Cardia
Marcelo Carnaval
Ivaldo Cavalcante Alves
Antonio R. Cazzali
Adalmir Chixaro
Clwber de Souza Mendes
Julio Cesar Bello Cordeiro
Ricardo Correa Ayres
Antonio José Cury
Everaldo Lima D'Alverga
Leonardo Dias Corrêa
Milton Vianna Doria
Marcos Ramos Esteves
Robson Fernandes
Davi Fernandes da Silva
Ulysses Fernandes de Freitas
Marcelo Ferreira da Silva
Ari Ferreira do Nascimento
E.P. Ferreira Torres Dos Santos
Marco Antonio Fontes de Sá
Priscila Forone
Eduardo Nicolau Francisco
Dado Galdieri
Luis Eduardo Dado Galdieri
José Gauliski Doval
Luiz Antonio Giope
Michel Gomes
Patrick Grosner
Dulce Helfer
Anja Kessler
Lucas Lacaz Ruiz
Paulo Sergio Liebert Augusto
Ulisses Job Lima
Mauricio Lima
Ricardo Fernandez Lima
Benito Maddalena
Gustavo H. C. Magnusson
Marcos Kiyoshi Honma
Americo Mariano
Eduardo Martino
Gleice Mere
Sergio Moraes
Angelo A. Da Motta Duarte
Fabio Motta Lins
Marta Nascimento
Paulo Henrique Pampolin
Adriano Orlandi Pereira
Paulo Martins Pinto
Pedro Ivo Prates Gomes
F. Quevedo de Oliveira
M. R. de Mendonca e Silva
Ricardo Rimoli
Michela Brigida Rodrigues
Jonne Roriz Concalves
Evaristo Sa
M. E. Sa' Martini Natividade
Paulo César Santos Araújo
Valdevino A. de Silva Jr.
Francisco De Souza
Jean Souza Lopes
V. Guedes Souza Pereira
Leandro Taqwes
Ricardo Teles
Marcelo Figueiredo Theobald
J.Tupinambá Vidal Cavalcante
Ovidio Vieira
Mauro Vieira
José Cláudio Vieira de Souza
Marcelo Vigneron
Luis Tadeu Vilani

BULGARIA
Kameliya Atanasova
Radoslavova
Dimitar Dilkoff
Nellie Doneva
Petar Ganev
Viktor Levi
Stoian Nenov
Oleg Popov
Todor Stefanov Todorov
Ivan Sabev Tzonev
Ivaylo Velev
Vesel Veselinov
Boris Voynarovitch

BURKINA FASO
Mohamadou Gansore
Etienne Kafando
Aristide Ouedraogo

CANADA
Beverley Abramson
Christopher Anderson
Benoit Aquin
Brian Atkinson
Deborah Baic
Martin Beaulieu
Bernard Beisinger
Normand Blouin
Chris Bolin
Zoran Bozicevic
Bernard Brault
Phil Carpenter
Jack Chiang
Dave Chidley
Donald Courchesne
Barbara Davidson
Brent Davis
Frazer Dryden
Bruce Edwards
Candace Elliott
Andre Forget
Gregory Fulmes
Edward Gajdel
Brian James Gavriloff
Roxanne Gregory
Brian Harder
Naomi Harris
Caroline Hayeur
Jonathan Hayward
Philippe Henry
Harry How
John Jakobfi
Emiliano Joanes
Ziba Kazemi
Marko Kokic
Todd Korol
Jean-Francois Leblanc
Rita Leistner
Roger Lemoyne
Jean Levac
Doug MacLellan
John Mahoney
Sylvain Mayer
Allen McInnis
Jeff McIntosh
Gerry Meyers
J.P. Moczulski
Farah Nosh
Gary Nylander
Louise Oligny
George Omorean
Lyle Owerko
Jason Payne
Goran Petkovski
Wendell Phillips
Vincenzo Pietropaolo
Pierre Paul Poulin
Peter Power
Jim Rankin
Marc Rochette
Steve Russell
Derek Ruttan
Babak Salari
Chris Schwarz
Peter Sibbald
Dave Sidaway
Steve Simon
Lana Slezic
Christopher Smith
David W. Smith
Andre Souroujon
Boris Spremo
Lyle Stafford
Michael Stuparyk
Larry Towell
Marcos Townsend
David Trattles
Stephen Uhraney
Kevin Unger
Carl Valiquet
Andrew Wallace
George Webber
Bernard Weil
Stephen Whelan
Simon Wilson
Paolo Orazio Woods
Iva Zimová

CHILE
Orlando Barria Maichil
Marco A. Fredes Cifuentes
Rodrigo E. Garrido Fernández
Ricardo H. Gonzalez Elgueta
Luis Alexis Hidalgo Parra
Christian M. Iglesias Parra
Marco A. Llanos Gonzalez
Juan Eduardo Lopez Villarroel
Rafael R. Martinez Armijo
Fernando Morales
Tomas Munita Philippi
Jaime Patricio Puebla Soto
Carla Andrea Ramirez Soto
Pedro A. Rodriguez Mauven
Mario Ruiz Ortiz
Victor Daniel Salas Araneda
Jorge M. Sanchez Castillo
Pedro Ugarte

Jorge Uzon
Eduardo Alejandro Vargas Sil
Carlos Alberto Vera Mancilla
Claudio A. Vera Ormeño
Frank Villagra

COLOMBIA
Maria Cristina Abad Angel
Luis Cristobal Acosta Castro
Luis Henry Agudelo Cano
Iliana Aponte Tovar
Plinio Elias Barraza Barboza
Felipe A. Caicedo Chacón
Abel E. Cardenas Ortegon
Gerardo Chaves Alonso
Rodrigo Cicery Beltran
Milton Diaz Guillermo
Edgar A. Dominguez Catano
Mauricio Duenas
Javier A. Galeano Naranjo
Martin Edwardo Garcia Pinto
Jose Miguel Gomez Mogollon
Mario A. Hernandez Romero
Julian Alberto Lineros Castro
Albairo Lopera Hoyos
William F. Martinez Beltrán
Mauricio Moreno Valdes
Eduardo Munoz Alvarel
José Manuel Pedraza Salazar
Bernardo Alberto Peña Olaya
Jaime O. Perez Munevar
Marcelo Roldan Toledo
Henry Romero
M. S. Saldarriaga Quintero
Roberto Schmidt
Joana Marcela Toro Mora
Gabriël Jaime Velez Quintero
John Wilson Vizcaino Tobar

COSTA RICA
Carlos Arturo Borbón Castro
Gloria Calderon Bejarano
Mario A. Castillo Navarro
Marco Monge Rodriguez
Juan Carlos Ulate Moya
Kattia P. Vargas Araya
David Vargas Chacon

CROATIA
Filip Horvat
Vlado Kos
Ivan Kovac
Sasa Kralj
Josip Petric
Hrvoje Polan
Drago Sopta

CUBA
José Azel
Cristóbal Herrera Ulashkevich
Jorge López Viera
Alejandro E. Pérez Estrada
Leysis Quesada
Luis G. Quintanal Cabriales
Vladimir Romero Sanchez
Emilio Valdés Espinosa
Liudmila Velasco

CYPRUS
Petros Karatzias

CZECH REPUBLIC
Josef Bradna
Milada Cistonova
Vladimir David
Alena Dvorakova
René Jakl
Radek Kalhous
Antonin Kratochvil
Stanislav Krupar
Lucie Parizkova
Libuse Rudinská
Jan Schejbal
Roman Sejkot
Tomas Svoboda
Jan Symon
Jaroslav Tatek
Jan Trestik
Jiri Urban
Vladimir Weiss
Robert Zakovic
Stanislav Zbynek

DENMARK
Jonas Ahlstroem
Adam Amsinck
Nicolas Asfouri
Jens Astrup
Soren Bidstrup
Michael H. Boesen
Thomas Borberg
Anders Brohus
Finn Byrum
Asger Carlsen
Jakob Carlsen
Jan Dago
Casper Dalhoff
Jens Dresling
Jacob Ehrbahn
Bardur Eklund
Lene Esthave
Jorgen Flemming
Peter Funch
Sinan Gakmak
Jan Anders Grarup
Toke Hage
Tine Harden
Ulrik Jantzen
Adam Jeppesen
Flemming Jeppesen
Nils Jorgensen
Ana Kari
Lars Hauskov Krabbe
Joachim Ladefoged
Claus Bjorn Larsen
Martin Lehmann
Ole Lind
Hanne Loop
Nils Meilvang
Voja Miladinovic
Lars Moeller
Benny Nielsen
Miklas Njor
Ulrik Pedersen
Erik Refner
Morten Rygaard
Henrik Saxgren
Soren Skarby
Betina Skovbro
Michael Svenningsen
Vibeke Toft
Sophie Tondering
Bo Tornvig
Robert Wengler
Martin Zakora

DOMINICAN REPUBLIC
Miguel Gomez

ECUADOR
Angel R. Aquirre Quindo
Francisco P. Bravo Armijos
P. R. Calahorrano Betancourt
B. S. Chambers Herrera
Vicente A. Costales Terán
C. X. Ortega De La Rosa
Galo A. Paguay Becerra
Jorge W. Penafiel Fajardo
Leen Armando Prado Viteri
Edison G. Riofrío Barros
Paul Giovanni Rivas Bravo
Patricio Xavier Teran Argüello
Eduardo Vinicio Teran Urresta
E. A. Vavenzuela Garzón
Jorge Marcelo Vinueza Garcia

EGYPT
Ahmed Amr Nabil
Gamal El-Arabic Mohammed
Mohamed El-Dakhakhny
Wael Kamal El-Din Taha

EL SALVADOR
Carlos F. Alemán Avendano
Carla Rocio Álvarez Vásquez
Diego Barraza Dominguez
José Alberto Cabezas Bernal
Julio César Campos Martinez
Francisco Javier Campos Sosa
Yuri Alberto Cortez Avalos
Milton Flores
Oscar R. Gavidia Hernández
Gabriela Hasbun
Joaquín Vladimir Lara Barrera
Salvador Melendez

José Alberto Morales Palma
Jorge Ulises Morán Rodríguez
Salomón A. Vasquéz Ponce

ERITREA
Girmay Gebremicael Abrama
Ibrahim Ali Haj Idris
Kidane Teklemariam
Tekeste Debru Teklemarian
Daniel Tesfai Kahsai
T. Abraham Tesfamariam

ETHIOPIA
Deneke Metaferia Bernahu
Fasika Ermias Mammo

FINLAND
Henna Aaltonen
Tommi Anttonen
Hannes Heikura
Markus Jokela
Petteri Kokkonen
Juhani Niiranen
Jussi Nukari
Timo Pyykkö
Erkki Raskinen
Jukka Ritola
Kimmo Räisänen
Eetu Sillanpää
Ilkka Uimonen
Tor Wennström

FRANCE
Lahcène Abib
Olivier Adam
Christophe Agou
Guilhem Alandry
William Alix
Patrick Artinian
Patrick Aventurier
Alain Le Bacquer
Georges Bartoli
Jérôme Bärtschi
Patrick Baz
Halim Berbar
Valérie Berta
Virgile Simon Bertrand
Bernard Bisson
Cyril Bitton
Florencia Blanco
Olivier Boëls
Christian Boisseaux-Chical
Samuel Bollendorff
Regis Bonnerot
Jerome Bonnet
Youssef Boudlal
Denis Boulanger
Alexandra Boulat
Hermine Bourgadier
Denis Bourges
Philippe Bourseiller
Eric Bouvet
Gabriel Bouys
Hervé Bruhat
Alexa Brunet
Jean-Pierre Brunet
Jerome Cabanel
Christophe Calais
Alvaro Canovas
Serge Cantó
Patrick Chapuis
Laurent Chardon
Jean-Marc Charles
Marc Charuel
Julien Chatelin
Marc Chaumeil
Eric Chauvet
Olivier Chouchana
Pierre Claquin
Denys Clement
Sebastien Le Clezio
Thomas Coex
Serge Moreno Cohen
Jerome Conquy
Philippe Conti
Scarlett Coten
Vincent Couarraze
Gilles Coulon
Christophe Daguet
Denis Dailleux
Eric Damidot
David Damoison

Julien Daniel
Ljubisa Danilovic
Georges Dayan
Beatrice De Gea
Gautier Deblonde
Regis Delacote
Jerome Delafosse
Luc Delahaye
Jerome Delay
Cyril Delettre
Magali Delporte
Francis Demange
Jacques Demarthon
Michel Denis-Huot
Jeromine Derigny
Philippe Desmazes
Xavier Desmier
Anne-Laure Detilleux
Eric Dexheimer
Gisele Didi
Dominique Dieulot
Fabrice Dimier
Tiane Doan Na Champassak
Stéphane Doulé
Claudine Doury
Marc Dozier
Christophe Dubois
Nicolas Dubreuil
Alexis Duclos
Thierry Dudoit
Frédéric Dufour
André Durand
Laurent Emmanuel
Alain Ernoult
Sebastien Erome
Isabelle Eshraghi
Albert Facelly
Eric Feferberg
Franck Fife
Frédérick Florin
Olivier Föllmi
Serge Fouillet
Mélanie Frey
Patrick Pierre Frilet
Raphaël Gaillarde
Nicolas Gallon
Florence Gaty
Arnaud Gaucher
Oliver Gauthier
Christoph Gin
Pierre Gleizes
Georges Gobet
Marc Gouby
Mathieu Grandjean
Gerard Gratadour
Jacques Grison
Olivier Grunewald
Jean-Paul Guilloteau
Pascal Guyot
Elisa Haberer
Valéry Hache
Philippe Haÿs
Nils Hardeveld
Guillaume Herbaut
Patrick Hertzog
Laurent Houdayer
Philippe Huguen
Frederic Jacquemot
Olivier Jobard
France Keyser
Tadeusz Kluba
Patrick Kovarik
Jean Philippe Ksiazek
Pierre Lablatinière
Brigitte Lacombe
Fréderic Lafarque
Vincent Laforet
Stephane Lagoutte
Abib Lahcéne
Nicolas Lainez
Patrick Landmann
Francis Latreille
Cyril Le Tourneur d'Ison
Ulrich Lebeuf
Didier Lefevre
Gilles Leimdorfer
François Lochon
Christian Franck Lombardi
Tony Lopez
Laurence Louis
Michel Lozano
Michel Luccioni

John Mac Dougall
Gregoire Maisonneuve
Pascal Maitre
Richard Manin
Pierre-Philippe Marcou
Tamar Marjollet
Olivier Martel
Clement Martin
Miguel Mata-Langlois
Pierre Mérimée
Bertrand Meunier
Damien Meyer
Jean-Christian Meyer
Philippe Millereau
Olivier Mirguet
Olivier Morin
Jean Francios Muguet
Jean-Pierre Muller
Roberto Neumiller
Hop Nguyen Manh
Jose Nicolas
Frederic Noy
Emmanuel Ortiz
Tadeusz Paczula
Serge Pagano
Matthieu Paley
Eric Pasquier
Jacques Pavlovsky
Pierre Perrin
Theo Pinganaud
Gerard Planchenault
Guillaume Plisson
Jean-Pierre Porcher
Eric Prinvault
Noël Quidu
Atiq Rahini
Gerard Rancinan
Laurent Rebours
Patrick Robert
Alexis Rosenfeld
Pascal Rostain
Marc Roussel
Johan Rousselot
Olivier Roux
Patrick Roux
Cyril Ruoso
Joël Saget
Erik Sampers
Alexandre Sargos
Frederic Sautereau
David Sauveur
Sylvain Savolainen
Laurent Sazy
Jean-Pierre Schwartz
Pascal Le Segretain
Franck Seguin
Chloe Seguin
Roland Thierry Seitre
Ahmet Sel
Bernard Seny
Thierry Seray
Antoine Serra
Jérome Sessini
Jean-Michel Sicot
Christophe Simon
Fabrice Soulié
Françoise Spiekermeier
Laurent Starzynska
Philippe Taris
Emmanuel Theo
Patrick Tourneboeuf
Eric Travers
Patrick Valasseris
Jacques Valat
Maya Vidon
Dung Vo Trung
Vo Trung Dung
Delphine Warin
Miguel Wendling
Philippe Wojazer
Michael Zumstein

THE GAMBIA
Njie Pamodou

GEORGIA
Tamaz Bibiluri
Konstantin Iantbelidze
Ketevan Mgebrishvili
Ramaz Natsvlishivili

GERMANY
Andrea Artz
Julia Baier
Theodor Barth
Stefan Bau
Andreas Becker
Marion Beckhäuser
Ben Behnke
Wolfgang Bellwinkel
Fabrizio Bensch
Arnold Bernd
Thomas Bernst
Klaus-Dieter Beth
Peter Bialobrzeski
Frank Bierstedt
Andreas Bock
Christoph Boeckheler
Sebastian Bolesch
Stefan Boness
Lutz Bongarts
Karsten Bootmann
Hermann Bredehorst
Gero Breloer
Hans-Peter Brenneken
Ulrich Brinkhoff
Hans Jürgen Britsch
Christian Bruch
Franka Bruns
Jörg Busghmann
Christoph Busse
Jan-Peter Böning
Jörg Böthling
Wolf Böwig
Janni Chavakis
Sven Creutzmann
Peter Dammann
Claudia Daut
Christian Ditsch
Thomas Dworzak
Sven Döring
Winfried Eberhardt
Werner Eifried
Thomas Einberger
Dirk Eisermann
Stephan Elleringmann
Stefan Enders
Hans-Georg Esch
Sibylle Fendt
Christine Fenzl
Jockel Finck
Bettina Flitner
Klaus D. Francke
Henner Frankenfeld
Guido Frebel
Thomas Frey
Mike Froehling
Sascha Fromm
Christoph Gerigk
Markus Gilliar
Jörg Gläscher
Bodo Goeke
Igor Gorovenko
Gosbert Gottmann
Thomas Grabka
Oliver Grottke
Patrick Haar
Michael Hagedorn
Alfred Harder
Alexander Hassenstein
Harald Hauswald
Gerhard Heidorn
Katja Heinemann
Holm Helis
Ilja Clemens Hendel
Katharina Hesse
Markus C. Hildebrand
Annegret Hilse
Ralf Hirschberger
Thomas Hoepker
Helge Holz
Thomas Hosemann
Andreas Hub
Frauke Huber
Wolfgang Huppertz
Karlheinz Jardner
Bernd Jonkmanns
Christian Jungeblodt
Claus Kiefer
Thomas Kienzle
Ulla Kimmig
Herbert Knosowski
Carsten Koall

Vincent Kohlbecher
Reinhard Krause
Tom Krausz
Gert Krautbauer
Ralph Krein
Johannes Kroemer
Dirk Krüll
Christian Kruppa
Andrea Künzig
Jens Küsters
Rainer Kwiotek
Andreas Kämper
Karl Lang
Paul Langrock
Matthias Ley
Andreas Lobe
Dorothea Loftus
Gerd Ludwig
Birgit-Cathrin Maier
Uwe H. Martin
Willi Matheisl
Oliver Meckes
Peter Meissner
Günther Menn
Dieter Menne
Martin Menzner
Jens Meyer
Marcus Meyer
Jörg Modrow
Hardy Müller
Konrad R. Müller
Wolfgang Müller
Heiner Müller-Elsner
Michael Najjar
Anja Niedringhaus
Ralf Niemzig
Axel Nordmeier
Nicole Ottawa
Laci Perenyi
Thomas Pflaum
Claus-Christian Plaass
Sabine Plamper
Marko Priske
Christophe Püschner
Thomas Rabsch
Rainer Raeder
Andreas Reeg
Uli Reinhardt
Jirl Rezac
Sascha Rheker
Martin Richter
Astrid Riecken
Karin Rocholl
Boris Roessler
Daniel Roland
Daniel Rosenthal
Volker Roth
Grischa Rueschendorf
Michael Sakuth
Ottfried Sannemann
Martin Sasse
Sabine Sauer
Deniz Saylan
Rüdiger Schall
Peter Schatz
Achim Scheidemann
Jordis Antonia Schlösser
Axel Schmidt
Harald Schmitt
Heidi Schneekloth
Markus Schreiber
Steffen Schrägle
Bernd Schuller
Stephan Schütze
Tobias Schwarz
Hartmut Schwarzbach
Dieter Schwerdtle
Karsten Schöne
Oliver Sehorsch
Siegfried Seibt
Michael Sieber
Roland Sigwart
Hans Silvester
Stefan Sisulak
Bertram Solcher
Peter Sondermann
Ralph Sondermann
Oliver Soulas
Renado Spalthoff
Martin Specht
Christof Stache
Sören Stache

David Steets
Wolfram Steinberg
Marc Steinmetz
Thomas Stephan
Günter Suchy
Jens Sundheim
Olaf Tamm
Isadora Tast
Andreas Teichmann
Oliver Tjaden
Dieter Tuschen
Markus Ulmer
Guenay Ulutuncok
Lothar Voeller
Stefan Volk
Helmuth Vossgraff
Heinrich Völkel
Florian Wagner
Martin Wagner
Uli Weber
Kai Weidenhöfer
Markus Weiss
Philipp Wente
Sabine Wenzel
Detlef Westerkamp
Sabastian Widmann
Henrik Wiemer
Ann-Christine Wöhrl

GHANA
Forstin Adjei Doku
Thomas Lynn
Salvata Koku

GREECE
Dimis Argyropoulos
Yannis Behrakis
Efstratios Chavalezis
Tina Gionis
Iakovos Hatzistavrou
Yiorgos Karahalis
Athina Kazolea
Yannis Kontos
Eleftherios Kostans
Kosmas Lazaridis
Tzekas Leonidas
Kassimatis Manolis
Stelios Matsagos
Aris Messinis
Stefania Mizara
Chryssa Panousiadou
Athanasios Papadopoulos
Lefteris Pitarakis
Michalis Sourlis
Stavrakis Thanassis
Sophie Tsabara
John Vellis

GUATEMALA
Jesus Alfonso Castaneda
Andrea L. Aragon Mejicano
Moises Castillo
Luis Garcia
Sandra V. Sebastian Pedro

HONDURAS
Orlando Sierra

HONG KONG, S.A.R. CHINA
Lei Jih Sheng
David Wong Chi Kin

HUNGARY
László Balogh
Ivan Benda
Bela Doka
Tivadar Domaniczky
Tibor Dombovari
Imre Földi
Balázs Gárdi
Pal Geleta
Jozsef Gjarmati
Czimbal Gyula
Peter Harsanyi
Attila Kisbenedek
Attila Kovács
Tamás Kovács
Soós Lajos
Zoltan Molnar
Tamás Révész
Balázs Róbert Zsolt
Andrea Schmidt

György M. Soós
Judith Stow
Peter Szalmás
Bela Szandelszky
Jozsef L. Szentpeteri
Koszticsak Szilard
Illyés Tibor
Zoltan Vancso
Sandor Vig
Péter Zádor

ICELAND
Jóhann Kristjánsson
Finnbogi Marinosson

INDIA
Pradip Adak
Piyal Adhikary
Ajay Aggarwal
Ali Arshad
Shashikant Bajpai
Mohan Dattaram Bane
Dilip Banerjee
Tarapada Banerjee
Sumant Barooah
Shyamal Basu
Kamalendu Bhadra
Gopal Bhattacharjee
Jayanta Bhattacharyya
A.K. Bijoraj
G. Binu Lal
Gautam Bose
P.C. Chacko
Rahul Chandawarkar
Anindya Chattopadhyay
Rajan Chaughule
Kamal Jeet Chugh
Sebastian D'Souza
Saurabh Das
Shantanu Das
Arko Datta
Suman Datta
Rajib De
P. Raghavan Devadas
Pradeep Dhivar
Tony James Dominic
Gajanan Dudhalkar
Jaganathanan Durai Raj
Arindam Ghosh
Subhendu Ghosh
Alok Bandhu Guha
Viajayanand Gupta
Santosh Harhare
Katragadda Harikrishna
Vyas Himanshu
Fawzan Husain
R.S. Iyer
Rajeev Jain
Jayakrishnan
N. Panicker Jayakumar
Shan Jayakumar
N.P. Jayan
Vibi Job
Kalariyammakal J. Jose
Jain Kader
Atul Kamble
Jyoti Kapoor
Rajan Karimoola
Hemant Kataria
Vikas Uddhav Khot
Girish Kingar
Kamal Kishore
Salil Kumar Bera
Mahadevan Lakshman
Atul Loke
Balan Madhavan
Shyamal Maitra
Sailendra Mal
Sham Manchekar
Johnson Mandumbal Kuriyan
Sameer Markande
Pramod Mistry
Aloke Mitra
S.K. Mohan
K. Mohanan
Bhaskar Mukherjee
Indranil Mukherjee
Shailesh Mule
Babu Murali Krishnan
James Sundar Murthy
Chowdavarapu Narayana Rao
Suresh Narayanan

Kedar Nene
Dave Nirav
Chandrakant Palkar
Josekutty J. Panackal
Dinesh Parab
Mukesh Parpiani
C.B. Pradeep
Bhagya Prakash
Neeraj Priyadarshi
Altaf Qadri
Mustafa Quraishi
Abdul Rahman
Ashish Raje
S.S. Ram
Ashish Rane
Shailesh Raval
M. Ravindranath
Kushal Ray
Samuel Robinson
Dominick Rodriques
Suman Sarkar
K. Sasi
Ghosh Satyaki
Bijoy Sengupta
Hemendra A. Shah
Basu Shome
Dinesh Shukla
Ajoy Sil
Brijesh Kumar Singh
Gautam Singh
Prakash Singh
Rajib Singha
Kailash Soni
Om Prakash Soni
Arun Sreedhar
Tamma Srinivasareddy
Anantha Subramanyamik
Adesara Sunil
J. Suresh
K.K. Suresh
Manish Swarup
Pardeep Tewari
Bino Thomas
Vibhash Tiwari
Ch. Vijaya Bhaskar Venkata
Satya Rao
Krishnappa Venkatesh
Remanan Jayamma Vishnu
Keshava Vitla

INDONESIA
Achmad Deni Salman
Agung Prabowo
Bambang A Fadjar
Tantyo Bangun
Arie Basuki
Beawiharta
Oka Budhi
Ali Budiman
Bernard Chaniago
Ade Dani Setiawan
Iwan Darmawan
Aryono Huboyo Djati
Iman Dwianto Nugroho
Riza Fathoni
Hariyanto
Rendra Hernawan
Afriadi Hikmal
Fernandez Hutagalung
I Komang Arba Wirawan
Bagus Indahono
Kemal Jufri
Iwayan Juniartha
Ralph Kholid
Pujianto Johan Leo
Roberto Maldonado
Mosista Pambudi
Pang Hway Sheng
Erik Prasetya
Edy Purnomo
Fadjar Roosdianto
Yayat Ruhiat
Dwi Setyadi
Poriaman Sitanggang
Sinartus Sosrodjojo
Taufik Subarkah
Subekti
Arief Suhardiman Sutardjo
E. Fiap Sutrisna Ramli
Wibudiwan Tirta Brata
Winarno Tjitra
Nuraini Widya Tjitra

Didi R. Wahyudi Rahardjo
Wasis Wobowo
Bagong Zelphi

IRAQ
Sameer Taha Ahmad
Ali Jassim Al-Nawfali
Zuhair Kadhim Al-Sudani
Toran Adham Ali
Saleh Muhsin Al-Samawi
Ibrahim S. Nadir
Lu'ay Sabah AL-Shekli
Fuad Shaker
Ali Talib

IRELAND
Marcus Bleasdale
Laurence Boland
Desmond Boylan
Deirdre Brennan
Seamus Conlan
Kieran Doherty
Colman Doyle
Denis Doyle
Michael Dunlea
Noel Gavin
Eric Luke
Dara Mac Dónaill
Denis Minihane
Seamus Murphy
Jeremy Nicholl
James O'Kelly
Declan Shanahan
Paul Stewart
Eamon Ward
Clive Wasson

ISLAMIC REPUBLIC OF IRAN
Arash Akhtari Rad
Ali Reza Attariani
Ebrahim Bahrami
Maryam Bakhshi
Majid Dozdabi Movahed
Javad Erfanian Aalimanesh
Amel Bordbar Faramarz
Mohammad Farnoud
Vaghari Ghadir
Amir Hoshyar Ghassemnejad
Mahmood Ghavampoor
Mansooreh Hajihosseini
Seyed Hamid Hashemi
Seid Reza Hashemi
Seyedi Jalil Hosseini Zahraii
Siamak Imanpour
Hashem Javadzadeh
Kamran Jebreili
Ali Karimi Rastegar
Kaveh Kazemi
Majid Khamseh Nia
Reza Khazali
Mohamad Kochak Pour
Soleyman Mahmoodi
Moslem Mahmoudian
Karim Malak Madani
Hadi Mehdizadeh
Valiollah Mohammadi
Mehdi Monem
Morteza Mousavi
H. Neshat Mobini Tehrani
Nazi Nivandy
Ali Pourmahmood
Morteza Pournejat
Saeed Rezania
Amir Rostami
Payam Rouhani
Majid Saeedi
Vahid Salemi
Mohsen Sanei Yarandi
Hamid Reza Sedighy
Seyed Ali Seyedi
Shahin Shahablou
Sheikh Mahmoudi Soroush
Pooyan Tabatabaei
Abbas Takin
Alfred Yaghobzadeh

ISRAEL
Ravid Biran
Jonathan Bloom
Rina Castelnuovo
Orel Cohen
Ra'anan Cohen

Gil Cohen Magen
Nir Elias
Eddie Gerald
Yoav Guterman
Israel Hadari
Eitan Hess-Ashkenazi
Gustavo Hochman
Nir Kafri
Menahem Kahana
Yariv Katz
Alex Kolomoisky
Ziv Koren
Miki Kratsman
Ronen Lidor
Ilan Mizrahi
Nadav Neuhaus
Barak Oserovitz
Ata Oweisat
Inbal Rose
Gur Salomon
Ariel Schalit
Shaul Schwarz
Ahikam Seri
Ariel Tagar
Mara Tamaroff
Netta Tauber
Gali Tibbon
Eyal Warshavsky
Pavel Wolberg
Oker Yizhar
Ronen Zvulun

ITALY
Francesco Acerbis
Salvatore Alagna
Alessandro Albert
Marco Albonico
Michele Annunziata
Roberto Arcari
Claudio Auriemma
Alfio Aurora
Antonio Baiano
Luca Baldassini
Luigi Baldelli
Isabella Balena
Alessandra Benedetti
Rino Bianchi
Paolo Bona
Tommaso Bonaventura
Marcello Bonfanti
Alberto Bortoluzzi
Enrico Bossan
Roberto Brancolini
Giovanni Del Brenna
Francesco Broli
Roberto Caccuri
Davide Caforio
Jean Marc Caimi
Silvio Canini
Stefano Cardone
Marco Casale
Davide Casali
Luciano del Castillo
Lorenzo Castore
Sergio Cecchini
Grazia Cecconi
Carlo Cerchioli
Daniela Cestarollo
Giuseppe Chiucchiú
Francesco Cinque
Lauria Ciro
Francesco Cito
Pier Paolo Cito
Francesco Cocco
Elio Colavolpe
Dario Coletti
Antonino Condorelli
Mauro Corinti
Matt Corner
Marzia Cosenza
Alessandro Cosmelli
Giorgio Cosulich
Vincenzo Cottinelli
Claudio Cricca
Marco Cristofori
Pietro Cuccia
Fabio Cuttica
Mauro D'Agati
Enrico Dagnino
Daniele Dainelli
Andrea Dapueto
Marco Di Lauro

Barile Domenico
Dario de Dominicis
Alfonso E. Dossi De Gregoris
Perazzini Ettore
Silvia Fabbri
Flavia Fasano
Gughi Fassino
Massimiliano Fornari
Ermanno Foroni
Franco Fracassi
Adolfo Franzò
William Gemetti
Vince Paolo Gerace
Corrado Giambalvo
Pietro Di Giambattista
Alberto Giuliani
Nicola Giuliato
Francesco Giusti
Giuliano Grittini
Gianluigi Guercia
Franz Gustincich
Guido Harari
Mario Laporta
Beatrice Larco
Saba Laudanna
Alessandro Lazzarin
Paolo Leone
Elio Lombardo
Marco Longari
Ruggero Lorenzi
Armando Di Loreto
Fabio Lovino
Stefano de Luigi
Stefano Lunardi
Nicola Lux
Alessandro Majoli
Jo Mangone
Antonio Mannu
Fausto Marci
Claudio Marcozzi
Luca Marinelli
Matteo Marioli
Carlo Marras
Andrea di Martino
Enrico Mascheroni
Roberto Masi
Massimo Mastrorillo
Daniele Mattioli
Andrew Medichini
Giovanni Mereghetti
Dario Mitidieri
Davide Monteleone
Silvia Morara
Alberto Moretti
Loredana Moretti
Emanuele Mozzetti
Giulio Napolitano
Alberto Novelli
Antonello Nusca
Piero Oliosi
Oliviero Olivieri
Maurizio Orlanduccio
Agostino Pacciani
Franco Pagetti
Stefano Paltera
Bruno Pantaloni
Eligio Paoni
Stefano Pavesi
Fabrizio Pesce
Maurizio Petrignani
Vincenzo Pinto
Antonio Pisacreta
Alberto Pizzoli
Piero Pomponi
Paolo Porto
Giancarlo Pradelli
Gianluca Pulcini
Giuliano Radici
Sergio Ramazzotti
Marco Rigamonti
Paolo Righi
Alessandro Rizzi
Roberto Rognoni
Elisa Romagnoli
Andrea Sabbadini
Ivo Saglietti
Andrea Samaritani
Sandro Santioli
Gianluca Santoni
Patrizia Savarese
Antonio Scattolon
Hannes Schick

Stefano Schirato
Massimo Sciacca
Ferdinando Scianna
Emmanuel Scorcelletti
Fabio Sgroi
Shobha
Paolo Siccardi
Gianluca Simoni
Massimo Siragusa
Mario Spada
Mauro Spanu
Giuseppe Terrigno
Alessandro Tosatto
Moreno Di Trapani
Giampiero Turcati
Marco Vacca
Antonio Vacirca
Paolo Ventura
Riccardo Venturi
Stefano Veratti
Paolo Verzone
Fabrizio Villa
Paolo Volponi
Daniel Dal Zennaro
Francesco Zizola
Pietro Zucchetti
Marko Zupone

JAMAICA
Ian Allen
Rudolph Brown
Norman Grindley
Michael Sloley

JAPAN
Tetsuji Asano
Taketazu Atsushi
Takao Fujita
Masaru Goto
Noboru Hashimoto
Ryuichi Hirokawa
Masako Imaoka
Yasuto Inamiya
Itsuo Inouye
Takaaki Iwabu
Teru Iwasaki
Katsumi Kasahara
Tomohisa Kato
Chiaki Kawajiri
Takao Kitamura
Thoshifumi Kitamura
Toyokazu Kosugi
Hironori Miyata
Toru Morimoto
Kenichi Murakami
Koichi Nakamura
Takuma Nakamura
Yaegashi Nobuyuki
Kazuhiro Nogi
Yasuhiro Ogawa
Yoshikazu Okunishi
Yuzuru Oshihara
Nobuko Oyabu
Takashi Ozaki
Sae Kani
Q. Sakamaki
Ko Sasaki
Atsushi Shibuya
Ekisei Sonoda
Chitose Suzuki
Ryuzo Suzuki
Kuni Takahashi
Yasuhiro Takami
Yuzo Uda
Kiyohumi Yamaguchi
Toru Yamanaka
Yuichiro Yanome
Jun Yasukawa
Mitsu Yasukawa

JORDAN
Osama Abughanim
Iyad Ahmad
M. Awad Ammar Jamil
Awad Awad
Isam Bino
Mohamed A.A. Salamah

KENYA
Anthony Kaminju
Noor Khamis
John Nganga

Omondi Onyango
Khamis Ramadhan
Eric Santos
Abdul Azim Sayyid
Khalil Senosi
Shadrack Otieno Ochieng

KYRGYZSTAN
Sagyn Ailchiev
Erkin Boljurov
Vladimir Pirogov

LATVIA
Andris Kozlovskis
Janis Pipars
Alnis Stakle
Vadims Straume

LEBANON
Mustapha Elakhal
Wael Hamadeh
Teddy Moarbes
Rabih Moghrabi

LIBYA
Marwan Naamani

LITHUANIA
Ramunas Danisevicius
Edis Jurcys
Tomas Kapocius
Petras Katauskas
Tomas Kaunecras
Kazimieras Linkevicius
Rolandas Parafinavicius
Andrius Repsys
Jonas Staselis
Ivanovas Vladimiras

LUXEMBOURG
Claude G. Diderich

MACEDONIA F.Y.R.O.M.
Ivan Blazhev
Petr Stojanovski

MADAGASCAR
Jean Lucien Ravonjiarisoa
Narivololona

MALAYSIA
Sawlihim Bakar
Anuar Bin Che Amat
Chen Chiang Loh
Art Chen Soon Ling
Chong Voon Chung
Goh Chai Hin
Abdullah Jaafar
Lee Keng Siang
Koh Kok Hwa
Jimin Lai
Leong Leong Chun Keong
Liew Wei Kiat
Bazuki Muhammad
Zainudin Noor Azizan
Vincent Thian
Aswad Yahya
Yau Choon Hiam

MALI
Yaya Alpha Diallo

MALTA
Michael Ellul
Matthew Mirabelli
Darrin Zammit Lupi

MAURITIUS ISLAND
Georges Michel

MEXICO
Daniel Aguilar Rodriguez
Hector A. Aguilar Sanchez
Alvarado Badillo
Miguel Alvarez
Juan C. Alvarez Senderos
Hector Amezcua
Jerónimo Arteaga-Silva
Julio César Asencio Gonzalez
Alfonso Carrillo Cazquez
Ulises Castellanos Herrera
Jorge Fabian Castillo Saldana

Luis Vicente Castillo Vazquez
Jesus R. Cebada Garubay
Claudio Cruz Valderrama
Elizabeth Dalziel
Elizabeth Esguerra
Alfredo Estrella Ayala
Tonatiuh Figueroa Monterde
Allan Fis Grossman
Daniel Gasca Velázquez
Maya Goded Colichio
Ramón Gonzalez Gutierrez
Hector Guerrero Skinfill
Carla Häselbarth Lopez
Charles Eric Anoré Jervaise
Pericles Lavat Guinea
Gerardo Leon Garcia
Elisa Lipkau Henriquez
Eric Lopez Vega
Jesus A. Martinez Garcia
Victor Mendiola Galván
Danilo A. Morales Contreras
Guadalupe J. Perez Perez
Carlos Porraz Sánchez
Miguel Ramirez Reyes
Arturo Ramos Guerrero
Rafael del Rio Chávez
Israel Rosas Camarena
Oscar M. Ruizesparza Herera
Oscar Salas Gómez
Eugenio Salas Orozco
Enrique Sifuentes Ramos
Abel Uribe
Enrique Valero
Eloy Valtierra
Rodolfo Valtierra Rubalcava
Luis Alberto Vilchez Pella

MOROCCO
Hamid Ben Thami

NEPAL
Ghale Bahadur Dongol
Deependra Bajracharya
Mukunda Kumar Bogati
Bajracharya Kaushal Ratna
Madan Kumar Panday
Naresh Kumar Shrestha
Dinesh Maharjan
Chandra Shekhar Karki
Prasant Shrestha
Sagar Shrestha

THE NETHERLANDS
Johannes Abeling
Jan Banning
Shirley Barenholz
Maurice Bastings
Frank van Beek
Jeroen van Bergen
Marcel G.J. van den Bergh
Yvonne van der Bijl
Peter Blok
Chris de Bode
Joris Jan Bos
Morad Bouchakour
Jeroen Bouman
Henk Braam
Paul Breuker
Dick Broekema
Fjodor Buis
Gitta van Buuren
Erik Christenhusz
René Clement
Rachel Corner
Peter Dejong
Kees van Dongen
Mathilde Dusol
Ilse Frech
Sandra Gallo
Hagit Gelber
Robert Goddijn
Martijn van de Griendt
Michel de Groot
Marco de Groote
Robbert Hagens
Hans Heus
Bastiaan Heus
Peter Hilz
Wim Hofland
Ronald de Hommel
Pieter ten Hoopen
Hans Hordijk

Pieter van der Houwen
Rob Huibers
Vincent W. Jannink
Justin Jin
Martijn de Jonge
Ama Kaag
Karijn Kakebeeke
Geert van Kesteren
Chris Keulen
Arie Kievit
Wim Klerkx
Toussaint Kluiters
Cor de Kock
Ton Koene
Erik Kottier
Jeroen Kroos
Gé-Jan van Leeuwen
Frans Lemmens
James van Leuven
Anke Ligteringen
Jaco van Lith
Kadir van Lohuizen
Emile Luider
Hein van Maasdijk
Alexander Marks
Michel Mees
Eliane Muskus
Erik-Jan Ouwerkerk
Maya Pejic
Mladen Pikulic
Patrick Post
Bernadet de Prins
Jeroen Putman
Antonio Quintero
Martin Roemers
Gerhard van Roon
Diana Scheilen
Paul van der Stap
Ruud Taal
Ella Tilgenkamp
Sven Torfinn
Robin Utrecht
Catrinus van der Veen
Sander Veeneman
Arnold Vente
Richard Vissers
Robert Vos
Klaas-Jan van der Weij
Eddy van Wessel
Emily Wiessner
Vincent van de Wijngaard
Herman Wouters
Daimon Xanthopoulos
Rop Zoutberg
Mark van der Zouw

NEW ZEALAND
Scott Barbour
Craig Baxter
Jocelyn Rae Carlin
Bruce Connew
Andrew Cornaga
Geoff Dale
Marion Van Dijk
Nicola Dove
Janet Durrans
Mark Dwyer
David Hancock
Jimmy Joe
David M. Kerr
Robert Marriott
Adrian Molloch
Peter James Quinn
Phil Reid
Martin de Ruyter
Dwayne Senior
Mark Taylor
Sandra Teddy
William West

NICARAGUA
Rossana Lacayo Hersuedas
Jeronimo Francisco Oporta

NIGERIA
Ademola Abayomi Akinlabi
Mustapha Kadarallah Areola
Kingston O. Daniel
Bade Daramola
George Esiri
Kehinde O.M. Gbadamosi
Olumuyiwa Hassan

C. Ikeanyi Chinyere Adaku
Taiwo Oladipupo
Joseph Bioye Oyewande
Alade Sam Olusegun
Adedeji Sunday Olufemi

NORWAY
Odd Andersen
Oddleiv Apneseth
Lise Aserud
Jonas Bendiksen
Stein Jarle Bjorge
Pal Christensen
Tomm Wilgaard Christiansen
Bjorn Steinar Delebekk
Helene Fjell
Kai Flatekval
Arnt E. Folvik
Jan Tore Glenjen
Pal Christopher Hansen
Jonterse Hellgren Hansen
Harald Henden
Frode Johansen
Frank Chr. Kvisgaard
Daniel Sannum Lauten
Bo Mathisen
Anders Minge
Mimsy Moller
Janne Moller-Hansen
Aleksander Nordahl
Ken Opprann
Espen Rasmussen
Frederik Refvem
Rune Saevig
Helge Skodvin
Espen Rost Stenerud
Knut Egil Wang

PAKISTAN
Khan Asghar
Zahid Hussein

PALESTINIAN TERRITORIES
Loay Abu Haykel
Musa Al-Shaer
Jamal Aruri
Adam Daud
Rula Halawani
Ahmed Jadallah
Abid Katib
Abbas Momani
Nasser Nasser
Fayez Nuraldin
Abed Omar Qusini
Mohammed Saber
Osama Silwadi

PANAMA
Alvaro Reyes Nunez

PEOPLE'S REPUBLIC OF CHINA
Cao Wei Song
Cao Yu Yuan
Chang Gang
Chen Bao Sheng
Chen Da Yao
Chen Feng
Chen Gang
Chen Gang
Chen Gensheng
Chen Hai Ping
Chen Jie
Chen Qinggang
Chen Xu Chang
Chen Zhi Wei
Chen Zhiqiang
Cheng Bing Hong
Cheng Heping
Cheng Tieliang
Chenghua Gao
Chiang Yung-Nien
Cui Bo Qian
Cui Zhi Shuang
Cun Yun Zhou
Dalang Shao
Deng Jia
Ding Weiguo
Dong Zhi Xiang
Du Bin
Fan Ying
Feng Ning

Gao Chong
Gao Erqiang
Gao Feng
Gao Ming
Gao Wei
Gaohua Zheng
Gu Xiao Lin
Gu Xumin
Guan Haitong
Guan Teng
Guan Yuankang
Guo Bailin
Guo Jianshe
Guo Tao
Guo Zhen Giang
Hai Long
Han Xuezhang
He DeLiang
He Haiyang
Hei Feng
Hong Guang Lan
Hu Jinxi
Hu Longzhao
Hu Qing Ming
Hu Weiming
Hu Yunsheng
Huang Jingda
Huang Yiming
Huang Yue-Hou
Huaqiang Zhao
Ji Cheng
Jia Guorong
Jia Ruiqing
Jiang Zhen Qing
Jianping Ye
Jin Liwang
Jin Si Liu
Jin-Hua Xia
Edward Ju
Ju Guangcai
Kang Taisen
Leng Rai
Li Fan
Li Haijun
Li Jiangcong
Li Jie
Li Jie Jun
Li Lin Lin
Li Mao Sheng
Li Ming
Li Xiaogang
Li Xiaoguo
Li Xin
Li Xinfeng
Li Zengi
Li Zhonghua
Liang Daming
Liao Wen Jing
Lin Yong Hui
Liu Aimin
Liu Dajia
Liu Gen Tan
Liu Jie
Liu Jin
Liu Liqun
Liu Shi Cong
Liu Shujin
Liu Wei
Liu Wei Qiang
Liu Yingyi
Liu Zhenqing
Lu Bei Feng
Lu Dao Xin
Lu Guang
Lu Xu Gang
Man Huiqiao
Mao Shuo
Robert Ng
Ning Zhou Hao
Pan Guoji
Pang Zheng Zheng
Peng Hui
Peng Lian
Pingping Zheng
Qi Hui
Qi Jieshuang
Qi Xiaolong
Qian Jinsong
Qijie Shuang
Qin Datang
Qin Wengang
Qingi Cao

Qiu Xiao Wei
Qiu Yan
Qungang Chen
Ran Yujie
Ren Shi Chen
Ren Xi-hai
Sa Pen-Cheng
Shao Kaiyuan
Shao Quanhai
Qilal Shen
Sheng Jiaping
Shi Jianxue
Shiliang Wang
Stefan Sobotta
Song Bujun
Song Gang Ming
Song Yang
Sun Haitao
Sun Jie
Sun Jun
Sun Liansheng
Sun Lin
Sun Ming Hong
Sun Ping
Sun Zhijun
Tian Fei
Tian Yu Wang
Tong Jiang
Oliver Tsang Wai Tak
Wan Chun
Wang Chen
Wang Jianying
Wang Jie
Wang Jingchun
Wang Li Nan
Wang Mianli
Wang Ri Xin
Wang Rui Lin
Wang Ruilin
Wang Shi Jun
Wang Tie Heng
Wang Xin Ke
Wang Xiwei
Wang Yan Zhong
Wang Yao
Wang Zhouze
Wei Hai-Zhou
Wen Xiao Han
Li Wending
Wu Fang
Wu Huang
Wu Niao
Wu Xue-hua
Wu Zhonglin
Wy Dong Yang
Xiao Huai Yuan
Xiao Jie
Xiao Lian-cang
Xiao Yunji
Xiaozhong Zhou
Xie Lin
Xie Minggang
Xiong PingXiang
Xishan Chen
Xu Jian Hua
Xu Jianrong
Xu Kangrong
Yan Bailiang
Yang Ming
Yang Peirong
Yang Shen
Yang Shu
Yang Xiaogang
Yang Yankang
Yao Fan
Ying Tang
Yu JianCheng
Yu Quanxing
Yuan Jingzhi
Yukui Huang
Yunhe Sun
Zeng Nian
Zhan Xiaodong
Zhang Deng Wei
Zhang Dou
Zhang Feng
Zhang Guojun
Zhang Hongjiang
Zhang Jie
Zhang Jun Hui
Zhang Liang
Zhang Min

Zhang Wei
Zhang Xiao Mei
Zhang Yan
Zhang Zhaozeng
Zhang Zhenyi
Zhao Bao Cheng
Zhao Hang Wang
Zhao Jianwei
Zhao Jing Dong
Zhao Jiye
Zhao LiJun
Zhao Tongjie
Zhao Ya-Shen
Zheng Congli
Zheng Qi Wen
Zheng Ting
Zhiyong Zhang
Zhou Chang You
Zhou Guoqiang
Zhou Qing Xian
Zhu Jzan Xzng
Zhu Ling
Zhu Sen
Zong Lu Fan
Zou Hong

PERU
Eitan Samesas Abramovich
Miguel A. Almeyda Bellido
Maria C. Atalaya Valencia
Renzo B. Fernandez-Baca
Martin Bernetti Vera
Cristóbal Bouroncle
Silvana Duarte Gilardi
Hector Emanuel
Cecilia Larrabure Simpson
Gary O. Manrique Robles
Hector Mata
Maria I. V. Menacho Ortega
Nicolas Mulder
Dante Piaggio Diaz
Juan Pelaso Ponce Valenzuela
Jaime Rey de Castro Belon
Oscar Alberto Roca Perales
Luis Daniel Silva Yoshisato
Abel del Solar Paredes
Jaime Javier Trelles Garcia
F. P. Vilcanaupa Bernal

PHILIPPINES
Joseph J. Capellan
Ramon I. Castillo
A. Castillo Penaredondo
Emmanuel Catabas
Manny Ceveta
Claro Fausto Cortes
Revoli Cortez
Jose V. Galvez Jr.
Maria Consel Gomez
Alan Robert Karaan
Victor Kintanar
Artemio Reyes Layno
Flordeliza M. Odulio
Max Pasion
Mike Perez
Marcial A. Reyes, Jr.
Rafael Taboy
Amelito Tecson

POLAND
Cezary Aszkielowicz
Bartlomiej Barczyk
Michal Bielecki
Piotr Blawicki
Marta Blazejowska
Robert Boguslawski
Grzegorz Celejewski
Antoni Chrzastowski
Filip Cwik
Grzegorz Dabrowski
Sylweriusz Dmochowski
Janusz Filipczak
Zbigniew Fiolka
Wojtek Franus
Piotr Gajek
Arkadiusz Gola
Andrzej Grygiel
Marek Grzesiak
Michak Grzybczak
Tomasz Gudzowaty
Rafat Guz
Krzysztof Hatadyna

Krysztof Hejke
Alexander Holubowicz
Stanislaw Jakubowski
Hubert Jasionowski
Maciej Jawornicki
Tomasz Kaminski
Anrzej Kielbowicz
Krzysztof Kobus
George Kochaniec
Roman Konzal
Grzegorz Kosmala
Piotr Kowalczyk
Robert Kowalewski
Karolina Kowalska
Miroslaw Kowalski
Kacper-Miroslaw Krajewski
Andrzej Kramarz
Witold Krassowski
Przemyslaw Krzakiewicz
Robert Krzanowski
Aneta Kula
Violetta Kus
Maciej Kuszela
Maciej Kusztal
J. Wojtek Laski
Arek Lawrywianiec
Anna Lewanska
Gabor Lörinczy
Andrzej Marczuk
Tomasz Markowski
Franciszek Mazur
Rafal Milach
Wojciech Miloch
Piotr Niedziela
Leonard Olechnowicz
Anna Olej-Kobus
Eliza Oleksy
Janczaruk Pawel
Mieczystaw Pawlowicz
Radoslaw Pietruszka
Leszek Pilichowski
Stanislaw Pindera
Hanna Polak
Ryszard Poprawski
Olgierd Rudak
Michal Sadowski
Bartosz Siedlik
Piotr Skornicki
Waldemar Sosnowski
Robert Stachnik
Marcin Szulzycki
Henryk Tkocz
Tomasz Tomaszewski
Lukasz Trzcinski
Jacek Turczyk
Pawel Ulatowski
Zdzislaw Wichlacz
Jachymiau Wojtek
Lukasz Wolagiewicz
Bartomiej Zborowski

PORTUGAL
Alexandre Almeida
Orlando Azevedo
Luís Barra
José Barradas
José Manuel Bouvida Cania
Antonio Manuel Carrapato
José Carlos Almeida Carvalho
Joao De Carvalho Pina
Ricardo Augusto Castelo
Leonel De Castro
Luis António Costa
Hugo Delgado Fernandes
Rui Pedro Duarte Silva
Jorge Miguel Ferreira Simào
Jorge Firmino
Eduardo Gageiro
Joao F. Gaspar de Jesus
Pedro Loureiro
Artur Machado
João Mariano
Tiago Marins Ferreira Petinga
Marco Paulo Mendes Freitas
Manuel de Moura
Bruno Neves
Paulo Novais
César Santos Nuno Antunes
Jorge Alexandre Pereira
Luís Ramos
Sandra Rocha
Nelson A. Rodrigues Garrido

Gonçalo Rosa da Silva
Pedro Sampayo Ribeiro
Carlos Alberto Santos Costa
Paulo Manuel Sargo Escoto
Miguel C. Sousa Dias
José M.I T. Oliveira B. Bacelar
Raquel J. Torres Simões Wise

PUERTO RICO
A. Enrique Valentin

REPUBLIC OF KOREA
Byung Soo Bae
Cho Sung Su
Choi Jae-ku
Jean Chung
Jae-Ho Ham
Sung-Chan Ham
Hyoung Chang
Lee Hyung Sik
Je Uk Woo
Jong Gak Park
Jung Myung-Gyo
Jea Uk Kang
Kim Jae Hwan
Kim Kyung-Hoon
Ok Huyn Lee
Lee Jin-Man
Sangjib Min
Myung Chun
Noh Soon Taek
Haseon Park
Il Park
Seokyong Lee
Seong Yeon Jae
Jin Seong-Chzol
Shin Shin Dong-Phil
Soo Hyun Park
Soo-Yong Kuk
Sung-Jun Chung
Yong I Kim

ROMANIA
Nora Agapi
Petrut Calinescu
Dorian-Manuel Delureanu
Vadim Ghirda
Dragos Lumpan
Sorin Mihai Lupsa
Sergiu Negrean
Radu Pop

RUSSIA
Yuri Abramochkin
Ravil Adiev
Andrei Alatyrtsev
Andrey Arkhipov
Armen Asratyan
Dmitri Astakhov
Eugene Astashenkov
Dmitry Azarov
Maxim Vladimirovich Babkin
Juri Barykin
Dmitry Beliakov
Alexey Beliantchev
Vladimir Bondarev
Leonid Cheljapov
Viktor Chernov
Anton Churochkin
Anton Denisov
Boris Dolmatovsky
Anatoly Doneyko
Boris Filippovich Echin
Andrei Efimov
Andrey Efimov
Mikhail Evstafiev
Vladimir Fedorenko
Sofia Fetisova
Ramil Galiev
Igor Gavrilov
Alexei Goloubtsov
Serge Golovach
Grigory Golyshev
George Gongolevich
Victor Gritsyuk
Alexandre Gronsky
Natalia Gubernatorova
Nikolai Ignatiev
Sergei Isakov
Sergey Kaptilkin
Pavel Kashaev
Edvard Khakimov

Nickolay Kireyev
Victor Kirsanov
Sergey Kiselev
Oleg Aleksandrovitsj Klimov
Andrey Kobylko
Yuri Kochetkov
Timur Koksharov
Alexej Kompaniychenko
Sergei Kompaniychenko
Yevgeni Kondakov
Alexey Kondrashkin
Pavel Korbul
Vladimir Korobitsyn
Anatoly Kovtun
Denis Kozhevnikov
Yuri Kozyrev
Igor Kravchenko
Vitaliy Krehalev
Igor Kubedinov
Sergey Kuksin
Alexey Kunilov
Yuri Kuznetsov
Oleg Lazarev
Teodor Lebedev
Konstantin Lemeshev
Alexsander Lisafin
Victor Lisicin
Natalya Lvova
Vladimir Lyubukhin
Pavel Markelov
Vita Masliy
Sergey Maximishin
Melnichenko
Wilhelm Mikhailovsky
Gennady A. Mikmeev
Andrei Mishenko
Sergei Moiseev
Sergey Molodushkin
Rustam Muhammadzian
Alexander Nemenov
Andrey Nikerlchev
Oleg Nikishin
Valeri Nistratov
Alexander Oreshnikov
Victor Parchaev
Alexander Polyakov
Sergey Ponomarev
Konstantin Postnikov
Oleg Prasolov
Daria Pudenko
Anatoly Rakhimbaev
Natalia Razina
Vladimir Rodionov
Ioulia Rodionova
Olga Ryabtsova
Evgeniy Rysikov
Vladimir Alexeevitch Shabankov
Vadim Shabunin
Andrei Shapran
Sergey Shekotov
Sergej Shevirin
Victor Shokhin
Vladimir Shootofedov
Ekaterina Shtukina
Pavel Smertin
Alexei Smirnov
Oleg Sourine
Anatoli Strebelev
Svetlana Sushchen
Vitaly Sutulov
Vladimir Syomin
Igor Tabakov
Alexandr Tkachov
Andrey Tkachyov
Vladimir Tokarev
Yuri Tutov
Peter Vasilyev
Sergei Vasilyev
Vladimir Velengurin
Alexei Vladykin
Yuri Vorontsov
Dmitri Vozdvijenski
Vladimir Vyatkin
Oleg Wastochken
Michail Zaguliaev
Konstantin Zavrazhin
Anatoliy Zhdanov

SAUDI ARABIA
Hassen Ali Hussin Alhabib

SIERRA LEONE
Patrick Bockarie Koroma

SINGAPORE
Chua Chin Hon
Ernest Goh
How Hwee Young
Huang Zhi Ming
Kwong Kai Chung
Law Kian Yan
Arthur Lee Chong Hui
Darren Soh
Terence Tan
Teck Hian Wee
Dennis Thongh
Seyu Tzyy Wei
Wang Hui Fen
Wong Maye-E

SLOVAKIA
Martin Bandzak
Jozef Barinka
Peter Brenkus
Marian Fridrichovsky
Dusan Guzi
Alan Hyza
Milan Illik
Martin Kollar
Marian Meciar

SLOVENIA
Bojan Brecelj
Petkovic Darije
Domen Grögl
Dusan Jez
Tomi Lombar
Matej Povse
Marko Turk

SOUTH AFRICA
Tyrone Arthur
Adrian Bailey
Peter Bauermeister
Jodi Bieber
Mariola Biela
Bam Bonile
Ruvan Boshoff
Paul Botes
Nicholas Bothma
Adam Broomberg
Thys Dullaart
Jillian Elaine Edelstein
Lettie Ferreira
Brenton Geach
Henry Greyling
Anton Hammerl
Chad Henning
John Peter Hogg
Rian Horn
Nadine Hutton
Andrew Ingram
Fanie Jason
Jeremy Jowell
Nonhlanhla Eddie Kambule
Adrian de Kock
Elské Kritzinger
Halden Krog
Anne Laing
Stephen Lawrence
Shivambu Lefty
Lisa Leslie
Charlé Lombard
Kim Ludbrook
Leonie Marinovich
Kendridge Mathabathe
Simon Mathebula
Gideon Mendel
Eric Miller
Mpho Goodwill Mphotho
Ntsoma Neo
Christine Nesbitt
Khaya Ngwenya
James Oatway
Siyabulela Obed Zilwa
Hein du Plessis
Antoine de Ras
Karin Retief
John Robinson
Mujahid Safodien
David Sandison
Sydney Seshibedi
David Silverman

Sibeko Siphiwe
Brent Stirton
Caroline Suzman
Ndabula Thobeka
Guy Tillim
Johannes George Vogel
Rogan Ward
Paul David Weinberg
Johan Wilke
Graeme Williams
Debbie Yazbek
Naashon Zalk
Anna Zieminski
Schalck Van Zuydam

SPAIN
Carmen Alemán Alvarez
Diego Alquerache
Genín Andrada
Jesús Antoñanzas Ibañez
Javier Arcenillas
Pedro Armestre
Ariadne Arnés Novau
Christian Baitg Schreiweis
Pablo Balbontin Arenas
Sandra Balsells
Juan Carlos Barbera Marco
Alvaro Barrientos Gómez
Consuelo Bautista Riveros
Héctor Bermejo-Ascorbe
Clemente Bernad Asiain
Pep Bonet Mulet
Xavier Calabuig Lluch
Alfredo Caliz Bricio
Nacho Calonge Minguez
José Camacho Fernandez
Luis Camacho Peral
Sergi Camara Loscos
Daniel Cardona Ferrer
Alejandro Carra Biosca
Andres Carrasco Ragel
Daniel Casares Romàn
Cristobal Castro Veredas
Carma Casulá
Xavier Cervera Vallve
Santiago Cogolludo Vallejo
Mireia Comas Franch
Andrea Comas Lagartos
Matias Costa
Marcelo Del Pozo Perez
José Delgado
Juan Diaz Castromil
Ignacio Doce Villemar
Sergio A. Enríquez Nistal
Juantxo Erce-Lacabe
Ramon Espinosa Tebar
Alberto Estevez Arias
Paco Feria Villegas
Carlos Fernandez Pardellas
Pere Ferre Caballero
Mónica Ferreirós Vila
Jose Ferrin Y Abal
Salvador de Sas Fojou
Fernando A. Garcia Arevalo
Francisco Garcia Campos
Victor Garcia Echave
Manuel Antonio Garcia Freire
G. Garcia-Villahil Basanez
Miguel Gomez Muniz
E. González Valderrama
Jordi Gratacòs Caparrós
Juan Jose Guillen Nunez
Soaquin De Haro Rodriguez
Jose Haro Sanchez
F.-J. de las Heras Álvarez
Julian Jaen Casillas
Emilio Lavandeira Villar
Alvaro Leiva
Santy López
Kim Manresa Mirabet
Fernando Marcos Ibanez
Francisco Márquez Sánchez
Enric F. Marti
Cecilia Martin
Gonzalo Martinez Lorenzo
Antonio Mejias Flores
Fidel Meneses Tienda
Fernando Moleres Alava
Raul Montanos Garcia
Alfonso Moral Rodrigues
Roberto Navarro Cataluña
Christina Nuñez

Enrique Del Olmo Gonzalez
Oscar Palomares Acenero
Cipriano Pastrano Delgado
José M. Paz Lopez
Sergio Perez
Raúl Pérez García
Antonio Jesús Pérez Gil
Jordi Play
Mariano Pozo Ruiz
Nacho Prejigueiro Santas
Joan Salvador Puig Pasqual
Sergi Reboredo Manzanares
Jose Miguel Riopa Alende
Manuel Rocca
Alberto H. Rojas
Alberto Rojas Maza
Lorena Ros
Abel Ruiz de León Trespando
Moises Saman
J. A. Sanchez de Lamadrid Rey
Gervasio Sanchez Fernandez
C. M. Sanchez Rodriguez
Lourdes Segade Botella
David Serrano Pascual
Jorge Sierra Antinolo
Juan Solano Maldonado
Tino Soriano
Nelson Souto Oviedo
Carlos Spottorno
Luis Ignacio Tejido Garcia
Javier Teniente Lago
Jose Antonio Torres
Xavier Torres Bachetta
Francis Tsang
Elena de la Vega
Miguel Vidal Solla
Roser Vilallonga Tena
Xulio Villarino Aguiar
Emma Villegas Muriana
Emilio Zazu Imizcoz

SRI LANKA
Upul Amarasinghe
Sumanachandra Ariyawansa
Ananda Sunilshantha Fernando
Mohamed Ayub
Samarasinghe A. Pradeep
Samarasinghe
Ranjith Premadasa
Ranawila Premalal
Wickrama Saman Mendis
Anushad Sampath Wedage
Dominic Sansoni
Kavisha Kombala Vithanage
Sriyantha Walpola
SUDAN
Jamal Bushra Shiekheldeen
Ahmed Elamin Bakhit
Osama Mahdi Hassan
Mohamed Ahmed Yassir

SURINAM
Marinus Zalman

SWEDEN
Martin Adler
Torbjörn Andersson
Urban Andersson
Roland Bengtsson
Sophie Brandstrom
Lars Dareberg
Andrey Deyneko
Jonas Ekströmer
Joakim Eneroth
Jan Fleischmann
Jessica Gow
Johan Gunséus
Johnny Gustavsson
Paul Hansen
Krister Hansson
Adam Ihse
Ann Johansson
Jonas Karlsson
Björn H. Larsson Ask
Christian Leo
Larseric Linden
Jonas Lindkvist
Johan Claes Lundahl
Joachim Lundgren
Chris Maluszynski
Markus Marcetic
Tommy Mardell

Paul Mattsson
Niklas Maupoix
Jack Mikrut
Henrik Montgomery
Björn Olsson
Mike Persson
Per-Anders Pettersson
Maria Ramström
Kai Ewert Rehn
Lennart Rehnman
Ann-Sofi Rosenkvist
Hakan Sjöström
Johan Solum
Göran Stenberg
Per-Olof Stoltz
Michael Svensson
Roger A. Turesson
Curt Waras
Jon Wentzel
Karl-Göran Zahedi Fougstedt

SWITZERLAND
Marco D'Anna
Manuel Bauer
Monica Beurer
Fabian Biasio
Markus Bühler
Christoph Bürki
Ladislav Drezdowicz
Daniel Forster
Andreas Frossard
Daniel Fuchs
Peter Gerber
Tobias Hitsch
Thomas Hoelblinger
Robert Huber
Alexander Keppler
Olivier Laffely
Marc Latzel
Henry Leutwyler
Juraj Lipscher
Roger Lohrer
Pierre Montavon
Massimo Pacciorini-Job
Daniel Reinhard
Jean-Claude Roh
Didier Ruef
Andreas Schwaiger
Andreas Seibert
Virginie Seira
Jean-Patrick di Silvestro
Hansüli Trachsel
Valdemar Verissimo
Olivier Vogelsang
Stefan Walter
Luca Zanetti
Andreas Zimmermann

SYRIA
Zuka Al Kahhal
Munzer Bachour
Chadi Bat
Nouh-Ammar Hammami
Akef Kammoush

TAIWAN R.O.C.
Chien-Chi Chang
Chang Tien Hsiung
Ying-ying Chiang
Chou Yuan Kai
Fan Yi Kung
Tsung Sheng Lin
Lin Chen Yi
Ma Li-Chun
Ming-Yang Lee
Alan Peng
Peng-Chieh Huang
Wei-Sheng Huang
Wu Yi-ping
Sam Yeh

TANZANIA
Khamis Hamad Said
Mohamed A. Mambo

THAILAND
Vinai Dithajohn
Pornchai Kittiwongsakul
Suthep Kritsanavarin
Sarot Meksophawannakul
Jetjaras Na Ranong
Rungroj Yongrit

TUNISIA
Ghaya Ben Attaya
Karim Ben Khelifa

TURKEY
Sandikcioglu Ahmet Zija
Muammer Baskan
Kenan Cimen
Hasan Murat Ersan
Murat Germen
Cemal Köyük
Aziz Uzun

TURKMENISTAN
Ahmed Ovezmuhamedov

UGANDA
Michael Nsubuga

UKRAINE
Sergiy Avramenko
Sergey Bondarev
Alexander Burkovsky
Boris Dvorniy
Gleb Garanich
Ljudmila Gontschar
Alexander Gordievich
Vitaliy Grabar
Sergiy Gumenyuk
Oleksandr Kharvat
Efrem Lukatsky
Leonid Naidiouk
Oxana Nedilnichenko
Alexander Nerubaev
Shynkarenko Oleksiv
Vladimir Osmushko
Georgiy Pasyuk
Sergiy Pasyuk
Oleg Poddubniy
Arvidas Shemetas
Aleksi Shynkarenko
Alexander Svetlovsky

UNITED KINGDOM
Richard Addison
Nigel Amies
Julian Andrews
John Angerson
Adrian Arbib
Martin Argles
David W. Ashdown
Matthew Ashton
Dan Atkin
Bob Aylott
Scott Bairstow
Richard Baker
Roger Bamber
Barry Batchelor
Sean David Baylis
Piers Benatar
Alistair Berg
Raymond Besant
Martin Birchall
Shaun Botterill
Stuart Boulton
Polly Braden
Ian Bradshaw
Adam Broomberg
Clive Brunskill
Simon Burt
James Burton
Andrew Buurman
Gary Calton
Mark Campbell
David Cannon
Richard Castka
Angela Catlin
Oliver Chanarin
Dean Chapman
David Charnley
William Cherry
Wattie Cheung
Daniel Chung
Garry Michael Clarkson
Benjamin Curtis
Simon Dack
Nick Danziger
Colin Davey
Peter Dench
Adrian Dennis
Nigel Dickinson
Ann Doherty

John Downing
Colin Dutton
Glenn Edwards
Neville Elder
Jonathan Elderfield
Stuart Mills Emmerson
Gavin Engelbrecht
Mark Evans
Sophia Evans
Sam Faulkner
John Ferguson
Stu Forster
Fabienne Fossez
Adam Fradgley
Stuart Franklin
Gordon Fraser
Stuart Freedman
Fu Chun Wai
Christopher Furlong
Kent E. Gavin
George Georgiou
John Giles
David Gillanders
Michael Goldwater
Mark R. Graham
Michael Graig
Tom Graig
David Graves
Ben Graville
Nick Gregory
Laurence Griffiths
Jonathan Guegan
Stephen Hale
Andy Hall
Brian Harris
Richard Heathcote
Mark Henley
Paul Herrmann
Tim Hetherington
Tom Hevezi
Michael Hewitt
Jack Hill
James Hill
Tommy Hindley
Phillip Nicholas Hodges
Jim Holden
Kate Holt
Jason P. Howe
Richard Humphries
Jeremy Hunter
Mike Hutchings
Caroline Irby
Chris Ison
Chris Ivin
Mark Jamieson
Tom Jenkins
Christian Keenan
Findlay Kember
Ross Kinnaird
Nicola Kurtz
Colin Lane
Kalpesh Lathigra
Stephen Lawrence
David Levenson
Barry Lewis
Geraint Lewis
Alex Livesey
Paul Lowe
Sinead Lynch
Ashley Maile
Paul Marriott
Tony Marsh
Eamonn McCabe
Tim McGuinness
Colin Mearns
Paul Mellor
Jerome Ming
Rizwan Mirza
David Modell
Andrew Moore
Jeff Moore
Mike Moore
Rod Morris
Nevil Mountford
Edward Mulholland
Rebecca Naden
Pauline Neild
Lucy Nicholson
Simon Norfolk
Heathcliff O´Malley
Charles M. Ommanney
Philiy Page

Rachel Palmer
Colin Pantall
John Perkins
Tom Pietrasik
Tom Pilston
Olivier Pin-Fat
Mark Pinder
Martin Pope
Gary Prior
Darren Quinton
Steve Race
Ben Radford
Scott Ramsey
Carlos Reyes Manzo
Kiran Ridley
Mike Roberts
Simon Roberts
Stuart Robinson
David Rose
Howard Sayer
Mark Seager
Tom Shaw
Phil Sheldon
John Sibley
Alex Smailes
Sean Smith
Mark Stewart
Tom Stoddart
Christopher Stowers
Justin Sutcliffe
Ian Teh
Edmond Terakopian
Andrew Testa
Hazel Thompson
Neil Turner
Aubrey Wade
Richard Wainwright
Howard H. Walker
Michael Walter
Richard Wareham
Nigel Watmough
Geoff Waugh
Felicia Webb
Andrew Weekes
Stewart Weir
Horace Wetton
Adrian White
Amiran White
David White
Gavin David White
Eric Whitehead
Kirsty Wigglesworth
Edward Willcox
Alan Williams
Greg Williams
James Williamson
Vanessa Winship
Philip Wolmuth
Matt Writtle
Sandy Young
Tony Yu Kwok Lam

URUGUAY
Leo Barizzoni Martinez
Enrique Kierszenbaum
Fernando D. Pena Cabrera
Pablo Daniel Rivara Suchanek
Miguel Rojo

USA
Sharon Abbady
Henny Ray Abrams
Douglas Abuelo
Gabriel L. Acosta
Michael Adaskaveg
Lynsey Addario
Noah Addis
Michael Albans
Jim Albright
Carmelo Alen
Michael Allen Jones
Maya Alleruzzo
Kwaku Alston
Stephen L. Alvarez
Andrew Alvarez
Kathy Anderson
Thorne Anderson
Patrick Andrade
Ryan Anson
Samantha Appleton
Charles Rex Arbogast
Glenn Asakawa

Kristen Ashburn
Osama Attar
Frank Augstein
Maria J. Avila-Lopez
Anita Baca
Brian Baer
Craig Bailey
Danilo Balderrama
Shawn Baldwin
Karen Ballard
Jeffrey W. Barbee
Richard Barnes
Don Bartletti
James Bates
David Bathgate
Max Becherer
Robyn Beck
Robert Beck
Natalie Behring-Chisholm
Al Bello
Amy Bennett
Benjamin Benschneider
Harry Benson
David Bergman
David Berkwitz
Nina Berman
Alan Berner
John Berry
Susan Biddle
John Biever
Chuck Bigger
Molly Bingham
Keith Birmingham
Matt Black
Eileen M. Blass
David Blumenfeld
Wesley Bocxe
Michael Bonfigli
James Borchuk
Harry Borden
Peter Andrew Bosch
Mark Boster
Khampha Bouaphanh
Tim Boyle
Gary Braasch
Heidi Bradner
Brian Brainerd
Neil Brake
Alex Brandon
William Bretzger
Paula Bronstein
Yoni Brook
Dudley Brooks
Kate Brooks
Kenneth R. Brooks
Frederick Brown
Jennifer Brown
Milbert Orlando Brown
Brian van der Brug
Simon Bruty
Paul Buck
Robin Buckson
Mark Bugnaski
Khue Bui
Gregory Bull
Richard Burbridge
David Burnett
David Butow
Renée C. Byer
Debbie Caffery
John Calaman
Julia Calfee
Matt Campbell
Darren Carroll
Patrick Carroll
Chuck Cass
Fernando Castillo
Joe Cavaretta
Sean Cayton
Lee Celano
Radhika Chalasani
Dennis Chamberlin
Chang W. Lee
Richard A. Chapman
Tim Chapman
Dominic Chavez
Doral Chenoweth
Charles Cherney
Stephen Chernin
Chien Min Chung
Jahi Chikwendiu
Alan Chin

Barry Chin
Nelson Ching
Andre F. Chung
Daniel F. Cima
Mary Circelli
Daniel Le Clair
Robert Clark
Tim Clary
Brian Cleary
Jay Clendenin
Rachel Cobb
Gigi Cohen
Carolyn Cole
Deborah Coleman
Sean Connelly
Kathryn Cook
Lori Ann Cook
Stewart Cook
Dean Coppola
Ronald Cortés
John Costello
Andrew Craft
Bill Crandall
Gregory Crewdson
Manny Crisostomo
Chris Curry
Rob Curtis
Anne Cusack
Rebecca D'Angelo
Roy Dabner
Scott Dalton
Meredith Davenport
Bruce Davidson
Amy Davis
Jim Davis
Patrick Davison
André DeGreave
Grant Delin
Julie Denesha
Daniel Derella
Robert Deutsch
Charles Dharapak
J. Albert Diaz
Al Diaz
Kenneth Dickerman
James Dickman
Cherie Diez
Timothy Dillon
Nuccio DiNuzzo
Kevork Djansezian
Samanda Dorger
Tony Dougherty
Larry Downing
Andrew Eccles
Aristide Economopoulos
Ron Edmonds
Debbie Egan-Chin
Davin R.M. Ellicson
Gerry Ellis
Don Emmert
Jason Eskenazi
Peter Essick
Joshua Estey
James Estrin
Jim Evans
Sarah Evans
Gary Fabiano
Timothy Fadek
Steven Falk
Barth Falkenberg
Patrick Farrell
David Fastovsky
Christopher Faytok
Esteban Felix
Gina Ferazzi
Jose Ismael Fernandez Reyes
Jonathan Ferrey
Stephen Ferry
Rob Finch
Brian Finke
Deanne Fitzmaurice
Mikel Flamm
Lauren Fleishman
Karen Pulfer Focht
Bill Foley
Tom Fox
Bill Frakes
Lloyd Jr. Francis
Thomas Franklin
Luke Frazza
Rick Frearson
Ruth Fremson

George Frey
Jen Friedberg
David Friedman
Gary Friedman
Rich Frishman
Carmine Galasso
Michael Gallegos
Patricia Gallinek
Sean Gallup
Alex Garcia
Eugene Garcia
Juan Garcia
Mark Garfinkel
Robert Gauthier
Eric Gay
Sharon Gekoski-Kimmel
Porter Gifford
Mark Gilliland
Thomas E. Gilpin
Sarah Glover
Robert Goebel
Arnold Gold
David Goldman
Julian Gonzalez
Russell Gordon
Chet Gordon
Mark Gormus
Jeff Grace
Jill Greenberg
Bill Greene
Stanley Greene
Lauren Greenfield
John Gress
Lori Grinker
Sergei Grits
Daniel Groshong
David Gross
Jack Gruber
David Grunfeld
Justin Guariglia
Dale Guldan
C.J. Gunther
David Guralnick
John Gurzinski
Barry Gutierrez
David Guttenfelder
Carol Guzy
Keith Hale
Heather Hall
Robert Hallinen
Mark M. Hancock
David Handschuh
Paul Hanna
Deborah Hardt
Dariyoosh Hariri
Mark Edward Harris
David Alan Harvey
Jeff Haynes
Gregory Heisler
Sean Hemmerle
Robert Hendricks
Mark Henle
Marcelo Hernandez
Steven Herppich
Tyler Hicks
Jeanne Hilary
Brian Hill
Erik Hill
Edward J. Hille
Michael Hintlian
Eros Hoagland
Bill Hogan
Jim Hollander
David S. Holloway
Stan Honda
Chris Hondros
Beverly Horne
Eugene Hoshiko
Rose Howerter
Eustacio Humphrey
Laura Husar Garcia
Ethan Hyman
Walter Iooss Jr.
Stuart H. Isett
Ted Jackson
Stephen Jaffe
Terrence Antonio James
Rebecca Janes
Kenneth Jarecke
Lynn Johnson
Mark Johnson
Barbara Johnston

Frank Johnston
Ian Jones
Sam Jones
Marvin Joseph
Ariane Kadoch Swisa
Sven Kaestner
Lisa Kahane
Joan Kanes
Hyungwon Kang
Doug Kanter
John Kaplan
Paul Kapleyn
Sylwia Kapuscinski
Ed Kashi
Karen Kasmauski
David Kaup
Courtney Kealy
James Keivom
Michael Kelley
Caleb Kenna
Brenda Kenneally
David Hume Kennerly
Mike Kepka
Brian Kersey
Lisa Kessler
Laurence Kesterson
John J. Kim
Yunghi Kim
Lui Kit Wong
Paul Kitagaki, Jr
Tim Klein
Heinz Kluetmeier
David E. Klutho
Richard H. Koehler
James Korpi
Jeff Kowalsky
Brooks Kraft
Benjamin Krain
Lisa Krantz
Amelia Kunhardt
Teru Kuwayama
Stephanie Kuykendal
Andre Lambertson
Rodney A. Lamkey, Jr.
Wendy Sue Lamm
Nancy Lane
Jerry Lara
Craig Lassig
Jim Lavrakas
Tony Law
Jared Lazarus
Amy Leang
Michael Lebrecht II
Matthew Lee
Sarah Leen
Mark Leffingwell
Neil Leifer
Mark Leong
Paula Lerner
Marc Lester
Catherine Leuthold
Mike Levin
Dan Levine
Esther Levine
Heidi Levine
Wendy Levine
Scott Lewis
William Wilson Lewis III
Jun-Yi Lin
Brennan Linsley
Steve Liss
Scott Lituchy
Michael Llewellyn
David Longstreath
John Loomis
Rick Loomis
Benjamin Lowy
Robin Loznak
Eric Lutzens
Michael Lutzky
Melissa Lyttle
John Mabanglo
Jim MacMillan
David Maialetti
Todd Maisel
Nirmalendu Majumdar
John Makely
Jeff Mankie
Rodney Mar
Maxim Marmur
Dan Marschka
Bob Martin

Glenn Martin
Pablo Martínez Monsiváis
James Mason
Laurie Matanich
Jay B. Mather
Marianne Mather
Tim Matsui
Rob Mattson
Tannen Maury
Robert Maxwell
Dave Maxwell
Robert Mayer
Nicholas Hezel McClelland
Darren McCollester
John McConnico
Cyrus McCrimmon
John W. McDonough
Ryan McGinley
Maryellen McGrath
Tricia McInroy
Joseph McNally
David McNew
Ian McVea
Daniel J. Mears
Kent F. Meireis
Eric Mencher
Doug Menuez
Jennifer Midberry
Tom Mihalek
George W. Miller
Lindsay Miller
Peter Read Miller
Lester J. Millman
Doug Mills
Donald Miralle
Mark Mirko
Logan Mock-Bunting
Andrea Modica
Genaro Molina
Yola Monakhov
Tim Montgomery
M. Scott Moon
John Moore
Jose M. More
Peter Kevin Morley
Christopher Morris
John Mottern
Ozier Muhammed
Peter Muhly
John Munson
Edward Murray
Vincent Musi
James Nachtwey
Adam Nadel
Joyce Naltchayan
Jon Naso
Donna E. Natale Planas
David Nelson
Mike Nelson
Scott Nelson
Trent Nelson
Amy Newman
Gregg Newton
Michael Nichols
Robert Nickelsberg
Steven Ralph Nickerson
James Nielson
Zia Nizami
Landon Nordeman
Luc Novovitch
Jason Nuttle
John O'Boyle
William O'Leary
Michael O'Neill
Charles Obare
Stephanie Oberlander
Randy Olson
Scott Olson
Dale Omori
Fahrettin Gütkan Örenli
Max Ortiz
Jack Orton
Charles Osgood
Ara Oshagan
José M. Osorio
James Parcell
Gerik Parmele
Judah Passow
Nancy Pastor
Bryan Patrick
Richard Patterson
Julie Pena

149

John Pendygraft
Erik Perel
Hilda M. Perez
Michael Perez
Algerina Perna
David J. Philip
Terry Pierson
Chad Pilster
Spencer Platt
Brian Plonka
William Benjamin Plowman
Suzanne Plunkett
Lisa Poole
Wes Pope
Gary Porter
Betty H. Press
Joshua Prezant
Jake Price
Carlos Puma
Gene J. Puskar
Anacleto Rapping
Matthew Ratajczak
Patrick Raycraft
Joe Readle
Anne Rearick
Jerry Redfern
Ryan Spencer Reed
Mona Reeder
Barry Reeger
Tom Reese
Tim Revell
Damaso Reyes
Martha Rial
Danielle P. Richards
Eugene Richards
Paul Richards
Helen Richardson
Charlie Riedel
L. Jane Ringe
Josh Ritchie
Kevin Rivoli
John Rizzo
Joshua Roberts
Michael Robinson-Chávez
John Roca
Paul Rodriguez
Rod Rolle
Vivian Ronay
Bob Rosato
Ricki Rosen
Amy Rossetti
Jeffrey L. Rotman
Scott Rovak
Raul Rubiera
Steve Rubin
Dina Rudick
Edward Ruiz
Victor Ruiz-Caballero
Jeffrey B. Russell
David L. Ryan
Carolina Salguero
Jeffery A. Salter
Gulnara Samoilova
Amy Sancetta
Marcio Jóse Sánchez
Joel Sartore
Renée Sauer
April Saul
Jonathan Saunders
Allen Schaben
Steve Schaeffer
Howard Schatz
Erich Schlegel
Eric Schmadel
Jake Schoellkopf
Sharon Schoen
David Schreiber
Rob Schumacher
Michael Schwartz
Paul David Scott
Paula Alyce Scully
Eric Seals
Ivan Sekretarev
Zoe Selsky
Andrew Serban
Bill Serne
Andréanna Seymore
Patrick Shannahan
Scott Sharpe
Gregory Shaver
Ezra Shaw
Scott Shaw

David Shea
Callie Shell
Lori Shepler
Oleski Shinkarenko
Benny Sieu
Joe Silverman
Martin Simon
Mike Simons
Stephanie Sinclair
Luis Sinco
Tim Sloan
Matt Slothower
John Smierciak
Chris Smith
Summar Smith-Zak
Stuart L. Smucker
Bahram Sobhani
Ted Soqui
Trygive Sorvaag
Pete Souza
Scott Spangler
Fred Squillante
Jamie Squire
Clayton Stalter
Shaun Stanley
John Stanmeyer
Shannon Stapleton
Monique Stauder
Susan Stava
Larry Steagall
George Steinmetz
Lezlie Sterling
Sean Stipp
Mike Stocker
Robert Stolarik
Wendy Stone
Scott Strazzante
Bruce C. Strong
Alice Su
Essdras M. Suarez
Anthony Suau
Robert Sullivan
Akira Suwa
Lea Suzuki
David Robert Swanson
Laurie Swope
Joseph Sywenkyj
Mario Tama
Teresa Tamura
Allan Tannenbaum
Ross Taylor
Jessica Tefft
Susan May Tell
Donna Terek
Joey Terrill
Mark J. Terrill
Sara Terry
Ted Thai
Shmuel Thaler
Shawn Thew
George Thompson
Irwin Thompson
Peter Thompson
Al Tielemans
Wyatt Tillotson
Lonnie Timmons III
Peter Tobia
Jeff Topping
Jonathan Torgovnik
Brian Totin
Bonnie Trafelet
Charles Trainor Jr.
Robert Trippett
Linda Troeller
Alexander Tsiaras
Scout Tufankjian
Susan Tusa
Jane Tyska
Gregory Urquiaga
Chris Usher
Victoria Ann Valerio
Nuri Vallbona
Vanessa Vick
Jose Luis Villegas
Kurt Vinion
Ami Vitale
David Michael van Voast
Sarah Voisin
Tamara Voninski
Dino Vournas
Dusan Vranic
Fred Vuich

Chriss Wade
Tom Wagner
Craig Walker
Richard Walker
Brian Walski
Jenny Warburg
Steve Warmowski
Paul Warner
Guy Wathen
Susan Watts
Kathleen Wayt
Alex Webb
Matthew West
James Whitlow Delano
Patrick Whittemore
Jonathan Wiggs
John Wilcox
Rick T. Wilking
Anne Williams
Clarence Williams
Gerald S. Williams
Jonathan Wilson
Mark Wilson
Ian E. Wingfield
Terry Winn
Roger Winstead
Damon Winter
Dan Winters
Michael S. Wirtz
Rhona Wise
Joshua Wolfe
Alex Wong
Ed Wray
Mandi Wright
Ron Wurzer
Cindy Yamanaka
Stefan Zaklin
Mark Zaleski
John Zich
Tim Zielenbach
Tom Zuback
Steve Zugschwerdt

UZBEKISTAN
Alimjan Jorobaev

VENEZUELA
Kike Arnal
Juan Barretto
Teresa Carreño
Jose Cohen
Jesus Antonio Contreras
Eladio A. Fariñez Alvando
E. J. Hernandez Sanabria
Juan Ernesto Jaeger Campos
Leonardo Liberman Lifschitz
Luis A. Noguera Escobar
Wendys Olivo Navarro
Pedro Ruiz Perez
Victor Sira
Luis Vallenilla Garcia

VIETNAM
Bach Ngoc Tu
Bui Thanh
Nguyen Dang Khoa
Dao Tien Dat
Doan Duc Minh
Hoang Quoc Tuan
Huynh Ngoc Dan
Le Kinh Thang
Le Minh Nhut
Le Tung Khanh
The Tri Nguyen
Nguyen Anh Tuan
Nguyen Dan
Lac Nguyen Dinh
Nguyen Duc Chinh
Nguyen Duc Sinh
Nguyen Manh Há
Nguyen Thé Lam
Nguyen Thi Thanh Son
Nguyen Van Thu An
Nguyen Van Xuan
Pham Thi Thu
Phamdinn Quyen
Tran Quoc Dung
Tuan Tran Quang
Vu Anh Hieu
Vu Quang Huy

YUGOSLAVIA
Zoran Bogic
Djordje Cubrilo
Aleksandar Dimitrijevic
Aleksandar Kelic
Sasa Maksimovic
Vladimir Milivojevic Boogie
Mihály Moldvay
Branislav Puljevic
Hazir Reka
Aleksander Stojanovic
Goran Tomasevic

ZAMBIA
Salim Henry
Tsvangirayi Mukwazhi
Emmah Nakapizye
Timothy Nyirenda

ZIMBABWE
Alexander Joe
Wilson Johwa

The world's finest books on
photography and photographers from

Thames & Hudson

Bailey **Blumenfeld** Bischof

Bill Brandt Brassaï **Cartier-Bresson**

Walker Evans **Lois Greenfield**

Horst **Hoyningen-Huene**

Jacques-Henri Lartigue **Duane Michals**

Lee Miller **Tim Page** Man Ray

Riboud Daniel Schwartz

Cindy Sherman W. Eugene Smith

For details of our new and forthcoming titles, please write to:
(UK) Thames & Hudson Ltd 181A High Holborn London WC1V 7QX
www.thamesandhudson.com
(USA) Thames & Hudson Inc. 500 Fifth Avenue New York NY 10110
www.thamesandhudsonusa.com

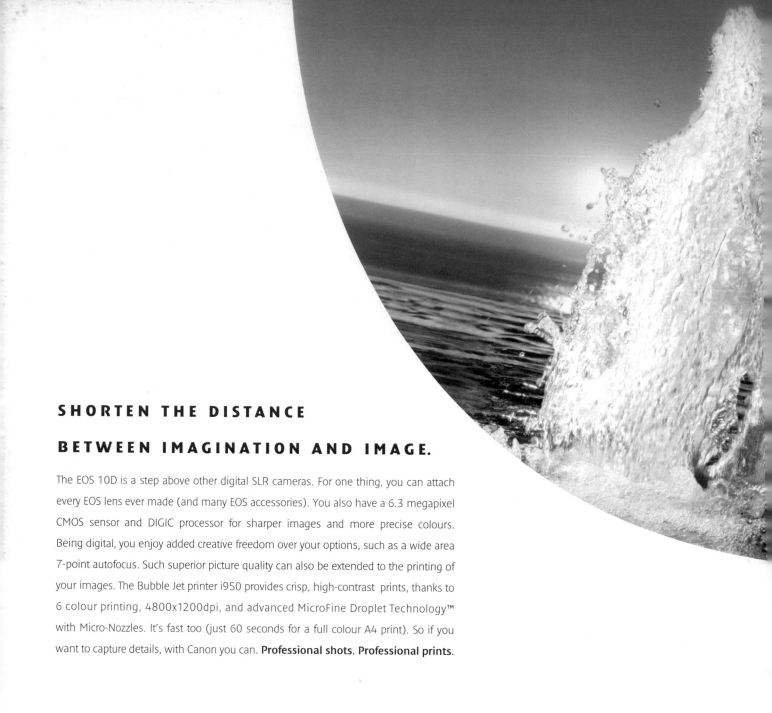

SHORTEN THE DISTANCE
BETWEEN IMAGINATION AND IMAGE.

The EOS 10D is a step above other digital SLR cameras. For one thing, you can attach every EOS lens ever made (and many EOS accessories). You also have a 6.3 megapixel CMOS sensor and DIGIC processor for sharper images and more precise colours. Being digital, you enjoy added creative freedom over your options, such as a wide area 7-point autofocus. Such superior picture quality can also be extended to the printing of your images. The Bubble Jet printer i950 provides crisp, high-contrast prints, thanks to 6 colour printing, 4800x1200dpi, and advanced MicroFine Droplet Technology™ with Micro-Nozzles. It's fast too (just 60 seconds for a full colour A4 print). So if you want to capture details, with Canon you can. **Professional shots. Professional prints.**

School feeding by WFP ensu
that education is not interrupt
Photo by Paula Alyce Sc

Food for Thought

In addition to feeding some 80 million
people per year, the World Food Programme
is the largest provider of school meals to
poor children in the world. By using food to
attract poor children to school, the agency
is able to ensure they receive at least one
nutritious meal a day and an opportunity to
learn.

By becoming the largest corporate sponsor
of the world's biggest humanitarian aid
agency, TPG is committed to making available
its people, skills, systems and assets to
support WFP.

Through this partnership, TPG and WFP aim
to fight the slow, agonising hunger that
affects millions of poor people around the
world.

TPG is the leading specialist in global mail,
express and logistic solutions.
World Food Programme is the logistic arm
of the UN and the world's largest
humanitarian organisation, feeding millions
of starving people every year.

TPG

Moving the world

WWW.TPG.COM

Copyright © 2003
Stichting World Press Photo, Amsterdam
Sdu Publishers, The Hague
All photography copyrights are held by the
photographers

First published in Great Britain in 2003 by
Thames & Hudson Ltd,
181A High Holborn, London WC1V 7QX
www.thamesandhudson.com

First published in the United States of
America in 2003 by
Thames & Hudson Inc., 500 Fifth Avenue,
New York, New York 10110
www.thamesandhudsonusa.com

Art director
Teun van der Heijden
Design
Heijdens Karwei
Picture coordinators
Saskia Dommisse
Nina Steinke
Captions & interview
Rodney Bolt
Editorial coordinators
Bart Schoonus
Elsbeth Schouten
Editor
Kari Lundelin

Lithography
Sdu Grafisch Bedrijf, The Hague
Paper
Hello Silk 135 g, quality Sappi
machine coated, groundwood-free paper
Cover
Hello Silk 300 g
Proost en Brandt, Diemen
Printing and binding
Sdu Grafisch Bedrijf, The Hague
Production supervisor
Rob van Zweden
Sdu Publishers, The Hague

This book has been published under the
auspices of Stichting World Press Photo,
Amsterdam, The Netherlands.

British Library Cataloguing-in-Publication
Data: A catalogue record for this book is
available from the British Library

ISBN 0-500-97623-6

Printed in The Netherlands

Jury 2003
Shahidul Alam, Bangladesh (chair)
photographer and director Drik Picture
Library
Pierre Fernandez, France
photo editor in chief Agence France-Presse
Eva Fischer, Germany
picture editor Süddeutsche Zeitung
Magazin
Sarah Harbutt, USA
director of photography Newsweek
Mitsuaki Iwago, Japan
photographer
Margot Klingsporn, Germany
director Focus Photo und Presseagentur
Herbert Mabuza, South Africa
photographer and picture editor Sunday
Times
Pablo Ortiz Monasterio, Mexico
photographer and picture editor Letras
Libres
Paolo Pellegrin, Italy
photographer Magnum Photos
Brechtje Rood, The Netherlands
picture editor Trouw
Maggie Steber, USA
director of photography The Miami Herald
Andrew Wong, People's Republic of China
chief photographer Greater China Reuters
Alexander Zemlianichenko, Russia
chief photographer Moscow bureau The
Associated Press

Children's jury 2003
Nina Gualandi, France
Images Doc
Javiera Jujihara, Chile
Las Ultimas Noticias
Agnes Kamikazi, Uganda
New Vision
Sterre Marente Kok, The Netherlands
de Volkskrant/SchoolTV Weekjournaal
Agnieszka Legutko, Poland
Gazeta Wyborcza
Selma Omerovic, Bosnia-Herzegovina
Gallery f.OTO
Victoria Rau, Germany
Geolino
Jørgen Thorkildsen, Norway
Verdens Gang
Zhang Xiaotong, People's Republic of China
China Youth Computer Information
Network

Office
World Press Photo
Jacob Obrechtstraat 26
1071 KM Amsterdam
The Netherlands

Telephone: +31 (20) 676 6096
Fax: +31 (20) 676 4471

office@worldpressphoto.nl
www.worldpressphoto.nl

Managing director: Michiel Munneke

Cover picture
Eric Grigorian, Armenia/USA, Polaris Images
Boy mourns at his father's graveside after
earthquake, Qazvin Province, Iran, 23 June

World Press Photo Foundation